T0305392

Film Production and Consumption in Contemporary Taiwan

Asian Visual Cultures

This series focuses on visual cultures that are produced, distributed and consumed in Asia and by Asian communities worldwide. Visual cultures have been implicated in creative policies of the state and in global cultural networks (such as the art world, film festivals and the Internet), particularly since the emergence of digital technologies. Asia is home to some of the major film, television and video industries in the world, while Asian contemporary artists are selling their works for record prices at the international art markets. Visual communication and innovation is also thriving in transnational networks and communities at the grass-roots level. Asian Visual Cultures seeks to explore how the texts and contexts of Asian visual cultures shape, express and negotiate new forms of creativity, subjectivity and cultural politics. It specifically aims to probe into the political, commercial and digital contexts in which visual cultures emerge and circulate, and to trace the potential of these cultures for political or social critique. It welcomes scholarly monographs and edited volumes in English by both established and early-career researchers.

Film Production and Consumption in Contemporary Taiwan

Cinema as a Sensory Circuit

Ya-Feng Mon

Amsterdam University Press

Cover image: *Blue Gate Crossing* (Yee Chih-yen 2002), courtesy of Arclight Films

Cover design: Coördesign, Leiden
Lay-out: Crius Group, Hulshout

Amsterdam University Press English-language titles are distributed in the US and Canada by the University of Chicago Press.

ISBN	978 90 8964 888 4
e-ISBN	978 90 4852 752 6 (pdf)
DOI	10.5117/9789089648884
NUR	670

Printed and bound by CPI Group (UK) Ltd, Croydon, CR0 4YY

To Dad and Mum

Table of Contents

Acknowledgements

I would like to express my gratitude to a number of people. Firstly, to Professor Chris Berry, for his incredible support and mentoring. To Dr. Pasi Väliaho, for the most valuable conceptual inspirations. To Professor David Martin-Jones and Dr. Amit Rai, for their encouragement and constructive advice. To my interviewees Chun-yi, Linwx, Summer, Lan, Grace, Emolas, Black Black, Village, Sandwich, T. Sean, Peichen, Flyer, Aileen Yiu-Wa Li, Chen Yin-jung, Yee Chih-yen, Hsu Hsiao-ming, Chang Chi-wai, Chien Li-Fen, Leste Chen, Patrick Mao Huang, Cheng Hsiao-tse, Rachel Chen, Fu Tian-yu, Liu Weijan, and Helen Chen: thank you for joining me on this long research journey. To Zoe C. J. Chen, Lin Wenchi, and all of my colleagues at *Funscreen*, for their assistance with the fieldwork. To Mathew Holland, who carefully read the first draft of this book. To Peter Conlin, for the vigorous discussions at the final stage of my writing. To Tadgh O'Sullivan, whose honest comments helped improve the early versions of the manuscript. To Chia-Chuan Chang, for her warm friendship and assiduous attention to the final draft. To my beloved Frieda, Stanley, and Charlie, for giving me the courage to get up in the morning.

To my family, without whose patience and generosity I would not have chased my dream.

1 Through the Nexus of Bodies and Things

Introduction

This book examines the sensory aspects of the power dynamics between the film industry and its audience, using post-2000 Taiwan queer romance films as a case study. It revisits scholarly distrust of the culture industry to address how and to what extent the power of capitalism has privileged the industry at the expense of the audience's freedom or personality.

Between July 2009 and March 2011, I interviewed filmmakers, film producers, marketers, and spectators, in addition to running a focus group of film viewers. The fieldwork materials unravel the practices of film production, promotion, and consumption in post-2000 Taiwan, where the film industry was booming once again after a decade of decay. From what I have learnt and observed, it is incontrovertible that there has been an imbalance of power between consumers and the culture industry, represented here by the film industry, and I have seen evidence of contestation. Notwithstanding this, my fieldwork material proved inadequate the political-economic analysis of power structures and the cultural studies approach to social resistance. This is because throughout my ethnographic research, I have seen people deal with volatility as part of the film experience. This includes the experience of producing and consuming film products. By volatility, I not only mean that power dynamics shift around or between film producers and consumers; but more importantly, I have perceived power dynamics shifting on the basis that film producers and consumers act in relation to one another when both are engulfed by sensations, feelings, impulses, and inexplicable intuition. In common sense terms, social dynamics have their affective and sensory aspects. Political economy and cultural studies, however, have paid insufficient attention to these aspects when it comes to the interplay between consumers and the culture industry. This insufficiency motivated me to work on this book, in which I approach the relationship between the film industry and the audience as unstable but affectual and therefore biopolitical. Ethnographically informed, I trace and attribute the power dynamics between the audience and the film industry to intervention by physical entities, including organic bodies, inorganic objects, and media technologies. I argue that the opaque intervention by these entities affects the physical bodies of film producers and consumers,

diversifies the result of cinematic communication, and as a consequence contributes to the instability of the biopolitical relationship between the audience and the film industry.

The Revival of an Industry

My first interest in the relationship between the film industry and the audience came as a general yet also urgent and personal concern regarding social conditioning. I therefore conducted my first film-related research in 2000, pondering the implications of the 'women's genre'. I struggled through classic theories from Freud, Lacan, Althusser, Adorno, to Christian Metz, Fredric Jameson, Laura Mulvey, and Jackie Stacey. I was suspicious of the film industry but had in mind only the Hollywood 'dream factory', which had always been said to (problematically) take the world by storm.

By way of comparison, the Taiwan film industry at the start of the new millennium was a sad relic from a past era of economic prosperity. The well-remembered glory days of the 1960s and 1970s were long gone. Those were the decades in which Taiwan martial arts films and romantic melodramas were exported in large numbers to Southeast Asian markets, enjoying huge popularity. Following this period, the Central Motion Picture Corporation (CMPC) sponsored a number of new directors who spawned what came to be called New Wave Cinema in the late 1980s and throughout the 1990s. The New Wave Cinema was recognised and celebrated on the international film festival circuit.[1] As a result, Taiwan was selected as one of the best film-producing countries in the 1990s.[2] Ironically, the total box office gross for local films plummeted to an all-time low in the domestic market. By the end of the twentieth century, the increasing difficulty in financing local film production had rendered a proper, locally made 'women's genre' completely unimaginable.[3] Hence, at the time of my first reflections on the relationship

1 Besides Hou Hsiao-hsien, whose historical epic *City of Sadness* won the Golden Lion Award at the Venice Film Festival in 1989, Edward Yang and Wan Jen are also considered Taiwan New Wave Cinema masters. The subsequent Taiwan New Cinema second wave involves internationally renowned filmmakers such as Tsai Ming-liang, Chang Tso-chi, and Lin Cheng-sheng.
2 Chang Shihlun, 'New Cinema, Film Festivals, and the Post-New Cinema', *Contemporary* 196 (2003): 98-100.
3 Having acquired a certain reputation on the international film festival circuit, established art film auteurs Hou Hsiao-hsien, Edward Yang, and Tsai Ming-liang capitalised on their niche global appeal and looked overseas for financing. Many of their works, Ti Wei observes, have since the mid-1990s been financed by medium-sized European or Japanese production companies and grossed better internationally as global commodities than they did locally. See Ti Wei, 'From

between the film industry and the audience, I could hardly consider myself at risk of being questionably 'brainwashed' by a local industry that was teetering on the brink of bankruptcy.

Looking back, I wonder who would have been aware that a staggering change loomed on the horizon at that specific moment. In December 2004, having become a journalist, I attended an academic conference on film studies in Jhongli, Taoyuan, hosted by National Central University (NCU), where the prospect of a dramatic revival of the film industry was the preeminent topic of discussion. Accordingly, the conference dedicated itself to the emergent promise of a functioning local film market during an hours-long roundtable discussion. During this discussion, the predominant concern was about marketing and production strategies based on the inspiration offered by the box office success of *Formula 17* (Chen Yin-jung 2004). A queer romance film, *Formula 17* tells the story of a country bumpkin's amorous pursuit of an infamous city playboy. By the time of the conference, the film had become the year's top-grossing local feature production.[4] The film's outspoken public relations consultant, who was present at the conference, detailed the execution of the film's triumphant marketing campaign, which had helped make the film a much-anticipated and well-received local production. To many attendees' surprise, the marketer's remarks covered details as trivial as the availability of suitable dining places near exhibition venues for audience members to have spontaneous post-screening discussions. Custom-oriented thinking/action, which was treated as if it was a newly discovered gospel, was claimed to have become the leading principle in business. In response to the claim, concerns were raised over the possibility that the quality of locally made films might deteriorate rapidly.

As the debate went on, I came to appreciate that I was surrounded by similar-minded people. Like me, the scholars, journalists, and film industry workers involved in the heated exchanges at the conference were all concerned with the relationship between the film industry and the

Local to Global: A Critique of the Globalization of Taiwan Cinema', *Taiwan: A Radical Quarterly in Social Studies* 56 (2004): 65-92.

4 Having grossed just short of NT$ 6 million ($ 200,000), *Formula 17* was hardly a blockbuster. *City of Sadness*, which established Hou Hsiao-hsien as a leading figure of Taiwan New Wave Cinema, made a box office record of NT$ 35 million ($ 1.2 million) in 1989. In 1999, however, at the very nadir of the local film industry's downturn, the 16 locally made films that were released grossed NT$ 12 million ($ 400,000) in total. By comparison, an achievement like *Formula 17*'s would conceivably appear rather remarkable. For statistics, see Shih-Kai Huang, 'A Political Economic Analysis of Taiwan Film Industry in the 1990s' (Master's thesis, National Chung Cheng University, 2004).

audience. Some conference participants were alarmed by the premise of the discussion, which indicated that cinema should be an audience-gratifying and profit-oriented business. Therefore, they felt impelled to problematise the implied industry-audience relationship as a dubious consequence of an unexpected revival of the industry. The unease they expressed with regard to emerging local film practices and the resultant debate at the conference suggested that in post-2000 Taiwan, a worthy case for the study of intricate interactions between the industry and the audience had arisen.

Like many other film industries around the world, the post-2000 Taiwan film industry is dedicated to the grand project of audience enticement. In order to sustain itself financially, the industry is eager for a business model that can be applied to new film products. These include models that provide guidelines regarding film content management and promotion planning. In the following sections and in the chapters to come, I will delineate how this has resulted in the adoption of film genericity. I will also examine how post-2000 Taiwan 'genre films' have been consumed against a backdrop of lifestyle marketing, a process by which film products are associated with miscellaneous consumer commodities and media technologies.

In the context of film production and consumption, the post-2000 Taiwan film industry has been keen to find out what film audiences want and what they *tend to do*. The process of film production and marketing entails offering desirable films or commodities that channel behaviours of consumption. As in the case of *Formula 17*, what is being channelled includes not only film consumption behaviour but also behaviours that may help bring about actual actions of film consumption, such as purchasing supper in a restaurant near a cinema and spreading word of the brilliance of a movie, for instance. Cinematic communication and its effect, in this sense, encompass a wide range of activities in a spectator's everyday life. Meanwhile, concerns about desires and behaviours lead the film industry into an intimate relationship with the audiences' bodies. According to some film industry workers I have interviewed, this means that via consumer commodities and media technologies, the film industry has tried relentlessly to seduce the senses of its potential consumers in the hope that the impact of the seduction will increase film consumption. Rendered in analytical terms, the seduction in question regards a biopolitical issue, which sees the industry participate in governing film audiences as modern subjects. As will be evidenced in later sections and chapters, audiences are, nevertheless, unruly subjects. The unpredictability of their behaviours means that the relationship between the film industry and the audience in post-2000 Taiwan is a precarious one.

These questions of enticement, sense seduction, biopolitics, unruliness, and precariousness, when considered with regard to the relationship between the film industry and the audience, are not exclusive to the post-millennium era, and certainly not to Taiwan. In the very specific context of revitalisation, the post-2000 Taiwan film industry's enthusiastic adoption of business models from around the world – or, more specifically, from the East Asian region and Hollywood – increases its similarity to counterparts from around the globe. With its implementation of limited-budget production and marketing, especially in the case of queer romance films, the post-2000 local film industry nonetheless retains its uniqueness.

This book analyses the industry's operation as a local phenomenon that reflects universal issues. However, as David Martin-Jones argues in applying Deleuzian film theories to world cinemas, pertinent local developments are what sustain the relevance of (potentially) universal concepts.[5] I address the post-2000 Taiwan film industry-audience relationship as being a result of a contested project of biopolitical governance, which links my research to recent advances in general film and media studies. Notwithstanding this, I will examine the biopolitical implications of the relationship with respect to the local rendition of globally circulated film genericity and cross-industry lifestyle marketing.

A Genre Innovation

Since its recent revival, the Taiwan film industry in the post-2000 era has rebuilt its relationship with local audiences. This developing relationship was first understood in terms of the changing properties of locally made film texts. Scholarly research on this subject traces the industry's revival to the year 2000 and ascribes this transforming relationship to the industry's increased use of generic language.

Darrell William Davis, for instance, argues that 2000 witnessed the rise of 'Cinema Taiwan'. Taiwan New Wave Cinema, Davis writes, has defined itself 'in opposition to the authoritarianism of martial law' enforced by the Kuomintang (KMT) government from 1947 to 1987. Cinema Taiwan, by contrast, presents 'critical-creative responses to local film's dispersion',

5 David Martin-Jones, *Deleuze and World Cinemas* (London and New York: Continuum, 2011), 234.

or rather to the local film industry's dysfunction.[6] By Davis's definition, Cinema Taiwan as a category consists of locally made films that 'crossed over to mainstream awareness and success' from the bleak industrial landscape of unremitting recession. Examples of 'Cinema Taiwan' include *Blue Gate Crossing* (Yee Chih-yen 2002) and *Formula 17*, whose production 'contest[s] commercial channels and textual address'; *Double Vision* (Chen Kuo-fu 2002), which 'selectively adapt[s] Hollywood modes of production to local genre conventions'; the kinetic puppet epic *Legend of the Sacred Stone* (Chris Huang 2000) which 'rekindles cinematic technique from indigenous qualities unique to Taiwan's popular traditions'; and a cycle of 'popular, essentially humanist documentaries', such as *Gift of Life* (Wu Yifeng 2004), *Let It Be* (Yan Lanquan and Zhuang Yizeng 2005), and *Viva Tonal: The Dance Age* (Jian Weisi and Guo Zhendi 2003).[7]

In terms of characteristics, Davis argues, each example of Cinema Taiwan remains 'unpredictable, unlikely to resolve into a clearly focused big picture'.[8] Drawing parallels between *Legend of the Sacred Stone, Blue Gate Crossing*, and *Formula 17*, he nevertheless detects a trend towards *intertextuality*, which links recent Taiwan popular cinema directly to 'tribes of comics, games, Japanese *dorama*' and other extra-cinematic art forms.[9] Such intertextuality, he observes, is adopted for the utilisation of extra-cinematic audience formations that are already in place. The enterprise of genre-mix, moreover, negotiates the compatibility between local and global cultural elements. *Legend of the Sacred Stone*, for instance, connects the entertainment value of action/martial art films and the local theatrical or televisual conventions of hand puppets. *Blue Gate Crossing* incorporates *dorama*. *Formula 17* adopts a style reminiscent of Japanese *shojo* anime

6 Darrell William Davis, 'Cinema Taiwan, A Civilizing Mission?,' in *Cinema Taiwan*, eds. Darrell William Davis and Ru-shou Robert Chen (London and New York: Routledge, 2007), 3-6.
7 Davis, 'Cinema Taiwan', 5. For further reference, the production of *Double Vision*, while executed by a local filmmaking team, was initiated and managed by Columbia Pictures Asia, whose founding in 1998 was aimed at engaging Asian filmmakers in producing Asia-oriented works for Asian regional markets. See Ti Wei, 'From Local to Global'. Meanwhile, *Blue Gate Crossing*, along with *Betelnut Beauty* (Lin Cheng-sheng 2001) and *20:30:40* (Sylvia Chang 2004), draws on 'investment by overseas, independent, mid-sized production companies'. See Fran Martin, 'Taiwan (Trans)national Cinema', in *Cinema Taiwan*, 131-45.
8 Davis, 'Cinema Taiwan', 5.
9 *Dorama* refers to modern Japanese idol television dramas. Darrell William Davis, 'Trendy in Taiwan', in *Cinema Taiwan*, 153-4.

while at the same time including Taiwanese renderings of camp materials like *Queer Eye for the Straight Guy* or *Sex and the City*.[10]

Apart from appropriations of generic language, Brian Hu adds in relation to *Formula 17* that the use of music-video vocabulary (i.e. quick edits and unusual camera setups) counters New Wave Cinema's distinctive adherence to long takes and long shots. The recruitment of a cast of good-looking television actors, meanwhile, exploits 'a built-in audience' as much as it retains a sense of glamour to squeeze 'squeals out of giddy teenage girls'. All these practices, Hu understands, prove that the (re)emergence of Taiwan mainstream cinema is attributable to effective executions of well-designed production schemes.[11]

Within the industry, the talk was likewise all about replicable genre conventions, smart visual effects, and efficient marketing operations. Aileen Yiu-Wa Li, the producer of the dazzling *Formula 17*, writes for example in *Taiwan Cinema Year Book 2005* that *Formula 17*'s unexpected success was achieved on two interrelated premises: predetermined genre guidelines and predefined audience reactions. 'Genericity concerns marketability', Li argues, 'Clearly defined generic qualities facilitate preselling the audience to the movie'.[12] Here, 'generic qualities' refer to textual properties that are easily associated with a globally established film product category. Elaborating on her own argument, Li then compares the general categories of Hollywood blockbusters, queer romance, children's films, and horror movies.

With *Formula 17*, Li explains, the adoption of the queer romance genre comes down to the issue of practicality:

> Hollywood blockbusters might have constituted the largest and the best-selling genre at the local box office. But the most feasible choices for a toddling industry like ours are queer romance, children's films and horror movies, according to my business partner Michelle Yeh and my own personal experiences as film marketers and distributers. Profit efficient, the actual production of these three genres does not tend to be costly.[13]

10 *Shojo* describes anime or comics that target young women by emphasising the emotional impact of friendly or romantic relationships. Davis, 'Trendy', 149.
11 Brian Hu, 'Formula 17: Mainstream in the Margins', in *Chinese Films in Focus II*, ed. Chris Berry (London: Palgrave Macmillan, on behalf of British Film Institute, 2008), 122-3.
12 Aileen Yiu-Wa Li, 'The Production Strategy for *Formula 17*', in *Taiwan Cinema Year Book 2005* (Chinese Taipei Film Archive, 2005), accessed March 21, 2013, http://www.taiwancinema.com/ct_52423_332.
13 Ibid.

While recognisable genericity was favoured for practical reasons (market-ability, budget, profit efficiency, etc.), genre conventions were nevertheless implemented strategically. Having settled on queer romance, Li and her production team proceeded to 'contrive a desirable viewing experience' for *Formula 17*. 'Our primary goal', she states, 'was to lessen the political burden of homosexuality with a comical ending, so the audience might leave the cinema bathed in relaxation'.[14] In other words, the connection between conventional queer romantic narratives and gay politics was deliberately undermined in an attempt to enhance the film's entertainment value. Taking sales into consideration, Li and her colleagues were doubtful about the effectiveness, if not the relevance, of conventional (re)presentations of gay identity. In this regard, *Formula 17* is definitely unexceptional among post-2000 Taiwan queer romance films.

Fran Martin remarks on a similar trade-off between gay politics and entertainment in her analysis of *Blue Gate Crossing*, another locally made queer romance film in which a Taipei tomboy falls secretly in love with her girlfriend who, however, has a crush on a boy. Martin regards the film as an example of the 'schoolgirl romance narrative' that circulated in China in the 1920s and 1930s as 'women's homoerotic school romances'.[15] Having survived in Taiwan literary, televisual, and filmic works produced since the 1970s, the genre recently gained solid support from the lesbian and gay movement in the 1990s. As a result, its persistence in the post-millennium era seems to show optimistic signs of 'lesbian identity politics [entering] fully into Taiwan's popular entertainment culture'.[16] An example of the genre, *Blue Gate Crossing* is the first mainstream Taiwan film to non-symbolically allow a tomboy protagonist the possibility of a future, meaning that the tomboy does not die or fade from view at the end of the story. According to Martin, the film marks a transformation of genre convention. The optimism, nev-ertheless, is attained on the dubious condition that the film has presented lesbianism ambiguously enough to suggest different interpretations of the tomboy protagonist's sexuality.[17]

For Martin, such genre innovation indicates a move towards 'despecifica-tion', detectable especially where the industry attempts to maximise the potential size of a film's audience. In the case of *Blue Gate Crossing*, she argues, not only does the ambiguity introduced in the sexual thematic

14 Ibid.
15 The term was coined by Tze-lan D. Sang rather than by Martin herself.
16 Martin, 'Taiwan (Trans)national Cinema', 137.
17 Ibid., 136-8.

serve to strategically draw the attention of multiple yet distinct audiences, including queer and non-queer spectators, but the adoption of a more or less transnational esthetic also enhances the film's accessibility and appeal to geo-culturally diverse international audiences.[18]

With Li and her colleagues concerned with marketability and profit efficiency, the despecification in *Formula 17* came about, however, as an inadvertent consequence. In order to deliver a queer romance that is free from realistic indications of gay politics, Li recalls, the production crew of *Formula 17* was preoccupied with the creation of a dreamy, fairytale-like atmosphere:

> Bright colors were used to dictate the visual tone of the film. Given the premise, the characters were also shown hanging out in well-designed, fashionable places. Their outfits, regardless of the characters' different social backgrounds, were made equally trendy. In general, the production design looked whimsical with a surreal touch. Short shots at the same time were intentionally produced to speed up the rhythm, assuring the strength of the comical effects.[19]

This production scheme was originally implemented to refresh the pre-existing audience for queer romance, assumed to be gay men in their thirties or young women in their twenties. Nevertheless, test screenings of the rough cut brought forth a scepticism among the core gay group, whose reception of queer romance, Li then realised, was dominated to a considerable degree by political thinking. To many in the gay community, the film's utopian happy ending was as good as condescending. The younger generations of the gay communities, on the other hand, were ecstatic about its novelty. 'What they saw and enjoyed', Li understands, 'was just a fun movie, a hilarious story. Their positive response helped reshape the marketing campaign later on'.[20]

The production of *Formula 17* was not exempt from the pressure to maximise either the film's market potential or its international appeal. The formation of its survival/profit strategy, as delineated (and interpreted) by Li, does not in a practical or a theoretical sense necessarily counter Martin's observation concerning the desirable effect of thematic or aesthetic despecification. Li's delineation, nevertheless, constitutes a conscious underscoring of an aspect of cinematic communication that has

18 Ibid., 139-40.
19 Li, 'The Production'.
20 Aileen Yiu-Wa Li, personal interview, September 10, 2009.

so far not been circumscribed by Martin's problematic which is informed by identity politics – be they sexual, national, or otherwise. Desperate to attract the widest possible audience, Li and the production team behind *Formula 17* worked more along the lines of sensation, as well as sexual or cultural difference. To the production team, films induce experiences before anything else. In its very essence, such an induction requires continuous sustenance from sensory stimulus. For a film to attain experiential effect and (hopefully) a resultant financial success, it seems in this case that there has to be 'wisely calculated investment in the immediate, most noticeable sensory impact'. After all, Li clarified, 'No other investment guarantees as much audience engagement in the current climate of film consumption'.[21]

Li's stated vision indicates a relationship between the film industry and the audience that revolves around the industry's calculated seduction of the audience's senses. As it happens, the vision is shared by quite a number of people involved in the local film industry. Cheng Hsiao-tse, whose directorial debut *Miao Miao* (2008) is yet another queer romance movie, maintained in all three of our personal interviews that the future of locally made films must be found in TV commercial-like visuals. 'Everybody loves TV commercials for their delicate visual effect', he said, 'If at the end of the day local film productions would always to some extent suffer limitations brought about by small budgets, delicacy of that nature is the least we filmmakers should endeavour to achieve'. Otherwise the audience would be forever lost to big-budget, high-profile foreign films.[22] While 'TV commercial-like visuals' may not always have been what local filmmakers had in mind when they set out to produce a commercially ambitious movie, the increasing use of special effects in the years following the release of *Formula 17* indicates a growing trend towards sensation.[23] Huang Chih-ming, the producer of the NT$ 20 million ($ 700,000) grossing horror film *Silk* (Su Chao-pin 2006), argued that 'All the audience looks for is some "smart" effects to cover cinema's entertainment aspects', which, he also explained with regard to the local industry's prospects, underline the fact that 'technical crafts are no doubt essential'.[24]

21 Aileen Yiu-Wa Li, personal interview, September 10, 2009.
22 Cheng Hsiao-tse, personal interview, July 30, 2010.
23 See Tu Hsiang-wen, 'The Significance of Special Effects in Taiwan Film Production', in *Taiwan Cinema Year Book 2007* (Chinese Taipei Film Archive, 2007), accessed March 25, 2013, http://www.taiwancinema.com/ct_56135_343.
24 See Ya-Feng Mon, 'The Audience Looks for "Smart" Effects', *Eslite Reader Magazine*, January 2007.

Thus, the adoption of generic language, the necessity for genre innovations, and the pursuit of cinema-generated sensations are strategically integrated for the purpose of audience enticement. As much as the integration exposes the film industry's efforts to gratify (or manipulate) the senses of the audience, it also points to a newly emergent intra-industry relation. That is, in post-2000 Taiwan, film producers like Li and Huang have admitted to their preference for collaborating with novice filmmakers like Cheng, who have a tendency towards (potentially) audience-gratifying visual effects.[25] These same filmmakers had been avid consumers of globally or regionally circulated genre films before they were recruited to work in/for the film industry. In this sense, the filmmakers' relation to the post-2000 local film industry constitutes one of many possible industry-audience connections. In Chapter 4 I will explore this particular connection.

Corporeal Appreciation

Technical crafts and visual effects, nevertheless, do not by themselves account for audience gratifications. The success of sense seduction incorporates contributions from miscellaneous consumer commodities, whose appearance in films integrates film production with film promotion. The incorporation of consumer commodities parallels generic characteristics in augmenting a film's marketability. Introducing daily objects in order to evoke sensations and to focus audience attention, incorporation as such also deepens the relationship between the film industry and the audience centred around sense seduction.

It may not have been a coincidence, therefore, that Aileen Yiu-Wa Li should pick out fashionable hangouts and trendy outfits to underline the significance of sensory effects while Cheng Hsiao-tse turned to TV commercials for aesthetic references. For the purpose of sensation induction, one could even see the intertextuality Davis has noted in recent Taiwan popular movies as ineluctable. Formally, the revived yet 'toddling' post-2000 Taiwan film industry has strived to follow a production model that was constructed at the birth of Hollywood high-concept films. These movies exhibit textual and extra-textual configurations that exemplify the excessive pursuit of sensory stimulation, owing partly to the maturing role of cross-industry alliances in the execution of their production and promotion.

25 See Ya-Feng Mon, 'Make Films for Audiences', *Eslite Reader Magazine*, December 2006.

According to Justin Wyatt, since the 1970s cross-industry alliances have become more dominant than ever in film history, which laid the foundation for high-concept film production. The alliances have helped secure the massive budgets invested in high-concept films and aided the encroachment of media conglomeration. As a result of cross-industry alliances, the crafts of design, casting, soundtracking, etc. have contributed to an advertising-fostered presentation of 'a method of living' in high-concept films.[26] Wyatt argues that, like advertisements, high-concept films centred on special effects 'sell a form of existence'.[27] They do so by offering 'visions of various lifestyles'.[28] In addition to showcasing the latest fashions, high-concept films are driven by an intricate mechanism of cross-media referencing to fulfil the task of exhibiting lifestyles. This means, the lives and experiences of film characters are formed and filtered through a common body of media knowledge. Instead of psychology, actions, and motivations, characters in high-concept films are constructed either out of their own or out of the films' various references to music, television, movies, and other media content.[29] Thus, 'defined almost entirely by his *taste*' in fashion, music, films, etc., a high-concept film character obliquely (or sometimes explicitly) advertises miscellaneous consumer and media products. Those same products, meanwhile, advertise the high-concept movie in discrete extra-cinematic contexts.[30]

On most occasions, the impact of 'taste culture' is understood symbolically in terms of social status or individual identity. However, 'the most striking result of the high concept style', Wyatt contends, 'is a weakening of identification with character and narrative'. In place of identification, 'the viewer becomes sewn into the "surface" of the film', appreciating the excess of sound-buttressed spectacles when s/he contemplates the style of the production.[31] To Janet Harbord, Wyatt's approach to high-concept film reception suggests a spectatorial distance, which breeds a disinterested attention to cinematic presentation, in contrast to a 'depth' of understanding or connection.[32] If this were the case, by appropriating a long-established production model, Aileen Yiu-Wa Li and the *Formula 17* production team

26 Justin Wyatt, *High Concept* (Austin: University of Texas Press, 1994), 60.

27 Ibid., 59. Wyatt has borrowed the turn of phrase from the French film director Etienne Chatiliez.

28 Ibid., 60.

29 Ibid., 57-9.

30 Ibid., 59-60, emphasis added.

31 Ibid., 60.

32 Janet Harbord, *Film Cultures* (London: Sage, 2002), 101.

would have endeavoured in vain to contrive a sense-engaging, relaxing viewing *experience* through technical configuration. Instead, their practice would have eventually kept the audience 'at a distance'. The paradox can only be solved on the condition that, alongside appreciation and contemplation, Wyatt recognises bodily activities that take place 'at a medium depth', that is, activities that take place at the experiential and perceptual level of the body. At this particular level, 'the body is only body, having nothing of the putative profundity of the self, nor of the superficiality of external encounter'. Brian Massumi calls this asubjective and non-objective level the 'medium depth' of the body, which is the dimension of the *flesh*.[33]

Intriguingly, in describing the production goals of *Formula 17*, Li enunciates the intention to circumvent homosexual identity politics in favour of pursuing physical effects identifiable as relaxation. Assuming a lifestyle-oriented cinematic spectacle has, for this reason, materialised on the 'surface' of *Formula 17* to effectively prevent the deep political connection of identification. Therefore, is it possible that from within the spectator the experience of physical relaxation has simultaneously emerged in the dimension of the flesh? The answer is obvious if one looks at the audience's reaction.

In a focus group discussion session I conducted for this research, two participants, Emolas and Grace, were huge fans of *Formula 17*. Asked what had made them enjoy the film so much, Emolas objectively singled out the exquisite visuals, whereas Grace became excited when detailing the film's witty combination of generic formulae. After an information-intense conversation, however, both proceeded to recount a lightness they had felt separately once they had laughed, smiled, and quietly gasped with the technically intelligent production.[34]

It is not surprising that film audiences do not – or at least do not always – embrace cinematic communication in terms of a distanced, knowledgeable appreciation of film crafts. Since the nineteenth century, popular scientific knowledge production/distribution has devoted itself to unpacking the execution of virtuoso theatrical and cinematic spectacles.[35] Although its objective was reportedly to prevent sensory deception, its existence indicates only the extent to which senses have always worked discernibly in the construction of a relationship between theatre/film and the audience.

33 Brian Massumi, *Parables for the Virtual* (Durham: Duke University Press, 2002), 59.
34 Emolas and Grace, focus group discussion, August 9, 2009.
35 See Michelle Pierson, *Special Effects: Still in Search of Wonders* (New York: Columbia University Press, 2002).

Otherwise, an effort to prevent sensory deception would not have been necessary. The intervention of the sensate body has been crucial in the formation of cinematic (mis)perception. So much so that even Eisenstein, whose political faith resides in his montage-fostered intellectuality, believed that intellectual cinema would become worthless without correlating 'sensory thought' or 'emotional intelligence'.[36]

In the history of film theory, corporeal connections have nevertheless been bypassed in favour of intellectual interpretations to the extent that the effect that sensory impressions create in spectators are not necessarily a focus of critical consideration. This has been the case even if the potential consequences of cinematic (mis)perception have, since the onset of the cinematic medium, attracted substantial attention. With or without technical misinformation, it has been regularly assumed that the mechanism of identification must sneak in at some point during film consumption in order to form the core of cinematic (mis)perception. As a consequence, psychoanalytic spectator theories conceptualise vision in the cinema space as the trigger for an identificatory process, alongside which visual pleasure surfaces to be theoretically grasped in libidinal rather than in sensual terms.[37] A Judith Butler-inspired approach to media reception, on the other hand, underscores identity-generative inscriptions that demonstrate media discourses may 'perform' on the spectator's body, without considering the possibility of any reactive bodily sensation.[38]

In this context, Wyatt's theory of 'surface' appreciation seems to have bypassed identity-based theories of film/media reception, however inadvertently. Now that Emolas and Grace's reception of *Formula 17*, described above, has supplemented Wyatt's theory and evidenced that craft appreciation

36 In Gilles Deleuze, *Cinema 2: The Time Image*, trans. Hugh Tomlinson and Robert Galeta (London: Athlone, 1989), 159.

37 Following both psychoanalysis and apparatus theory, Christian Metz, however, integrates spectatorial vision with the operation of cinematographic machines through the explanatory concept of identification. That way, he tangentially touches upon the use of the spectatorial body by counting the spectator as 'part of the apparatus' that modulates visual perception as a result of cinematographic communication. Within the cinema space and during the film screening, he writes, '[t]here are two cones in the auditorium: one ending on the screen and starting both in the projection box and in the spectator's vision insofar as it is projective, and one starting from the screen and "deposited" in the spectator's perception insofar as it is introjective (on the *retina*, a second screen)'. Perception, in Metzian theory, is nonetheless a delicate concept to work with. Described as introjected onto (the second screen of) 'the retina', cinema-informed visual perception to Metz feeds into a 'consciousness' whose constitution is less theorised with respect to bodily/cerebral function. Christian Metz, *The Imaginary Signifier*, trans. Celia Britton et al. (Bloomington: Indiana University Press, 1982), 50-1, emphasis added.

38 See, for instance, Angela McRobbie, *The Aftermath of Feminism* (London: Sage, 2009), 59-69.

weakens the mechanism of identification without compromising the generation of corporeal connection, the study of a spectator's relation to a lifestyle-advertising (high-concept) film requires, among other things, an examination of the spectator's physical reaction. The stale expression of '*brain*washing' would in this case capture with a certain precision the corporeal, non-identificatory bearing the film industry may have upon spectators. Between cinema and the brain (as a body part), there does exist a material linkage that, to borrow Deleuze's words, deserves 'molecular' tracing.[39]

Given this premise, the effects of a film text, whose production in the current climate of film circulation is ineluctably informed by promotion schemes, must (to a certain degree) be sought 'around, on, within' the spectator's body.[40] Accordingly, the audience's relation to the film industry is to some extent built upon a corporeal foundation. Chapter 3 in this book examines cinematic effects and the industry-audience relationship in these terms.

(Re)configuration of Bodies and Things

Thus, via cross-industry alliances and text manipulation, the newly revitalised Taiwan film industry, like other film industries around the globe, effects corporeal changes.[41] This invites urgent concerns over 'biopolitical' control, a situation in which the industry purposefully feeds the audience with cinema-generated sensations for capital reproduction. Control doubtless plays a prominent part in the current relationship between the film industry and the audience in Taiwan. In the imaginations of Aileen Yiu-Wa Li, Cheng Hsiao-tse, and Huang Chih-ming, for the industry to thrive or survive, biopolitical 'control' must first of all become technically possible.

Of course, by any definition, biopolitics involves more than the controlled production of sensations. For Antonio Negri, who is concerned with the

39 See Gilles Deleuze, 'The Brain is the Screen', trans. Marie Therese Guirgis, in *The Brain is the Screen: Deleuze and the Philosophy of Cinema,* ed. Gregory Flaxman (Minneapolis and London: University of Minnesota Press, 2000).

40 See Judith Butler, *Gender Trouble* (New York and London: Routledge, 2006), 184.

41 Interested in and concerned with 'tactile, kinetic, redolent, resonant, and sometimes even taste-ful' experiences of films, Vivian Sobchack has alternatively approached the question of the cinema-body relation through phenomenology and the cross-modality of the senses. See 'What My Fingers Knew', in *Carnal Thoughts* (Berkeley: University of California Press, 2004), 53-84.

relation of the labour force to value generation in late/global capitalism, the biopolitical defines a social context of reproduction which 'integrates production and circulation'.[42]

In the Frankfurt School's pivotal formulation, the integration of production and circulation/consumption – a 'newer', more sophisticated form of social control – compels consumption and renders it commensurate with the ethos of production. Herbert Marcuse writes, for instance:

> We may distinguish both true and false needs. 'False' are those which are superimposed upon the individual by particular social interests in his repression: the needs which perpetuate toil, aggressiveness, misery and injustice. Their satisfaction might be most gratifying to the individual, but this happiness is not a condition which has to be maintained and protected if it serves to arrest the development of the ability (his own and others) to recognize the disease of the whole and grasp the chances of curing the disease. The result then is euphoria in unhappiness. Most of the prevailing needs to relax, to have fun, to behave and consume in accordance with the advertisements to love and hate what others love and hate, belong to this category of false needs.
>
> [...] The very mechanism which ties the individual to his society has changed; and social control is anchored in *the new needs which it has produced*.[43]

Thus, the pleasure principle has been lost, Marcuse declares. Gratification, like production, has long been subject to social regulation.

Marcuse's argument that the emergent mechanism of social control is productive of *needs* is an arresting one. Unpacking these needs in practical terms, he instances the need 'to relax, to have fun, to behave and consume' – all of which point to actions, or tendencies for action. Advertising (plus advertisement-infused or advertisement-fostering cultural productions) implements a procedure of human manipulation, argue Adorno and Horkheimer.[44] If this is the case, it seems that in Marcuse's formulation the effectiveness of the procedure, measured in relation to the ultimate goal of capital reproduction, is contingent not only on psychological but also on sensorimotor mobilisation. Without underscoring (or even realising)

42 Antonio Negri, 'Value and Affect', trans. Michael Hardt, *Boundary 2* 26.2 (1999): 83.
43 Herbert Marcuse, *One-dimensional Man* (Boston: Beacon Press, 1964), 4-9, emphasis added.
44 Theodor W. Adorno and Max Horkheimer, *Dialectic of Enlightenment*, trans. John Cumming (London and New York: Verso, 1979), 163.

it, Marcuse has hinted that the creation of (new) needs, false or otherwise, entails channelling the use of the body. It is this channelling that has, matter-of-factly, blurred the boundaries between the regularisation of production and consumption/gratification.

There is, nevertheless, a difference between Marcuse's and Negri's theories. It lies in the acknowledged degree to which, and the way in which, capital has subsumed the process of social reproduction. For Marcuse, and in Patricia Ticineto Clough's words, 'along with the extension of mass consumption, the reproduction of the labourer is drawn into the market'.[45] In the light of the Frankfurt School's tragic vision of passive compliance, the integration of production and consumption represents a market-led reproduction that aims to discipline, normalise, and delimit. Yet in Negri's later elaboration of market-commanded reproduction, the value of labour is sought and found in the sheer bodily capacity 'to act'. According to Clough, this means that in order to maximise value production, the market economy must and will capitalise on any possible bodily actions. In the circumstances, bodily capacities can only be circumstantially expanded or contracted, effectively channelled but never subject to limitation.[46] Where needs are persistently produced and bodily activities canalised, this is to say the target-focused standardisation of human needs has constituted less and less of an issue in contemporary consumer economy. Instead, the market is after bodies that are ready to mutate or deviate – or, in other words, bodies that are highly active and infused with dynamic possibilities for change.[47]

This difference between Marcuse's and Negri's theorisation (of reproduction) recalls the contrast between the Foucauldian disciplinary society and the Deleuzian 'control' society. In 'Postscript on the Societies of Control', Deleuze writes that within disciplinary societies, a subject/labourer is governed/reproduced in various spaces of enclosure – families, schools, barracks, factories, etc. – each of which regulates the activities of the human body in accordance with specific *laws* to maximise productivity.[48] Control societies, on the other hand, seek ultra-dynamic relationships with their subjects/labourers. Instead of restricting bodily activities with rules or laws, control societies constantly change the parameters of governance to serve the purpose of governance. In so doing, they allow diversity in the actions

45 Patricia Ticineto Clough, 'Introduction', in *The Affective Turn*, eds. Patricia Ticineto Clough and Jean Halley (Durham and London: Duke University Press, 2007), 23.

46 Clough, 'Introduction', 25.

47 Ibid., 19-20, 25.

48 Gilles Deleuze, 'Postscript on the Societies of Control', *October* 59 (1992): 3.

of their governed subjects/labourers, and they adjust to these actions while at the same time canalising the subjects/labourers' behaviours.[49]

There is little contention among theorists that cinematic communication has from its inception been deeply involved in the project Marcuse conceptualised as (new/false) needs production. Wyatt's analysis of advertisement-permeated high-concept films, in fact, echoes Adorno and Horkheimer's conviction that 'advertising and the culture industry merge technically as well as economically'.[50] Serving as approximate advertisements, for instance, lifestyle-showcasing films, whose production revolves around cross-industry alliances, seek to impose guidelines regarding what 'to love and hate' when it comes to consumption for the purpose of gratification. Due to the spectatorial distance suggested in Wyatt's theory, however, this particular process of guideline imposition rids itself of the mechanism of identification, which by prescribing social identities risks limiting the bodily potential for diverse actions. As a consequence, lifestyle-oriented cinematic communication may prove a suitable case for the study of the Negrian/Deleuzian process of social reproduction.

Ethnographically speaking, the biopolitical impact of lifestyle-oriented cinematic communication has been observed as anticipating and reinforcing a body-mediated linkage between the film text and a miscellany of consumer products. This, of course, boils down to the role of cross-industry alliances in film production and promotion.

For example, in the case of *Blue Gate Crossing*, the main cast was scheduled to turn out at events to promote branded commodities as diverse as music records, luxury watches, designer jeans, retail sneakers, beauty products, and mobile communication services during the film's limited local release. Some of the goods were featured in the film; others were not. Regardless, the cast's presence attached the disparate (or somehow symbolically connected) everyday objects to a vaguely defined, overly atmospheric, ideally glamour-charged impression brought forth by, or for, the promoted movie. Under these circumstances, any sensory connection to the related products could (potentially) initiate, enhance, modify, or sustain the experience of the movie, and vice versa. Even past possession of a related object would also work the same magic. In one focus group discussion, for instance, a participant, Lan, was thrilled to recall a piece of old clothing she owned that happened to appear in *Blue Gate Crossing*.[51]

49 Ibid., 4-7.
50 Adorno and Horkheimer, *Dialectic*, 163.
51 Lan, focus group discussion, January 31, 2010.

As such, the practice of film production and film promotion, loaded with the task of product presentation and that of sensation/action initiation, is carried out through the film industry's (re)configuration of a network of body-object relations. Within the network, a spectator's body is related to a movie as it is also related to various consumer products and to the main cast's bodies. In many cases, these body-object-film relations are enabled via further mediation, that is, via the operation of different media platforms that are utilised in film marketing, including television, radio, subway posters, the Internet, etc. In this sense, miscellaneous media technologies are incorporated into the (re)configured network as objects that bear on the spectator-film connection.

Generated via cross-industry alliances, product placement, or cross-media marketing, the industry-(re)configured network of body-object relations informs the result of cinematic communication. Where genre films and their sensory effects are considered, in the face of the network the effects in question cannot remain solely attributable to a specific generic language or to the technical crafts the language's adoption entails. Rather, the effects are filtered through multiple bodies and things. Actively bringing numerous body-object relations into being, the film industry further invests in the sensory impact of genre films. Since in this case the sensory impact might end in the spectator's acting 'to relax, to have fun, to behave and consume',[52] the investment could advance the potential for biopolitical control. In this book I discuss this network of body-object relations within two different contexts. In one, I examine the body-object relations' collective impact on the audience's connection to film texts and by extension to the film industry. In the other, I single out the body-Internet relation to explore how the use of the Internet in film marketing has restructured the interaction between the film industry and the audience.

As the network is constantly in formation, the impact of the (re)configured body-object relations may often appear fluid and present. Nonetheless, once incarnated, it could stretch over time to bring about recurrent urges or evoke old memories. The latter is illustrated by Lan's recollection of an old item of clothing after watching *Blue Gate Crossing*. The former, meanwhile, can be evidenced by the fact that a number of my focus group participants have habitually utilised the Internet to search for information regarding previously viewed movies. The global and the local, as embodied in the diverse commodities incorporated, have also, in the network of bodies and things, become interwoven or proximately juxtaposed.

52 Marcuse, *One-dimensional Man*, 5.

'Real life is becoming indistinguishable from the movies', claimed Adorno and Horkheimer. The authors argue that although illusive in essence, mass-manufactured sound films have unjustly homogenised individual thoughts and behaviours, '[leaving] no room for imagination or reflection on the part of the audience'. As a result, they say, mass-manufactured films have forced spectators to equate them 'directly with reality'.[53] On the basis of the sensations or actions generated by films and film-related body-object connections, there exists a distinct integration of life and movies, one that blends movies with reality when the sensory experiences of the two affect each other. This includes when, for instance, the experience of a mundane object (either a commodity or a communicative technology) influences the experience of a movie, and vice versa.

Probing the mechanism behind recent film production and promotion, Janet Harbord observes that nowadays films – high concept or otherwise – tend to be sold 'as the primary product in a range of related commodities'. The film products consequentially function as 'the cohering factor in a range of lifestyle products' – so much so, she suggests, that film genres can neither be defined in terms of textual properties nor by the composition of their target audiences. Rather, in the current environment of film production and consumption, they can be understood in relation to the clustering of lifestyle formations.[54] This is not merely a genericity tactically (re)organised in the face of prevailing genre innovations or cross-genre intertextuality, even though on account of cross-media referencing Wyatt has underlined this form of intertextuality as a distinctive feature of lifestyle-oriented cinematic communication. But it is also a genericity brought forth through the integrated practices of film production and promotion. Defined thus, a film genre represents a grand nexus of mundane objects/technologies that bear on, or is borne upon by, bodily senses. Accordingly, generic film communication involves sensory activities that take place within the nexus, in connection with pertinent objects or technologies.

It is generic communication as such that this book investigates in order to examine the relationship between the post-2000 Taiwan film industry and its audience. As a result of the investigation, Chapter 4 extends Harbord's conception of film genres and argues that, in respect to filmmaking, a

53 Adorno and Horkheimer, *Dialectic*, 126.
54 Harbord, *Film*, 77-83. A recent example of this, I think, could definitely be found in the groundbreaking success of *The Matrix* franchise. See Matthew Kapell and William G. Doty, ed., *Jacking in to the Matrix Franchise* (New York: Continuum, 2004), and Stacy Gillis, ed., *The Matrix Trilogy* (London: Wallflower, 2005).

film genre functions like a canal system for cinema-initiated sensations to flow and alter among various bodies and things. Given this premise, the audience's relation to the industry has also been restructured with regard to generic film communication.

A Volatile Non-oppositional Relation

What industry-audience relationship has thus far emerged from the industry-(re)configured network of bodies and things? What characterises the relationship, apart from the relevance of biopolitics?

Writing on social control, Marcuse pointed out the 'particular social interests' that have unfairly superimposed 'false' needs on individuals. Biopolitics considered, Clough specifies that the social interests in question stand for the converging of state politics and the market economy.[55] The latter includes powerful sectors of the culture industry, among which is the film industry that (re)configures body-object connections. In this context, the key question I would like to raise is whether the practices of film production and film promotion always serve the profit-concerned film industry in its biopolitical control over mass society.

In the aftermath of cultural studies and post-structuralism, few critics deem monolithic hegemony to be a useful concept in the understanding of power relations. Instead, the notions of negotiation, contestation, struggle, and dynamism command more attention within studies of political/economic dominance. With respect to lifestyle-oriented cinematic communication, examples of such dynamism are available where the film industry (re) configures bodies and things to effect behaviours of consumption but the audience (re)acts unpredictably, thereby hampering the industry's efforts.

Take, for instance, the Internet campaign for Cheng Hsiao-tse's debut film *Miao Miao*. The marketing plan brought together a wide variety of free gifts, including shoulder bags, soft toys, cosmetics, etc. The free gifts were offered to readers of the film's official blog on condition that the blog readers participated in communicative activities on that same blog. These included sharing sentimental real-life stories and purchasing the film's related commodities. Used to strengthen the readers' connection to the promoted movie and to attract the attention of more Internet users, participation from blog readers was thus encouraged by the sensual appeal of particular consumer products. In response to campaigns like this, several

55 See Clough, 'Introduction'.

of my focus group participants admitted to having recounted personal stories on film promotion websites. Driven by the offer of free gifts, their communicative actions nevertheless led them to associate the free gifts with objects and people unrelated to the promoted films – with possessions and friends from the past, for instance. Some of these associations evoked such strong sensory memories that they effectively undercut the advertised movies' memorability.[56]

In *Convergence Culture*, Henry Jenkins has analysed similar cases in which industrial contrivances backfire 'as consumers seek to act upon the invitation to participate' in the life of media products or franchises.[57] Jenkins' analysis emphasises the function of 'collective *intelligence*' in computational-networked communication. The inadequacy in this analysis, nonetheless, relates to the fact that Jenkins has downplayed factors other than human intellect. The aforementioned free-gift hunters, for instance, did not 'break down' the reciprocal relations they were expected to share with the media or the film industry[58] because they had collectively forged industry-challenging knowledge. Nor did they frustrate the agenda of media/film marketers in an attempt to counteract the effect of industrial manipulation. Rather, they confront industrial activities on a daily basis by living, acting, shopping, and communicating in a world that is mediated by numerous consumable *things*. These are things that simultaneously affect intellects and bodies. In lifestyle-oriented cinematic communication, object-generated bodily affections are usually desirable. Through free gifts, for instance, the film industry seeks bodily affections for the sake of film promotion. In the case of the aforementioned free-gift

56 Chun-yi, Village, and San, focus group discussion, August 15, 2010. On a similar note, Janet Harbord writes of the precarious relationship a spectator may now have to film production due to the very prevalence of DVD technology. Created for the proliferation of ancillary products, the most basic DVD format, when working in combination with the remote control handset, enables the spectator to slow, quicken, or pause the moving image. With menu options allowing scene selection, it further opens up a film's sequencing to spectatorial manipulation. The viewer's relation to the film and to the industry that produces the film, Harbord argues in accordance with Laura Mulvey, is consequentially 'changed in terms of a dynamic of power'. See Janet Harbord, *The Evolution of Film* (Cambridge: Polity, 2007), 127-31, and Laura Mulvey, *Death 24 x a Second* (London: Reaktion, 2006). In this regard, Wanda Strauven argues, DVD technology is comparable to nineteenth-century 'domestic optical toys', such as thaumatrope. The operation of the latter likewise requires spectators to use their hands and 'allows for some *manipulation* or "interactivity" during the viewing process'. See Wanda Strauven, 'The Observer's Dilemma', in *Media Archaeology*, eds. Erkki Huhtamo and Jussi Parikka (Berkeley: University of California Press, 2011), 148-63, emphasis in original.
57 See Henry Jenkins, *Convergence Culture* (New York: New York University Press, 2008).
58 Ibid., 20.

hunters, ironically, the generated affections also disrupted the marketing schemes.

Body-mediated disruption as such instantiates power negotiation in a biopolitical sense. As stated above, recent theories of biopolitics see the process of social reproduction as being subsumed under capital and associate the subsumption with market-prompted biopolitical control. With respect to lifestyle-oriented cinematic communication, its Negri-inspired reading is a compelling one. That is, in the era of lifestyle-showcasing films, the market economy controls social reproduction to optimise the value of sheer bodily capacities. In this case, resistance to control depends also on the potentiality of the body. This incorporates, according to Negri, the body's capacity to circumvent control and retain volatility.[59]

Bodily volatility manifests itself when the organic body co-operates with inorganic things. My focus group participants, for example, ended up frustrating Internet film-marketing campaigns with the assistance of free gifts and through their sensory memories of past possessions. This book explores object-fostered bodily volatility in its different forms. In Chapter 6, I examine the film industry's relationship with the audience with regard to the volatile body, which thwarts film marketing plans as the body engages the Internet medium for communication. On the other hand, in Chapter 3 I discuss how mundane objects destabilise the sensory impact of (genre) movies, and by extension undermine the film industry's biopolitical control.

The existence of power dynamics notwithstanding, the dichotomy between the audience and the film industry, on the basis of which the possibility of power negotiation subsists, is more elusive than it is imagined to be. This is because the industry, like the audience, is itself caught up in a network of body-object relations. The promotion of *Blue Gate Crossing*, for example, involved connections between selective consumer commodities and the main cast's bodies. The audience's experience of the movie becomes interwoven with these connections. The film experience, in this sense, is a product of industrial manipulation, even though the audience's volatile bodies may bring about an unpredictable response to the manipulation. However, the industry in this case does not manipulate the audience from the 'outside', as an absolute adversary to or the complete opposite of the

59 Negri, 'Value', 88. See also Brian Massumi, 'Requiem for Our Prospective Dead (Toward a Participatory Critique of Capitalist Power)', in *Deleuze and Guattari: New Mappings in Politics, Philosophy, and Culture,* eds. Eleanor Kaufman and Kevin Jon Heller (Minneapolis: University of Minnesota Press, 1998), 40-64.

audience. Rather, the 'manipulation' only takes effect when the industry and the audience become interconnected in the industry-(re)configured network of bodies and things.

In delineating contemporary media cultures, John Thornton Caldwell provides more examples of industry-audience interconnections. One of them concerns how the film/media industry has incorporated consumer activities into professional practices. Like their audiences, film/media industry workers see films, watch DVDs, surf the web, and participate in cross-platform communication. For promotional purposes, they also disseminate information about the industry to engage the audience's curiosity. As a consequence, a gradual *desegregation* of productive and consumptive experiences and practices comes into being.[60] Theorising the influence of Web 2.0, which increasingly involves the audience in media content provision, George Ritzer and Nathan Jurgenson alternatively discuss the industry-audience desegregation in terms of 'prosumption' – the mergence of production and consumption.[61]

Neither Caldwell nor Ritzer and Jurgenson raise the issue of body-object relations. However, to follow Negri's theory, the integration of production and consumption is precisely the late capitalist context from which bi-opolitics emerge. In this sense, prosumption invites questions of biopolitical governing without holding the audience in opposition to the media/film industry. In this book, I interrogate this non-oppositional relationship with respect to filmmaking and Internet film marketing. I will argue that both the cinematic apparatus and the Internet medium have facilitated audience participation in film (value) production. Each communicative technology, as a result, allows the film industry to take advantage of the audience's bodily capacities. The industry-audience desegregation, however, does not lead to the thorough domination of film consumers, since the consumer's body remains volatile as it co-operates with various physical entities in film prosumption.

60 See John Thornton Caldwell, *Production Culture* (Durham and London: Duke University Press, 2008).
61 See George Ritzer and Nathan Jurgenson, 'Production, Consumption, Prosumption', *Journal of Consumer Culture* 10.1 (2010): 13-36. The term 'prosumption' was originally coined by Alvin Toffler. See Alvin Toffler, *The Third Wave* (London: Pan Books in association with Collins, 1981).

The Way Out of Control

Like many recent publications in film studies that concern biopolitical governing, this book acknowledges the Deleuzian proposition that a body brought into contact with cinema is a body under the influence of the cinematic apparatus – insomuch as the body and the apparatus eventually merge to form an inseparable organism-machine assemblage. Integrated with Foucault's delineation of the emergence of biopolitics, with which the body became governed via painstaking (re)arrangement of its surroundings, the Deleuzian proposition has broadly been considered paradigmatic within film and media studies when it comes to theorising the biopolitical power in/of media technologies. Pasi Väliaho's *Mapping the Moving Image* provides but one example of how the Foucault-Deleuze paradigm has been cited to maintain the instrumentality of media technologies in the configuration of sovereignty over the body.[62] Less taken into account in works like Väliaho's, however, is the full promise of the Foucault-Deleuze paradigm. That is, with or without being incorporated into the function of a biopolitical regime, physical entities surrounding a body are capable of affecting and altering the body. This allows the contingency that, either intentionally or randomly, any given entity – including organic bodies and inorganic things – may effect body changes alongside or in the wake of media technologies.

This book notes the contingency in question to present a case study instance of contested biopolitical governance. It demonstrates the way in which fortuitous connections among miscellaneous entities have laid the foundations for the ineluctable contestation between the governed and governance. The ethnographic research helps trace biopolitical power as an immediate *effect* of various bodily experiences that have emerged from regulated or irregulated relations between a body and its surroundings – to follow Foucault's reasoning in *Discipline and Punish*. In Bruno Latour's terms, this research would thus represent the requisite process to track down in an intricate assemblage of thing-body interactions the material constitution of otherwise abstract social/political forces.[63]

The acknowledgement of contestation enables a refined reading of a theory clearly citable in the analysis of sovereignty over the body – especially when at issue is a sovereignty that is deemed a consequence of communication, techno-scientific developments, or the operation of culture industries in the late capitalist society. This is the theory pertaining to

62 Pasi Väliaho, *Mapping the Moving Image* (Amsterdam: Amsterdam University Press, 2010).
63 See Bruno Latour, *Reassembling the Social* (Oxford: Oxford University Press, 2005).

'the Societies of Control'. The Deleuzian concept warns against the ever more adaptive late capitalist power by drawing attention to how it has simultaneously turned more compelling and penetrating. Inspired by the concept, a considerable number of analyses of late capitalism have yielded to the temptation of picturing the late capitalist control as an overarching monopoly. They allege that since Foucault's insight into the subtle exercise of 'disciplinary power', the capitalist regime has anew cannily stretched the effect of its governance by means of flexibility.[64] If anything, sovereignty in late capitalist societies is nevertheless an arresting fantasy. In *Empire*, Michael Hardt and Antonio Negri underscore the prominence of the 'multitude' as the source of an inevitable social force that permits resistance to the adaptable late capitalist regime. In their context, the multitude consists of a responsive but uncontrollable population whose unruliness stems collectively from indeterminate bodily capacities.[65] Having empirically demonstrated the compromised sovereignty of late capitalism over the body, this book presents a concrete case of the 'multitude'. In fact, it takes the concept of the multitude beyond the limit of the human body/population, so to eventually dispute the absoluteness of 'control' on the basis of chance assemblages of bodies and things.

The core chapters investigate selective aspects of the dynamic, desegregational and prosumptive relationship between the film industry and the audience with respect to the nexus of body-object connections (re) configured around post-2000 Taiwan queer romance films. Arguments are developed on the basis of sensory experiences brought about by generic film communication which, in the context of my discussion, includes communicative activities revolving around film texts and Internet film marketing campaigns. Mediated by objects and technologies, these communicative activities not only permit the industry to exert influence on the audience's bodies, but they also help incorporate film consumption into film production. Both consequences underline the industry's involvement in biopolitically governing the audience's bodies but do not guarantee the full subjection of the audience to the industry.

Preceding analyses of empirical materials, the next chapter reflects upon the ethnographic methodology I have employed in the research so as to acknowledge two more instances of mediation. These are the mediation of language in personal interviews and in focus group discussions, and

64 See, for example, Patricia Ticineto Clough's introductory chapter in *The Affective Turn* (Durham: Duke University Press, 2007).

65 Michael Hardt and Antonio Negri, *Empire* (Cambridge: Harvard University Press, 2000).

the mediation of the researcher in the process of knowledge production. Both cases of mediation underline that ethnographic research outcomes capture the studied phenomena only partially and uncertainly. A process at once affective and intellectual, nevertheless, the practice of ethnography inextricably involves the researcher, the informants, and the everyday objects that bear on the progression of the research. This intertwined involvement renders the outcomes of ethnographic research the fruits of a collective agency, which helps prevent knowledge production from being fully dominated by the academic profession.

As the first instance of empirical analysis, Chapter 3 has at its core the phenomenon that film spectators re-enact film content. Using the reception of *Blue Gate Crossing*, the chapter examines the experiences of a group of audience interviewees and focus group participants and centres the discussion on their bodily citations of cinematographic expression. The accounts offered by the interviewees and participants throw into question theories of identification, discursive performativity, and technological determinism. They feed instead into the central argument of this book that intervention by mundane physical entities limits the power of cinema. Ranging from a computer screen and a human body to digital film stills saved on iPods, these entities affect the spectator's body and diversify the effect of cinematic communication. Due to such diversification, the spectator's bodily citation may not indicate full subjection to the cinematographic expression or to the industry's biopolitical manipulation.

Chapter 4 analyses interviews with post-2000 Taiwan filmmakers to clarify the mechanism of filmmaking as a form of generic communication. It demonstrates how filmmaking is in itself an enterprise of homage, with filmmakers inexorably replicating cinematographic formulae for self-expression. The practice of filmmaking as such is conceptualised as a result of embodied cinematic experience. This means filmmakers are propelled by their previous experiences as spectators to cite existing modes of cinematographic expression, just as any spectator may in daily life re-enact a film scene. Like the spectator's bodily citation of cinematographic expression, the filmmaker's enterprise of homage is susceptible to intervention by physical entities. As a consequence, the enterprise of homage does not necessarily lead to a full replication – and therefore to a loss of cinematic creativity – even if the acts of replication assist in the reproduction of cinematographic language to facilitate the emergence of film genericity. Since the enterprise of homage entails filmmakers consuming film works before becoming involved in filmmaking, film production

as a particular modality of generic communication constitutes an example of film prosumption.

Chapter 5 examines the official blog of *Miao Miao* to reveal the way in which the film industry and its audience have, via Internet marketing, collaborated on film production. Like those in the cinema, communicative activities on a film's official blog engage the audience and the film industry in sensorimotor communication. That is, when actively engaged in computational-networked communication, both parties experience as Internet users information-evoked sensations and turn these sensations into communicative action. As communication on the blog potentially contributes to the effectiveness of *Miao Miao*'s marketing – and therefore to increasing the value of the movie – the blog marketing campaign involves both the audience and the industry in film value production. Given that the involvement of both parties is affective, communicative activities on the blog are comparable to filmmaking, which renders blog marketing a genuine instance of film prosumption.

Either taking the form of filmmaking or blog marketing, film prosumption raises a biopolitical issue about the film industry mobilising spectator bodily capacities for possibly lucrative film production. Chapter 6 continues exploring the execution of Internet film marketing to answer the question as to whether participatory communication has further submitted film audiences to the industry's exploitatory efforts. With regard to film marketing in post-2000 Taiwan, it is argued that bodies participating in film (value) production within or without the film industry have likewise frustrated the late capitalist power by being unpredictable, indeterminate, and ambiguously conducive to capital reproduction.

2 Mediated Knowledge

Methodology

At an early stage of my research, I formulated a hypothesis that the film industry and its audience are affectively related. Ever since, I have centred my research on the physical experiences of both the audience and the industry workers. The research has in the past years repeatedly generated the question as to whether I would use scientific equipment to monitor changes in my informants' physical condition. At academic conferences or at casual house parties, many of those I spoke to seemed to expect that I would detail variations in heart rates or sweat levels in order to evidence my proposed theories.

 I, however, collected the majority of my fieldwork material via personal interviews and focus group discussions. This chapter reviews these methods. The first half delineates the progress of the ethnographic research, conducted between mid-2009 and early 2011. I will recount certain tentative findings and explain how they have effectively led me to reconceptualise the relationship between the film industry and the audience. In the second half, I address the adequacy of ethnography in the study of bodily phenomena.

Enticement via Formulaity

When I first set out to undertake my field research in July 2009, I was interested in the sensory aspects of cinematic communication and inspired by Janet Harbord's approach as outlined in *Film Cultures*. On the latter premise, I saw films as a process that strings together the practice of production, distribution, exhibition, official competition, marketing, and consumption. I based my first working hypothesis on this understanding. The hypothesis prompted me to study the film industry-audience relationship as a product of the *film process*. The work at this stage brought my attention to the fact that the post-2000 Taiwan film industry had endeavoured to entice its audience's senses by means of generic cinematographic language. Generic cinematographic communication, I then realised, permits a transmission of sensory perception between the filmmaker and the spectator.

 To start out on the fieldwork, I spent July to September 2009 in Taipei reconstructing the film process of *Formula 17* (Chen Yin-jung 2004), a queer romance movie whose box office success was said to have changed the

relationship of Taiwan film audiences to local film productions. I set down a work plan that consisted of three tasks. Firstly, I meant to build up a 'production file' for *Formula 17*. Pertinent work included a survey of the film's media coverage and marketing materials, a retrieval of screening records that specified exact venues and dates, a review of production documents gathered by the film company 3 Dots Entertainment, a report on the DVD release and sales, the assemblage of published film reviews, a complete listing of competition entries and prizes won, and a careful analysis of the film text. Secondly, I arranged to interview the film's producers, marketers, and director to ascertain details of the film's production and marketing. Thirdly, I decided to conduct a survey on audience experiences, which commenced with an online search for audience responses. In-depth interviews and group discussions followed.

To recruit interviewees from the general audience, I put an advertisement in *Pots*, a Taipei-based weekly event listings publication. The same advertisement also circulated online via *Funscreen*, a weekly e-paper that covers news from the local film industry. The advertisement called for research participants who had seen *Formula 17* and were interested in locally made queer romance films. Although no payment was offered in the advertisement, I received 33 responses via email. Each of the volunteer interviewees was then asked to fill in a personal information form. On the form, the interviewees revealed their occupation, age, gender, place of residence, preferred name in quotes, the locally made queer romance films they had seen, and whether they would mind being interviewed in a group setting. Three out of the 33 volunteers were at that time in their thirties, 3 were in their teens, and the rest were in their twenties. Of the 33, 21 were university students (including graduate students), 26 were female, and 25 lived in Taipei.

Over a period of four weeks, I met 20 people out of the 33 volunteers. Of these 20, 5 were male, 2 were in their thirties, 1 was in the teens, and 14 lived in Taipei. Thirteen volunteers had to be given up due to failure to agree on appointment times. Eight volunteers were interviewed individually, as requested. According to their available times, the rest of the volunteers were divided up and interviewed either in a group of 4 or in a group of 8.

At interviews and group discussions, I tried to maintain the focus on *Formula 17*. Yet, unavoidably, both the industry workers and the filmgoers compared *Formula 17* to other locally made queer romance films. They ended up commenting considerably on other films as well.

Meetings with industry workers and audience volunteers proved very fruitful in this first stage of research. I soon realised that both the industry

and the audience had paid significant attention to the sensory effect of films, the adoption of generic formulae, and the cinematographic representation of the local reality. On the industry side, the producer and director of *Formula 17* emphasised on separate occasions the extra effort they had put into production design. The producer, Aileen Yiu-Wa Li, considered the budget spent on production design a 'wisely calculated investment', as effective design generates 'immediate, most noticeable sensory impact' on the audience, which might allow the audience to enjoy the movie.[1] The audience volunteers, on the other hand, quoted stunning visuals when asked to elaborate on their interest in certain films.

To industry workers, sensory impact was often pursued by means of film genre conventions. The genre conventions that concerned them, however, reflected very little about the configuration of the locally made queer romance cycle. Instead, they referred to mercantile and linguistic concepts that had circulated around the globe or in the East Asian regional market. In her article published in *Taiwan Cinema Year Book 2005*, Aileen Yiu-Wa Li clarifies, for example, how *Formula 17* stemmed from a carefully formulated strategy of genre film making. The 'genre' in question is queer romance. What had interested Li during her strategy formulation was an internationally established product category. Her calculation revolved around potential markets (both domestic and overseas) and product marketability.[2]

In 2008, I was commissioned by the e-paper *Funscreen* to interview the *Formula 17* director Chen Yin-jung for a feature story. At our meeting, Chen elucidated how generic cinematographic language had framed her (self-) expression. '[W]ith the assistance of generic conventions, I show people what I have observed from my perspective', she said. 'If what I have observed would somehow make me cry or laugh, seeing it, people would probably cry or laugh, too'.[3] In her context, genre pertained to the linguistic formulae she had adopted from Hollywood and Hong Kong commercial movies (see Chapter 4).

When I interviewed Chen and Li respectively in 2009, both reiterated the significance of generic features in their separate work for the film industry. Their accounts corroborate a widespread observation that post-2000 Taiwan filmmaking has a tendency towards regionally or globally

1 Aileen Yiu-Wa Li, personal interview, September 10, 2009.
2 Aileen Yiu-Wa Li, 'The Production Strategy for *Formula 17*', in *Taiwan Cinema Year Book 2005* (Chinese Taipei Film Archive, 2005), accessed September 19, 2013, http://www.taiwancinema. com/ct_52423_332.
3 Chen Yin-jung, personal interview, January 17, 2008.

established generic expression. This is indeed what Fran Martin argues in 'Taiwan (Trans)national Cinema' published in 2007, as have a number of local industry workers in a series of interviews I had conducted for *Eslite Reader Magazine* in late 2006.[4]

Many of my audience interviewees were familiar with, and sensitive to, regionally or globally circulated generic language. They processed the relevance of film genericity on a sensory level, just as Aileen Yiu-Wa Li's comment suggested. The interviewees discussed the way they had laughed, cried, or felt annoyed when they noticed generic formulae being adopted in locally made films. Grace, who participated in a group discussion on August 9, 2009, described how hard she had laughed at Chen Yin-jung's witty citation of generic Hong Kong farce comedies.[5] Chun-yi, another participant in the same group, is a fan of Japanese director Shunji Iwai. Having seen *Eternal Summer* (Leste Chen 2006), she was furious that quite a few film reviews had compared the locally made queer romance to Iwai's works. Resentful, she insisted that *Eternal Summer* represented at best a 'failed copy'.[6] On the basis of these diverse *feelings*, the audience interviewees did not perceive post-2000 Taiwan queer romance films as a 'genre'. Rather, they categorised *Formula 17* as a farce (romantic) comedy and the 2002 production *Blue Gate Crossing* (Yee Chih-yen) as a coming-of-age story (see Chapter 3 for the film synopsis and Chapter 4 for production details).

During my stay in Taipei, another feature story commission from *Funscreen* gave me access to Fu Tian-yu, the director of the then newly released Taiwan queer romance *Somewhere I Have Never Travelled* (2009) (see Chapter 4 for the film synopsis). During the interview, Fu explained her use of cinematographic language. Her delineation brought to light the tension between generic expression and the representation of Taiwan local reality. Fran Martin writes of this tension in 2007, suggesting that the visibility of the local has in post-2000 Taiwan queer romance been overridden by the film industry's pursuit of marketability via globally consumable generic expression.[7] But Fu understood the tension differently. Like Chen Yin-jung, she emphasised how global/regional generic formulae had helped translate her *subjective perception* of the local reality. The result of the translation

4 See Fran Martin, 'Taiwan (Tran)national Cinema', in *Cinema Taiwan*, 131-45. Ya-Feng Mon, 'The Audience Looks for "Smart" Effects', *Eslite Reader* Magazine, January 2007. Ya-Feng Mon, 'Michelle Yeh: Pursue the Smart Money', *Eslite Reader Magazine*, January 2007. Ya-Feng Mon, 'Make Films for Audiences', *Eslite Reader Magazine*, December 2006. See also Chapter 4.

5 Grace, focus group discussion, August 9, 2009.

6 Chun-yi, focus group discussion, August 9, 2009. See Chapter 4 for *Eternal Summer* synopsis.

7 See Martin, 'Taiwan (Trans)national Cinema'.

stood *true* to her, she stated, even if her audience might not necessarily agree.[8] In a later interview with Aileen Yiu-Wa Li, another dimension was added to the issue. Li argued that generic cinematographic language had diversified the cinematic representation of the Taiwan locale. 'Until very recently, Taiwan Cinema did not manage to present the most fashionable areas around the country', she said, defending the trendy rendition of Taipei in *Formula 17*.[9]

More than media coverage, screening records, published reviews, and my own textual analysis of *Formula 17*, the interviews and group discussions summarised above brought my enquiry into focus. They pointed out to me that I was investigating a film industry-audience relationship defined by sensory enticement. In post-2000 Taiwan, the film industry attempted to entice the audience via global or regional film genericity, which informed the practice of film production. Audience enticement as such entails the mediation of the filmmaker's subjective perception. The actual effect of the enticement is, on the other hand, found in the audience's affective reactions.

From a film producer's perspective, audience enticement is necessary for the sale of any given movie. Between the filmmaker and the spectator, nevertheless, the implementation of the enticement allows a potential transmission of sensory perception. What the *Formula 17* director had found funny, for instance, also made my audience volunteer Grace laugh. This last finding determines the subsequent development of my field research.

How Objects Matter

In the second stage of my field research, my interest focused on the perception transmission between the filmmaker and the spectator. Drawing on the theory by Annette Kuhn, who used family photos in her study of cultural memory to assist in the progression of interviews, I used films as *objects* to elicit from the audience volunteers accounts of their sensory response to cinematographic expression.[10] I screened films before focus group meetings. At group discussions, I then learnt that everyday objects and human bodies had significantly mediated film experiences. Interviews with marketers and crewmembers further confirmed the relevance of object/body mediation to film promotion and production.

8 Fu Tian-yu, personal interview, August 14, 2009. See also Chapter 4.
9 Aileen Yiu-Wa Li, personal interview, September 10, 2009.
10 See Annette Kuhn, 'Photography and Cultural Memory', *Visual Studies* 22.3 (2007): 283-92.

In January and February 2010, I was in Taipei applying the research method I had previously tried on *Formula 17* to *Blue Gate Crossing*. I chose the latter film for my second case study because it had generated lively exchanges in audience group discussions.

Apart from building up a 'production file' for the film, I arranged to interview the producer, the director, and the marketer. Director Yee Chih-yen then suggested an interview with the film's executive producer, as he thought the executive producer would have a better grip on the production details. An online search for audience responses was carried out. Besides this, 12 out of the 20 audience volunteers I had met were invited back for further focus group discussions. These 12 participants had been more articulate than the others and had seen more locally made queer romance films. Among them, 3 were male, 1 was in her teens, and 8 lived in Taipei. According to their available times, the 12 volunteers were later divided into two groups of 6 people.

I aimed to delve deeper into the perception transmission between film-makers and spectators. For this purpose, I focused the director interview on Yee's relationship to the cinematographic language he had used. With the audience focus groups, the goal was to let the participants verbally clarify their physical reactions to *Blue Gate Crossing*. In order to facilitate the clarification, every participant was asked to recall and share his/her first experience of the film. Each group discussion then started after a full screening of *Blue Gate Crossing*.

In 'Photography and Cultural Memory', Annette Kuhn demonstrates how in her study of cultural memory she has used the *object* of a family photo to assist an interviewee in undertaking 'memory work'. She seeks to understand 'the nature and the workings' rather than the literal content of cultural memory. Hence the 'memory work' she intends to engage with is 'an active practice of remembering which takes an inquiring attitude towards the past and the activity of its (re)construction through memory'.[11] I did not use the *film object* in focus group discussions to elicit personal memories of the past. Instead, the film object was utilised to evoke instantaneous responses to cinematographic (re)presentations. I worked under the raw assumption that the immediate physical reactions to a film might stay somewhat stable in quality, if unavoidably lessened in intensity, on occa-sions of repetitive viewing. On this premise, I hoped the screening of *Blue*

11 Kuhn, 'Photography', 283-4. Kuhn cites the definition of 'memory work' from her earlier work 'A Journey through Memory', published in *Memory and Methodology*, ed. Susannah Radstone (Oxford and New York: Berg, 2000).

Gate Crossing would help the group participants re-experience the film; insomuch that they would easily articulate their physical reactions to the film. Having thus planned, I was fully aware that a changed viewing context could drastically alter the film experience in question. Therefore I was also prepared for unexpected outcomes.

Ultimately, the film object I employed did not function altogether differently from Kuhn's family photos. The film screening brought back memories of *Blue Gate Crossing* to many participants. These included memories of their past experiences of the film, and memories of the viewing contexts from which the past experiences had emerged. An ineluctable topic surfaced in both group discussions as to how the difference in viewing contexts had led to the difference in film experiences. The participants compared what they had felt and what they just felt of the film. In fact, they endeavoured to account for the difference in their feelings. These endeavours then brought about 'an inquiring attitude towards the past' – in the sense that the participants were eager to examine and (re)interpret their past experiences of *Blue Gate Crossing.*

It was from these examinations and (re)interpretations that I picked up a primary clue to the (potential) cause of varied experiences of the same movie. In delineating their past experiences, the participants invariably specified when, where, and with whom they had seen the film. Then followed a detailed description of the viewing environment in which they had experienced the movie. Village, for instance, recalled she had once seen *Blue Gate Crossing* on television. It was at a New Year's family gathering, when she was at her grandparents' place. 'The television set was so old that the image blurred', she remembered. The blurry image did not hinder her from feeling sad at the bittersweet coming-of-age story. The sadness she felt was, however, 'oddly entwined with the festive atmosphere [...] with the whole family bustling around and everything'.[12]

In his research on television consumption, David Morley argues that various social/interpersonal relations cross the context of television viewing.[13] In Village's case, it seemed other relations could have also crossed the viewing context, that is, the relations that Village's sensate body bore to the objects (i.e. the old television set) and to other human bodies (i.e. the whole family that bustled around) in the viewing environment. Specifically, Village had experienced the objects and the bodies *as* the environment of television/

12 Village, focus group discussion, January 24, 2010.
13 See David Morley, *Television, Audiences and Cultural Studies* (London and New York: Routledge, 1992).

film consumption. The totality of these sensory relations informed her affective connection to *Blue Gate Crossing*.

A later interview with the film's marketer Chien Li-Fen furthered this thought on the viewing context. During the interview, Chien showed me a document that lists all the marketing activities she had planned and executed for *Blue Gate Crossing*. I was surprised to learn the main cast had turned out at many cross-industry alliance events to promote branded commodities. Not all the promoted commodities were featured in the film. However, a glance at the document brought to mind Janet Harbord's theory that films today are sold 'as the primary product in a range of related commodities'.[14] Harbord's theory helps clarify how film consumption is ineluctably carried out in a context that integrates films with tie-in products and ancillary markets. It is in this same context that a spectator develops his/her affective connection to films.

Besides those involving other human bodies, the sensory relations to miscellaneous objects sustain a spectator's affective connection to films. This is to say in composing the viewing context, various objects mediate the film-spectator connection. Obviously, not all object mediation as such can be traced back to film marketing activities. Nevertheless, by means of cross-industry alliances, tie-in products, and ancillary markets, the film industry actively engages in introducing object mediation. The engagement constitutes a prominent aspect of the industry-audience relationship, which I have sought to explore in affective and sensory terms.

My interview with executive producer Chang Chi-wai added a new dimension to object mediation. Chang told numerous stories about utilising or avoiding *things* to facilitate the production of *Blue Gate Crossing*. He was especially proud of his work that resulted in the widely acclaimed street cycling scenes. These scenes show the main characters cycling along tree-lined streets. Many of the audience volunteers I interviewed claimed the street cycling scenes to be their favourite episodes from the movie (see also Chapters 3 and 4). Recalling the filming of these scenes, Chang detailed the difficulties the crewmembers had to deal with:

> We did not have proper tracking devices to film the follow shots. In the end, we had to do it in either of the two ways we knew. Sometimes we used a van – removing the rear doors, putting the cameramen in the boot, and driving crazy like that in front of the cycling actors. Other times we

14 Janet Harbord, *Film Cultures* (London: Sage, 2002), 82. See Chapter 5 for further discussion of this.

used a regular car – removing the windscreen, putting a cameraman in the front seat, and chasing after the actors. No kidding! We did not even have the right equipment to protect the cameras, you know. All that we could do was wrap the machines in large, heavy duvets. It simply looked ridiculous![15]

In addition, there was the deployment of sound and lighting equipment. In order to keep the locations suitable for filming, Chang's assistants also had to park all the cars they could find along the chosen tree-lined streets 'so they could easily move the cars right before filming, to make the streets look nice and clean'.[16] To Chang, film production is concerned first and foremost with the arrangement of things. For the sake of appropriate object utilisation, he then employs and arranges human bodies (like those of his assistants).

Chang's accounts foregrounded the relevance of object/body mediation in the context/environment of filmmaking. How the executive producer arranges *things* immediately bears on the result of filming and the effect of the director's adopted language. Object/body mediation through the executive producer's work therefore affects the transmission of sensory perception between the filmmaker and the audience. An enquiry into such transmission as a window on the industry-audience relationship therefore requires a good grip on details of film production.

All in all, the outcomes of this second-stage research underscore the significance of object/body mediation. Not only do they reveal how such mediation informs film consumption and production, but they also underline the role of film marketing in sustaining an affective film-spectator connection. Both indicate object/body mediation is relevant to the study of the film industry-audience relationship, provided the relationship resides in film-interfaced perception transmission between the filmmaker and the audience. This finding sets the parameters for the final stage of my research.

Internet-Generated Network

Informed by the outcome of the second stage research, the final stage of my fieldwork furthered the investigation into experiences of film production and consumption with respect to object/body mediation. As I bore in mind

15 Chang Chi-wai, personal interview, January 21, 2010.
16 Ibid.

how Harbord has underlined the position of film marketing in linking film consumption to commodity consumption, I made an extra effort to uncover the effect and the executive details of film marketing. The result led my attention to computational-networked communication, which in our age of cross-media marketing underlines Internet technology as a specific object that mediates cinematic communication.

This last stage of my field research took place between July 2010 and March 2011. From July to September 2010, I repeated my research method on two more post-2000 Taiwan queer romance films, *Eternal Summer* and *Miao Miao* (Cheng Hsiao-tse 2008) (see Chapter 5 for the film synopsis and production details). I selected *Eternal Summer* and *Miao Miao* to be my final case studies because I believed both films bear similarities to *Blue Gate Crossing* in terms of textual properties. All three are coming-of-age stories that revolve around love triangles. Since the similarity appeared quite obvious to me, I did not understand why it had never come up at previous audience group discussions. The group participants, as did industry workers, merely discussed global or regional generic formulae.

A 'production file' was developed for each film while I arranged to interview the producers, the directors, and the marketers. I also tried to contact the executive producers of both films, but was unsuccessful in both cases. I searched online for audience responses, and gathered in one focus group all the 12 audience volunteers who had participated in the research on *Blue Gate Crossing*.

Focus group discussions were centred on clarifying the participants' physical connection to each film. Extra attention was paid to object/body mediation, which I sometimes traced to pertinent marketing activities. The participants were also encouraged to recollect how marketing campaigns had affected their past experiences of each film. Curious to know if the group participants would eventually notice the textual similarities, I arranged the focus group discussions in two consecutive days and screened the three films back to back. Questions regarding the shared textual properties were also raised in my interviews with film producers, directors and marketers.

The director interviews still focused on the filmmakers' relationships to their adopted cinematographic language. To make up the unachieved interviews with the executive producers, both directors were also asked to detail the filming processes. Interviews with the marketers covered topics ranging from strategy formulation to resource deployment. Delineation of the latter usually centred on cross-industry alliances and tie-in products. To grasp the big picture of post-2000 Taiwan film marketing, I also interviewed senior marketers who had conducted successful campaigns

but had not been directly involved in the promotion of *Eternal Summer* or *Miao Miao*. These included Helen Chen, the executive director of the distribution company Cimage, which marketed a number of well-received local productions during the 2000s (see Chapter 6).

The investigation into film marketing soon stood out in this stage of research and gave prominence to the position of the Internet in facilitating cinematic communication. Pertinent findings altered my view on cinema as a film-interfaced transmission of perceptions.

To the marketers, the Internet constitutes a strong channel for the dissemination of promotional materials. At interviews, the marketers were eager to delineate and reflect upon the ways in which they had used the Internet to circulate (potentially) *audience-affecting* information. Like film producers who had sought to gratify the audience via sensory impact, the marketers tried appealing to Internet users' sensory tendencies. Patrick Mao Huang, who marketed *Eternal Summer,* said for example that visually attractive web page design and intimate celebrity confessions had proved effective at generating online attention.[17] The hyperlinks, on the other hand, have rendered it easier for marketers to package films in relation to their related commodities. On *Miao Miao*'s official blog, for instance, cross-industry alliances were highlighted via hyperlinks that give readers access to collaborative promotional events. In the same way, free gifts from corporate sponsors were offered to readers on various conditions (see Chapter 5). *Eternal Summer*'s official blog, meanwhile, announced and launched tie-in products, such as the original soundtrack and the tie-in novel.

In the audience focus group discussions, some participants admitted they had capitalised on free gift offers. Many had used tie-in products to conserve physical reactions to films, either by repetitively listening to the original soundtracks or by reading the tie-in novels, for instance. The majority of them, however, associated reactions to films with Internet use. A few participants remembered forwarding film trailers or writing online recommendations when feeling excited at certain films. However, the most common online activity was to search for relevant information after seeing an exciting film. '[A]ny effective element in a movie could prompt *googling*', one participant later explained.[18]

Search acts as such were also carried out by industry workers who *googled* for the purpose of market monitoring. The marketers were especially keen to find out from online audience responses how effective their promotional

17 Patrick Mao Huang, personal interview, August 2, 2010. See also Chapters 5 and 6.
18 Chun-yi, Skype interview, February 1, 2011, emphasis added.

strategies had been. The filmmakers, for their part, were desperate to get a grip on how their work had been received. In the latter case, since the filmmakers were free to speak out as Internet users, public rows did burst out when criticisms were searched for and found. *Miao Miao* director Cheng Hsiao-tse, for example, once had an argument with online film critic jimulder, who on his personal blog claimed to have access to *Miao Miao*'s behind-the-scenes secrets and criticised the film on that basis.[19] Via the blog's comment function, Cheng and jimulder exchanged highly emotional messages. The heated dispute showed that both were overwhelmed by excitement. Although the excitement felt by Cheng and jimulder might have been different from that which prompted the audience's film-related googling, both pointed to the linkage between Internet communication and physical/affective agitation. That film marketers like Patrick Mao Huang had aimed to cater to Internet users' sensory tendencies represented another aspect of this linkage.

These findings inform my theory of object/body mediation in two ways. Firstly, the audience's active use of tie-in products and free gifts attests to the earlier finding that a spectator's relations to the objects scattered within the viewing context affect his/her connection to a given movie. The use of the products and gifts also backs up the theory that film marketing intervenes in the spectator-film connection by means of tie-in products and ancillary commodities. Secondly, it has become conspicuous that the Internet threads together the various dimensions of sensory and affective cinematic communication. The audience's online search communicates the physical/affective excitement generated at film viewing. The marketers entice the senses to circulate Internet information that may later be associated with film works. On the Internet platform, affective agitation can bring about direct exchanges between industry workers and the audience, while the introduction of tie-in products and ancillary commodities impacts on physical connection to films. To a large extent, the Internet has become a highly specific object that powerfully mediates sensory/affective cinematic communication.

The first stage of my fieldwork led me to take an interest in film-interfaced transmission of perception. I had intended to reconceptualise the film industry-audience relationship as affective and sensory. Now, further

19 The argument took place on jimulder's personal blog in November 2008. My last access to the blog was in September 2010. The web page in question was then removed from cyberspace. Cheng Hsiao-tse, however, brought up this online quarrel in our Skype interview on March 5, 2011.

ethnographic research allowed me to see the perception transmission is enabled in a broader network that extends beyond cinema itself or the connection between filmmakers and the audience. This network manifests itself in Internet communication. It brings into view the fact that sensory/ affective cinematic communication arises from media convergence.

In post-2000 Taiwan, the Internet has effectively brought together cinema and consumer commodities, film experiences and online communication, the filmmaker and the spectator, the practice of film production, marketing, and consumption. All listed connections have a sensory/affective aspect that (re)configures the relations of the audience to films, to the film industry, and to film industry workers. In this sense, the mediation of the Internet helps substantiate my first hypothesis that the film industry-audience relationship is the product of a *film process*, which presents production, marketing, and consumption as inextricable practices.

The Industry-Audience Relationship

Carefully going through all the ethnographic data, I decided to pursue arguments along two lines. One revolves around film text and the cinematic apparatus, the other around film marketing and Internet communication. Four core arguments were developed with regard to sensory/affective cinematic communication. One concerns the position of generic formulae in the expression of a filmmaker's subjective perception. One regards frustration in Internet marketing. The other two relate to the re-enactment of film scenes and intimacy in computational-networked communication. In order to substantiate the latter arguments, supplementary interviews were conducted in February and March 2011.

How filmmakers use generic cinematographic language to communicate subjective views intrigued me throughout my research. Following Chen Yin-jung and Fu Tian-yu, *Blue Gate Crossing* director Yee Chih-yen, *Eternal Summer* director Leste Chen, and *Miao Miao* director Cheng Hsiao-tse also suggested that global or regional generic formulae assisted the communication of their personal perspectives. In addition, all five filmmakers associated their use of cinematographic language with their spectatorial histories. That is, each of them acknowledged the influence of previously viewed film works (see Chapter 4 for a full discussion). I understood the latter finding as an indication that film consumption has integrated into film production. By itself, the integration represents a specific aspect of the audience-industry connection. A crucial linkage was however missing,

as it seemed paradoxical that subjective views should find expression in impersonal generic formulae. I would only uncover the linkage once I had delved deeper into the physical connection between films and spectators.

Another phenomenon that quickly stood out from my field notes related to the marketer's anxiety over online marketing. *Eternal Summer* marketer Patrick Mao Huang, for instance, dreaded processing the information he had acquired via Facebook research. 'Everybody "likes" everything on Facebook nowadays', he explained. As a result, the responses a film generates on the social networking website cause confusion rather than indicate the true level of popularity.[20] Confusion of this kind has led to misjudgements, which in turn ended in surprising box office failures. *Miao Miao* constitutes a case as such. The film grossed NT$ 2.3 million ($ 76,000) in Taipei after its production company and distributor had invested a considerable amount in Internet marketing. The box office gross was minute compared to that of *Cape No. 7*, the top-grossing locally made feature in the same year. The latter film grossed NT$ 230 million ($ 7.7 million) in Taipei and NT$ 520 million ($ 18 million) in the domestic market.[21]

The audience focus group gave me a few clues to the marketers' distress. At discussions, I noted that the participants had appropriated film promotion materials for their own purposes. Most commonly, they would engage in online activities, enticed by certain free gifts, without paying enough attention to the advertised movie.[22] Sometimes marketing materials only had an effect on them once they had seen the marketed film and became excited enough to 'google' the film.[23] In these cases, promotional materials were used against the marketer's intention, even though the marketer had successfully catered to the Internet users' sensory tendencies and influenced them affectively.

The relevance of film scene re-enactment struck me relatively late, when I ultimately noticed that Summer, a focus group participant, had a noteworthy connection to the film *Blue Gate Crossing*. By the time we met, Summer had repeatedly viewed the film on DVD for several years. She had also visited the film set regularly and quoted script lines in daily conversation. With the assistance of everyday objects, such as a bicycle, she had habitually re-enacted scenes from the movie (see Chapter 3). The focus group viewed

20 Patrick Mao Huang, personal interview, August 2, 2010. See also Chapter 6.
21 Regina Ho, 'Review of Box Office of 2008 Taiwan Films', in *Taiwan Cinema Year Book 2009* (Taipei: Chinese Taipei Film Archive, 2009), 100 &107. See also Chapter 6 for detailed discussion.
22 Chun-yi, Village, and San, focus group discussion, August 15, 2010.
23 Ibid.

Summer with interest, calling her a fervid fan of *Blue Gate Crossing*. Yet there was nothing peculiar in the way Summer had reacted to *Blue Gate Crossing*. Other focus group participants also admitted to re-enacting movie scenes. Linwx, for her part, attempted to re-enact the street cycling scenes from *Blue Gate Crossing*.[24] Lan, on the other hand, imitated a main character in the same movie and inscribed her secrets on a stadium wall.[25] Calling to mind theories of *embodied* communication, these mimetic actions render the film-spectator connection not merely incontrovertible but also observable. Given that film scene re-enactment often necessitates the deployment of mundane objects (i.e. bicycles, ballpoint pens, a stadium wall), the mimetic actions further attest to my theory of object/body mediation. That is, in the group participants' re-enactment of film scenes, various mundane objects mediated their physical connection to *Blue Gate Crossing*. Provided the cinematographic image represents the filmmaker's subjective perception, film scene re-enactment instantiates the transmission of such perception.

Thus, film scene re-enactment brings together several of my main concerns throughout the research. To dig deeper into the phenomenon, I emailed the 12 focus group participants in February 2011. With the email I also enclosed a list of questions related to the re-enactment of film scenes. I had listed the questions to assist the participants in articulating their past experiences, but the questions were also formulated in such a way that they linked film scene re-enactment with miscellaneous activities covered in film production, marketing, or consumption. I specified in the email that the question list was for casual reference. The participants might each choose to answer questions of interest to them. Besides this, they might choose to answer via email or Skype conversations. Nine out of the 12 participants accepted the interview invitation; 4 of them chose to be interviewed individually via Skype.

The additional interviews engaged me in Internet communication practically every day throughout February 2011. A few email interviews generated follow-up exchanges about film experiences. Some Skype conversations continued on MSN Messenger Service or Facebook. In this period of intensive Internet use, the official blog of *Miao Miao* caught my attention. What rendered the blog unusual was director Cheng Hsiao-tse's frequent replies to reader comments. His diligence generated 417 comments under his personal statement, while other post entries on the blog hardly brought forth more than 10 comments (see Chapter 5). Through interviews and other

24 Linwx, focus group discussion, January 24, 2010.
25 Lan, focus group discussion, January 31, 2010.

fieldwork material, I had learnt that post-2000 Taiwan film marketers were keen to promote industry-audience intimacy. They brought film actors and directors to marketing events and prompted them to interact face-to-face with potential audiences. They had also circulated film production diaries online and encouraged the virtual presence of film celebrities (see Chapter 5). Many filmmakers replied to blog reader comments under these circumstances. Few, however, were as enthusiastic as Cheng was, and his extraordinary passion for communication with the audience parallels Summer's exceptional fervour about film scene re-enactment.

Cheng's communicative effort brought a novel industry-audience relationship into being. The relationship is the fruit of multifaceted film marketing, which in post-2000 Taiwan is substantially mediated by Internet communication. In the interest of further enquiries, I interviewed Cheng about his online exchanges with the audience on March 5, 2011, via Skype.

Artefactual Intervention

The sensory/affective aspects of cinematic communication have been studied before. The outcomes can, for example, be found in Vivian Sobchack's *Carnal Thoughts*, Ann Cvetkovich's *An Archive of Feelings*, Laura Marks' *The Skin of the Film*, and Pasi Väliaho's *Mapping the Moving Image*. In all the named works, sensory activities in cinematic communication are delineated (with the assistance of theoretical frameworks) in relation to the analysis of film text. My interest in the cinematic transmission of sensory perception, nevertheless, developed alongside empirical research as it simultaneously fed into the research. Due to the empirical nature of my approach, I was often pressurised to provide 'appropriate evidence' for my theory. On explaining my research, for instance, I was frequently asked if I had used scientific equipment to monitor an informant's physical reactions to movies. It seems a common sense assertion that in order to study the physical connection of human beings to objects or to other human beings, a researcher must at least be able to detail changes in the informants' heart rates, sweat levels, etc. Given the circumstances, it became a pressing question whether interviews and focus group discussions were suitable research methods.

However, over the course of my research, I never considered employing scientific methods. One of the obvious reasons is that I did not train in science. More importantly, I was interested in the social and cultural implications of the physical aspects of cinematic communication. This

means I would have pursued interpretations of the bodily phenomena, even if I had got a grip on variations in the informants' sweat levels or heart rates. How an interpretation as such can be produced is undoubtedly a political issue. Through interviews and focus group discussions, I meant above all to engage my informants in the production of interpretations.

It did not come as a surprise that on my invitation filmmakers and film audiences were keen to reflect on and delineate their bodily experiences. Film producers and marketers, on the other hand, tended to describe how they had tried to enable certain spectatorial reactions. Their statements, nevertheless, also revealed their own affective involvement in film-related communication.[26] With regard to all these accounts of affective investment, two issues require addressing in order to justify my methods of research. One concerns the qualities of the given accounts, and the other my reading of those accounts. In addressing the first issue, I also seek to answer the question regarding appropriate evidencing.

In interviews and focus group discussions, interpretation of bodily experiences takes place on two correlated levels. Where speaker inter-vention is concerned, the interpretation emerges when the informants interrogate their present or past experiences to 'objectively' contextualise the experiences. It is on this level that Village undertook what Kuhn terms 'memory work' and described her encounter with *Blue Gate Crossing* at a New Year's family gathering. Her association of the film experience with an old television set, her family, and the festive atmosphere indicates her effort to contextualise, that is, to situate her film experience in a context, which she believed had helped produce her physical reactions. It is also on this level that filmmakers explained their use of generic cinematographic language. As stated above, they situated their adoption of global/regional generic formulae in relation to their spectatorial histories.

The contextualisation thus provided may be further contextualised. In Kuhn's words, accounts of past experience represent an active 'construction' of that experience. As a consequence, the results of active remembering do not present 'truth' but rather 'evidence of a particular sort: material for inter-pretation, to be interrogated, mined, for its meanings and its possibilities'.[27] At several points throughout my research, the informants spontaneously took up this task of further interpretation. Emolas, for instance, revealed

26 In Chapter 6, where I examine the practice of Internet film marketing, I foreground the marketer's affective involvement in communication.

27 Kuhn, 'Photography', 284. These phrases are again from Kuhn's citation of her earlier work 'A Journey through Memory'.

in our Skype interview on February 6, 2011 that he had carefully thought about the remarks he had made at focus group discussions. 'I wondered why I had put things that way', he said, 'Did the words of other participants affect my thought somehow?'[28] From time to time in interviews or group discussions, I would also raise questions to encourage the informants to reflect on their expressed opinions.

Nevertheless, the majority of further interpretation set forth in this book represents my subsequent analysis of the informants' initial interpretation. The politics surrounding my analysis will be considered later in this chapter. Suffice it to say that I concur with Kuhn in her reading of informant accounts. As the accounts can always be mined for multiple meanings and possibilities, my analysis realises only some of the possibilities. This relativity in my research outcome, however, cannot be ascribed exclusively to my methods of research. Scientific measurement, for instance, would have brought about the same result. To elaborate this point, I shall turn to a different level of informant interpretation.

Where the medium is concerned, interpretation indicates the sheer fact of language intervention. With respect to the informants' initial interpretations, that is, the research material collectable from interviews or focus group discussions is ineluctably mediated by (the use of) language. How much accuracy the medium of language has allowed in interpersonal communication remains a matter for debate. In pertinent theories, linguistic performativity maintains that rather than convey reality and ideas, language produces them. Linguistic mediation as such represents one of the strongest examples of social/cultural intervention in the constitution of nature, or in the phenomena of the physical world (see also Chapter 3).

Andy Clark echoes such a theory of social/cultural intervention by associating it with cognitive psychology and the computational theory of mind. His argument is straightforward: like many other artefacts, language is a tool of environmental manipulation. Besides enabling communication, Clark argues, the use of language effects numerous changes in our living environment. These include, for example, offloading memories and thoughts onto the world:

Here we simply use the artifactual world of texts, diaries, notebooks, and the like as a means of systematically storing large and often complex bodies of data. We may also use simple external manipulations (such as leaving a note on the mirror) to prompt the recall, from onboard biological

28 Emolas, Skype interview, February 6, 2011.

memory, of appropriate information and intentions at the right time. Thus, this use of linguistic artifacts is perfectly continuous with a variety of simpler environmental manipulations, such as leaving an empty olive oil bottle by the door so that you cannot help but run across it (and hence recall the need for olive oil) as you set out for the shops.[29]

One may object to the comparison of language with an empty olive oil bottle and insist on language's additional complexity. The point Clark appears to make, however, is that a material instrumentality exists in language. Hence when used in context (with the contextual assistance of a mirror object, for instance), language might physically inform bodily/brain functions and alter the configuration of human thoughts/memories, as would an empty olive oil bottle or other instrumental objects.

In this sense, it is possible to draw a parallel between language and scientific equipment. In research on affective investment, the tool of language yields verbal interpretations of bodily experience just as appropriate scientific equipment might otherwise provide information about changing heart rates. The imperative issue, nevertheless, is that the similarity between the two approaches has not been stressed enough. The reflection on linguistic intervention has developed to such an extent that in interviews or focus group discussions, researchers are invariably warned against taking even the most self-reflective informant accounts as 'truth'. However, using common sense, people would not always assume scientific findings as 'evidence of a particular sort: material for interpretation, to be interrogated, mined, for its meanings and its possibilities'.[30] Yet is any existent piece of scientific equipment not also an artefact and capable of effecting social/cultural intervention that informs bodily functions and reconfigures the phenomena of the physical world?

Regardless of the answer, scientific methods do at least mediate and limit possible understandings of the body. In her review of recent studies on bodily capacities, Lisa Blackman delineates and criticises a tacit partiality towards scientific evidence. The humanities and social science disciplines have introduced scientific knowledge in order that they can emphasise bodily matter in relation to complex social phenomena. Their reliance on scientific evidence, nevertheless, poses the threat of reducing the body to its automatic functionality. A reduction as such effectively obstructs the understanding of the liminal characteristics of the body. As Blackman

29 Andy Clark, *Being There* (Cambridge, MA and London: MIT Press, 1997), 201.
30 Kuhn, 'Photography', 284.

argues, bodily liminality arises as a consequence of ever-dynamic social interactions and from the borderline between automatism and cognitive function.[31] Read with respect to my research, this confirms that scientific findings would not necessarily guarantee more – or more vital – clues to sensory activities in cinematic communication.

I stand by the argument that via the mediation of language and their cognitive capacities, my research informants provided me with verbal material to be further 'interrogated, mined, for its meanings and its possibilities'. No immediate connection subsists between the material provided and a comprehensive truth. Rather, the informants' use of language brought about artefactual intervention, which might have informed and reconfigured the pursued truth in question. This inevitable intervention set off an ultra-dynamic interplay between my fieldwork material and the phenomena it represents. As a result, the capture of the phenomena by the material is merely partial, and likely to be always uncertain. The same applies to outcomes of scientific research, whose execution likewise entails artefactual intervention. Partiality resides with scientific evidence, even before the evidence is subject to further interpretation.

Joint Authorship

Further interpretation, meanwhile, constitutes a moral issue when an ethnographic researcher is involved, according to Jackie Stacey.[32] Can the researcher justifiably interpret the words of the researched? When s/he does, what does the interpretation imply? These are the persistent questions with regard to the legitimacy of ethnography.

Ien Ang addresses these questions in proposing an 'interpretative ethnography'. She argues that 'empirical findings [...] acquire their relevance and critical value in the context of [an] emerging theoretical understanding'.[33] If the plurality and diversity of experiences constitute the central concern of empirical research, she states, such plurality and diversity are not 'just simple facts that emerge more or less spontaneously from the empirical interview material'. The establishment of significant differences concerns 'a matter of interpretation'. In David Morley's *Family Television* project, for instance, an interpretative framework is necessary in order to connect

31 See Lisa Blackman, *Immaterial Bodies* (London: Sage, 2012), 77-99.

32 Jackie Stacey, *Star Gazing* (London and New York: Routledge, 1994), 71.

33 Ien Ang, *Living Room Wars* (London and New York: Routledge, 1996), 51.

differences in media reception with 'the way in which particular social subjects are structurally positioned in relation to each other'.[34] However, 'interpretations always inevitably involve the construction of certain representations of reality'. Consequentially, subjectivity and partiality is inextricable from ethnographic knowledge. In subjectivity and partiality lies 'the inherent symbolic violence in any kind of research'.[35]

Valerie Walkerdine discusses symbolic violence in 'Video Replay'. The article reports findings from her participant observation in a working class family, with its focus on an occasion where the family watched the video *Rocky II* (Sylvester Stallone 1979) together. Complex power relations impacted on this video viewing inasmuch as Walkerdine's analysis starts from a response of disgust to what she has observed. Walkerdine states that she had an impulse to criticise the working class father, in particular his obsession with violence and macho sexism. However, the negative response was soothed away once she had viewed the same video herself. Her working-class upbringing brought a sense of empathy during the video viewing. The empathetic response in turn allows her engagement with the father's psychic tendencies.[36]

The complexity in this research experience leads Walkerdine to challenge the configuration of media audience studies in the mid-1980s. With the assistance of either psychoanalytic theories or ethnography, she argues, the academic presents mass media audiences as 'sick (voyeuristic, scopophilic) or as trapped within a given subjectivity (whether defined by the social categories of class, race and gender or by a universalised Oedipal scenario)'.[37] Not only does such presentation fail to translate the audience's psychical dynamic, but it also reflects a 'perverse' desire on the side of the intellectuals. Intellectuals are so obsessed with 'the illusory tropes of an oppressive ideology' that they invest in a fantasy, wherein they are endowed with the power to make the audience see, or to see and speak for the audience. This generates the tendency to see the audience as 'the other' and the will to extract knowledge from this 'other'. The knowledge in question revolves around the mass audience's structure of pleasure, which is regularly opposed to 'the academic emphasis on rationality and intellectualization'. This false dichotomy exposes the exercise of modern power. In the face

34 Ibid., 49-50.
35 Ibid., 49-52.
36 Valerie Walkerdine, 'Video Replay', in *Formations of Fantasy*, eds. Victor Burgin, James Donald and Cora Kaplan (London: Methuen, 1986), 168-71.
37 Ibid., 195.

of diverse subjects, the power seeks to civilise and regulate through the cumulation of knowledge.[38]

To lessen symbolic violence, Walkerdine decides on an unconventional research approach:

> I wanted to use my own fantasied positions within those practices as a way of engaging with their unconscious and conscious relations of desire and the plays of anxiety and meaning. Often, when interviewing the participants I felt that I 'knew what they meant', that I recognized how the practices were regulated or that I understood what it was like to be a participant. Using this 'recognition' [...] seems to me an important step beyond assertions that academics should side with the oppressed, that film-makers should see themselves as workers or that teachers should side with pupils. Such rhetoric may represent *our* wish-fulfilling denial of power and responsibility – a way of disavowing our position instead of accounting for it.[39]

In practice, the approach was adopted on two levels. On the one hand, Walkerdine digs into her multiple social positioning and her psychic needs/ fantasies. On the other, she uses the results for a reference point by which she explores how her informants perceive her as a researcher and how they understand their own experiences.

The way Walkerdine engages self-reflectivity and self-reflexivity has, since the mid-1980s, become standard in ethnographic research. What has seldom been underlined with regard to her approach is the affective aspect in her self-reflexivity. To know what the informants mean in interviews, to understand what it is like to be the researched, and to *empathetically* engage with the informants' psychic tendencies, a researcher needs more than intellect and good intentions. Like all other social occasions, interviews, participant observations, and focus group discussions are permeated with bodily suggestions and energetic exchanges that, according to Lisa Black-man, also have psychic pulls.[40] Walkerdine's first response of *disgust* to a working class father's behavioural tendencies had a bodily dimension. Her later replacement of disgust with empathy represents a change in bodily sensations.

38 Ibid., 195-6.
39 Ibid., 191, emphasis in original.
40 See Blackman, *Immaterial Bodies*.

Walkerdine has read her affective investment critically and sympto-matically. It is for this purpose that she traces her affective response back to her upbringing and social positioning. In Chapters 3 and 4, however, I will argue with respect to cinematic communication that identity is a consequence of the body's incessant interaction with its surroundings. This includes the interaction with other organic bodies, miscellaneous non-organic objects, and media technologies. Given this perspective, I have not been as concerned with the way the researcher's upbringing or social positioning may impact on the progress of ethnographic research, even if, as in Walkerdine's formulation, the implication of upbringing or social positioning is also incessantly in formation with regard to environmental or historical change.

What has concerned me instead is the affective dynamics evident in interviews and focus group discussions. Like Walkerdine, I also tried using my experience as a reference point to empathetically explore the way in which my research informants interacted with me and the way they had understood their bodily experiences. However, as my research progressed, my reference point was constantly on the verge of being lost. This is because during the interviews and group discussions, I was not always able to isolate my experience from the ongoing dynamic process of the affective and verbal exchange.

The most memorable example took place when I interviewed Linwx on February 10, 2011. This was an additional Skype interview on film scene re-enactment, in which the focus group participant detailed her ambiguous bodily experiences of *living in the movie* (see Chapter 3). Her delineation of the experiences was beautiful and moving. Insomuch, I became so excited and emotional that I could not stop revealing similar experiences on my part. My self-disclosure in turn elicited more responses from her. The conversation ended up going on for hours. Likewise, the interview with filmmaker Fu Tian-yu progressed in a state of exhilaration, as we both had a great deal to share about how cinema had shaped our perception of places and people.

In some cases, my self-disclosure was more strategic but no less spontane-ous. After the screening of *Eternal Summer* on August 14, 2010, for instance, the focus group discussion was dominated by a few participants who had always disliked the movie. They blamed the production team for making practical mistakes and centred the discussion on ridiculing these errors. The situation upset me, since I had experienced the film differently. I noticed some of the group participants might have shared my annoyance because they *sighed* and *frowned* in reaction to certain comments, or *folded their*

arms across their chests. Wanting the silenced participants to speak out, I intervened in the discussion. I described the use of colour and light in the movie, and discussed how it had brought back memories of my teenage melancholy. Several participants followed this line of communication. In the end, two participants, Flyer and Emolas, had to aggressively defend their view that careless errors had irretrievably reduced the appeal of the film. 'That is not the point!' replied the agitated Black Black, who had been fascinated by the film's gloomy atmosphere. 'When you see a movie', she said, 'you neglect trivial errors to gain emotional satisfaction'.[41]

Thus, if my personal experience had a role to play in the ethnographic research, it did not serve as a reference point, which allowed me to empathetically compare and engage with my informants' experiences. Rather, the production, remembrance, and delineation of my experience have been incorporated and generated in the research. They mark my active involvement as both affectual and intellectual. Meanwhile, my relationship to the informants is both affectively and cognitively interactive.

When I sat down at my desk to write, I interpreted the informants' accounts on the basis of the felt and recognised interaction. Reading interview transcripts, for instance, evoked the affective response I had experienced at interviews. The evoked response then called to mind details of the interviews – the setting, the atmosphere, the way things were said, the manner in which words were responded to. I could only make sense of the transcripts in relation to all these details, and mainly in relation to my subjective experience of the details. This subjectivity of mine was nonetheless formed in interactions, which is to say, to a certain degree it represents *inter-subjectivity*.

Like Village's affective connection to *Blue Gate Crossing*, the inter-subjectivity in question does not only indicate my relationship to the informants on occasions of interviews or group discussions, but affectively and cognitively, the informants and I were also influenced by various objects. During the personal interview with Yun-xuan, for instance, my digital recorder almost ran out of battery. A 'Battery Low' warning flashed every few minutes on screen, which perceptibly undercut my concentration. Reading the interview transcript at a later time, I realised I did not recall the content of my conversation with the audience volunteer. Ironically, the cause of my amnesia was the same machine that had saved my lost memories.

41 Flyer, Emolas, and Black Black, focus group discussion, August 14, 2010.

All in all, an inter-subjectivity mediated my interpretation of inform-
ant accounts and represents my relations to people and things during the
interviews or focus group discussions. How does this inter-subjectivity
inform the ethical relationship between the researcher and the researched?
To answer this question, I will turn to Lisa Cartwright and her argument
about facilitated communication.

Facilitated communication (FC) is a method that assists autistic children
to express themselves. Its practice involves a professionally trained facilita-
tor, who skilfully supports the body (the arm or hand in many cases) of an
autistic child with his/her own body so that the child can write or type
on a computer for self-expression. When the method was recognised as
successful, it created a scandal, as facilitators were accused of manipulation.
In her study of facilitated communication, Cartwright describes the scandal:

> [An] aspect of the controversy centered on the possibility of facilitator
> influence over the child's written text, and the potential that facilitators
> might, in some cases, have in fact projected [...] narratives, consciously
> or unconsciously, onto the unwitting child, using it as a vehicle, ventril-
> oquist-like, to express the facilitator's own memories or fantasies [...][42]

Formulated as such, the controversy is about authorship, about whether the
written accounts generated in facilitated communication could actually be
ascribed to the autistic child.

Comparing facilitated communication to all other forms of inter-
subjective communication, Cartwright argues that what has problematised
the former is the false conception of an 'independent' author, as 'authorship
never resides solely with one subject or another'.[43] In interpersonal commu-
nication, Cartwright writes, 'speech is always performed intersubjectively,
at the behest of another and in the imagined space of the other's multisen-
sory gaze'.[44] This by itself may only suggest that what is communicated
interpersonally is always already *mediated* by other subjects and/or by the
imagined gaze of other subjects. Yet is mediation not manifest in all forms
of communication? Consider, for example, communicative acts as facilitated
by paper and pencils, computers, mobile phones, or any media technologies.
What a subject – any subject – confronts on a daily basis rests on highly

42 Lisa Cartwright, *Moral Spectatorship* (Durham: Duke University Press, 2008), 159.
43 Cartwright, *Moral Spectatorship*, 193. Cartwright cites Laura Sabin and Anne Donnellan's
research on facilitated communication to make this statement.
44 Ibid., 198.

mediated contexts of communication. In these contexts, Cartwright states, the identification of authorship is a complex task. In most cases, one must acknowledge autonomous authorship to be 'an unrealizable ideal', even when 'those involved in the authoring do not have communication impairment' and even when 'the mediating device is a machine'.[45] This is not to say power relations do not exist in mediation. Power, Cartwright stresses, is 'necessarily distributed across subjects'.[46] In the same manner, sociality and communication are inevitably brought into being across multiple bodies.[47]

I see the dynamics involved in facilitated communication as applicable to those that exist between the researcher and the researched. It must be possible that in ethnographic research, the researcher exerts influence over the accounts of the researched. There is also the potential that the researcher might, consciously or unconsciously, project narratives onto the researched in order to express his/her own memories or fantasies. Under these circumstances, the research findings can appear problematic, with the desire of the researcher likely overriding the needs of the researched. However, it is also (noticeably) true that the researcher's influence – or the researcher's desire to express his/her memories and fantasies – is intersubjectively produced during the process of the research. Researcher mediation (on top of language mediation, technology mediation, etc.) may prevent the claim of research findings being absolutely true, yet it does not negate the contribution of the researched. Rather, as in facilitated communication, the inter-subjectivity born out of the researcher-researched interaction only complicates the identification of authorship.

Following Cartwright, who contends that in facilitated communication the authorship of the autistic child is not independent from that of the facilitator, I would argue that the researcher and the researched share the authorship of a presented research. The authorship is shared not merely because the researched, obviously, provides the material to be further interpreted by the researcher, but the researcher's interpretation, as stated above, is also mediated by what fieldwork material might generate through the process of interpretation. Transcripts could evoke memories or affective responses that are associated with interviews or group discussions, for instance. This specific process of mediation incorporates the informants' contribution in its diverse forms, which, alongside spoken words, may

45 Ibid., 200. Cartwright references Richard Grusin's article 'What Is an Electronic Author?' to make this argument.
46 Ibid., 198.
47 Ibid., 211.

include bodily gestures and speech tones. Besides, the mediation process incorporates contributions from everyday objects that have surrounded and affected the researcher-researched interaction. Construed as such, research findings, although usually presented in the researcher's writing, are doubtless fruits of *a collective agency* – a concept I will reiterate in later chapters.

Recognising research authorship as shared does not eradicate the power struggle between the researcher and the researched. Intersubjective power dynamics are inescapable, as Cartwright insists. In this sense, the relationship between the researcher and the researched will always raise ethical questions. However ethically worrying, intersubjective power struggles make possible the practice of ethnography and the emergence of the resultant collective agency. The acknowledgment of collective authorship, on the other hand, renders even clearer why ethnographic research is appealing.

As cited above, the false dichotomy between the researched mass audience and the intellectual researcher in the mid-1980s concerned Valerie Walkerdine. For her, alongside the latter group's knowledge production, there is an attempt to civilise and regulate the former group, who in her formulation has been unfairly conceptualised as hedonistic and pleasure-seeking. Nonetheless, in the practice of ethnography, any dichotomy between the researcher and the researched is doomed to be false, as the segregation of the researcher, the researched, and the environment that surrounds both is not possible in a practical sense. So long as the researcher communicates intersubjectively and engages daily objects throughout his/her ethnographic research, a collective agency is bound to emerge. This is the case whether joint authorship is admitted to or not. By virtue of collective agency, the academic profession does not in any case fully dominate the production of knowledge, even if knowledge production might remain entwined with an academic desire to pathologise or regulate whoever is researched.

Mediation in Knowledge Production

When the research informants actively contextualised their present and past film experiences, they provided interpretations of their experiences. As fieldwork material, the interpretations would later go through further interpretation when I analysed them and presented my analysis in written form.

The fact of informant interpretation effectively denies my fieldwork material the linkage to a comprehensive truth. My subsequent effort to

analyse the initial interpretation further distances the written presentation of my research from the comprehensive truth. Following Annette Kuhn, I understand the presented results as constituting *some* of the possible conclusions I might have drawn from the fieldwork material. But I reject any suggestion that the recognised relativity in the presented outcomes of my research must be ascribed to my ethnographic approach. As I have argued, if a scientific approach had been adopted, the same relativity would have persisted. This is because neither the ethnographic nor the scientific approach could escape the mediation of artefacts. The former necessitates the mediation of language, for instance, while the latter relies on appropriate equipment. Artefactual mediation as such effects social/ cultural intervention, which informs and reconfigures the phenomena of study. Consequently, either approach leads to partial and uncertain capture of the studied phenomena. This is the case even before the findings are subject to the researcher's further interpretation.

The researcher's intervention in the research, meanwhile, is inextricable from the involvement of the informants or the miscellaneous objects that inform the enquiry. At once affective and cognitive, this correlation has a perceptible impact on the production of fieldwork material, so does it mediate the subsequent material analysis.

On these premises, I see this research as a joint effort. The outcomes have stemmed from a collective agency, which integrates contributions from the researcher, the researched, and their shared surroundings. The emergence of an agency as such is entangled with the power relations that have crisscrossed the research. These include the power struggles between the researcher and the researched. Nevertheless, throughout the research, the collective agency prevents knowledge production from being fully dominated by the academic profession. In later chapters I will argue that an agency shared among various bodies and things similarly undercuts the (bio)political influence of the film industry.

3 Bodily Fantasy

Embodied Spectatorship and Object Intervention

Summer was the first person I talked to when I started my research for this book. It was July 2009. In her email, she said she was familiar with Da'an District in Taipei and would like to meet me in that neighbourhood. Somewhere near the Affiliated Senior High School of National Taiwan Normal University would be ideal, she added. So we met at a coffee shop a few blocks away from the high school. She told me she had planned to once again visit the high school campus after our interview 'because that's the place *Blue Gate Crossing* was filmed and set'.[1]

Produced and later on released by Arclight Films in September 2002, *Blue Gate Crossing* (Yee Chih-yen) tells the story of Kerou, Yuezhen, and Shihao. All three characters go to the Affiliated Senior High School of NTNU in Da'an District. Tomboyish Kerou is secretly in love with her best friend Yuezhen. Yuezhen, for her part, has a crush on the school hunk Shihao. Obsessive and desperate, Yuezhen asks Kerou to convey love messages on her behalf. The personable Shihao, however, becomes attracted to Kerou. Thereafter, all three high-schoolers live through an eventful summer, each falling victim to their immature love triangle.

Summer's encounter with this bittersweet queer romance film was accidental but life-changing. When *Blue Gate Crossing* first hit the big screen, she had just started secondary school in Hualien, a county on the eastern coast of Taiwan, and had never before been bothered about the uneven distribution of locally made films. She had her first glimpse at clips from the film when she saw on television a music video with the pop singer Cheer Chen, whose record company Rock Record Co., Ltd. was in a cross-industry alliance with Arclight Films. The images appealed to her. She recalled in our 2009 interview and on several later occasions how a line spoken by the character Yuezhen of Shihao had attracted her attention via the music video and ever since became a line she would occasionally quote in her daily life.[2] Summer bought the film's tie-in novel,[3] read it repeatedly and intensively. But because *Blue Gate Crossing* was not scheduled to be shown

1 Summer, personal interview, July 18, 2009.
2 The scripted line in question reads in Mandarin, 'Wo lao gong a, chuan hua chen shan na ge a', meaning 'that one over there in a floral shirt, he's my future husband'.
3 Yee Chih-yen and Yang Ya-che, *Blue Gate Crossing* (Taipei: New Rain Business, 2002).

in any cinema near her, she did not get to see the film properly until her first year in high school, when a DVD was finally given to her as a birthday present. 'From then on, I never could stop watching it', she said:

> In the high school years, I watched the DVD at home a couple of times each day. My mum could barely stand it and always whined about not watching enough variety shows when I was around. In university, I still watched it every day in my dorm room. In the end, it would only take a brief glance from my roommate to see what I was watching, and she would say, 'Come on, not THAT again!'[4]

Alongside repetitive DVD viewing, Summer developed a habit of visiting the campus of the Affiliated Senior High School of NTNU. Throughout my field research, she seldom failed to update me or other focus group participants regarding changes in the campus since the film had been made. Besides, 'acting the film out', she admitted, had in previous years been incorporated into her daily practice. Speaking, for example, of the scenes she and many other focus group participants had found most impressive from *Blue Gate Crossing* – those in which Kerou and Shihao cycle through the city streets chasing one another in dazzling sunlight – she thus described her re-enactment of the movie:

> Back in my high school days, once I was on my bike, I would automatically put on the *Blue Gate Crossing* soundtrack in my head. If I happened to ride through a tree-lined street, with the sunshine shining down on me, the inner soundtrack would make me so happy.[5]

Quoting scripted lines in everyday conversation, on the other hand, had also come 'fairly natural' for her.[6]

4 Summer, focus group discussion, January 31, 2010.
5 Ibid.
6 Summer, email interview, March 1, 2011.

Governance via Cinema

Nearly a real life 'Nurse Betty', Summer incarnates a spectator's most deeply felt intimacy with a precious movie.[7] Comments made in various cultural products (such as the film *Nurse Betty*) relate such intimacy to 'escapism', which either ridicules the spectator or dismisses her affection as the result of an obsessive or disturbed mind. Studied under the concept of 'embodiment' or power relations, experiences and practices that have come about as the direct or indirect consequences of film-spectator intimacy have provoked diverse responses in scholarly works. Each suggests a problematic relationship of the film industry to the audience.

In the psychoanalytic tradition, these experiences and practices are first and foremost read through the lens of identification. Specified by Laura Mulvey as one of the two psychic mechanisms that enable visual pleasures in cinema, cinematic identification is argued to have extended Lacan's concept of the mirror stage and enabled the spectator's (mis)recognition of a perceived human image as his/her ideal self-image. In Mulvey's formulation, as well as in psychoanalytic theories in general, the mechanism of identification is conceptualised as a function that introduces, facilitates, and consolidates the force of the symbolic/patriarchal law as a prominent factor in subject formation. Mulvey and successive psychoanalytic film theorists have considered cinema a mass medium that continuously triggers the identificatory process within a subject. Given that premise, they have associated the cinematographic with the social. They have done so by elucidating (and re-elucidating) the ways in which identificatory practices have been activated *in* the cinema to serve, or circumvent, 'the unconscious of patriarchal society'. Their theories, as a result, link cinema-related experiences with social practices *outside* the cinema. In this they suggest the power of (cinematic) communication intervenes in the process of social formation, and vice versa.[8]

7 Directed by Neil LaBute and released in 2000, the film *Nurse Betty* tells the story of Kansas waitress Betty Sizemore. After witnessing her husband's murder, Betty assumes the identity of a nurse character in her favourite soap opera *A Reason to Love* and pursues a relationship with Dr. David Ravell, a main surgeon character in the same television programme, embodied by actor George McCord. She ends up developing a relationship with George and being brought as a new character onto the show. During the shooting of the episodes, Betty then sees the inner workings of a television show and towards the end of the film, falls back into 'reality'.

8 See Laura Mulvey, *Visual and Other Pleasures* (Basingstoke: Palgrave Macmillan, 2009); Teresa De Lauretis, *Alice Doesn't* (London: Macmillan, 1984); Mary Ann Doane, *Femmes Fatales* (New York and London: Routledge, 1991).

Derived from J.L. Austin's concept of 'performative utterances', whose execution 'does' rather than reports on 'things', the idea of performativity renders even more conspicuous the entanglement of communication/discourse with social affairs. In clarifying the relevance of performativity in media studies, Sarah Kember and Joanna Zylinska argue that the role of media is 'not *only* to perpetuate ideas' but more significantly 'to bring about realities'. Following Joost Van Loon and other theorists, they contend 'media are *generative*'. Rather than discursively or aesthetically present an idea or ideal that either reflects or masks 'the real', they argue that 'media contribute to the production' of the real.[9]

When read in these terms, extra-cinematic practices such as Summer's could be conceptualised as enabled by cinematic statements that have helped bring about the spectator's *bodily citation* of a movie. Known for her contentious theorisation of performativity in regard to gender identity, Judith Butler, who did not write specifically about media and media effect until very recently,[10] has delineated the driving mechanism behind such bodily citations. In the much-discussed *Bodies that Matter*, Butler recapitulates her contention developed in *Gender Trouble* that gender and sex are one and the same thing, both the true effects of a highly fabricated regulatory *discourse* that imposes primary and coherent identity in support of the practice of compulsory heterosexuality. Re-formulating the concept in psychoanalytic terms, she states, if the ego as a sexed/gendered being is secured and achieved through 'identificatory' practices, these practices are a repetition of *actions* compelled by discourse and, by extension, the symbolic law. In other words, identification, which in Lacanian parlance

9 Sarah Kember and Joanna Zylinska, *Life after New Media* (Cambridge, MA and London: MIT Press, 2012), 36-8, emphases in original. If in many cases it seems there have been events whose existence is anterior to and independent of their media coverage, the credit crunch in the late 2000s decisively brought media's generative role to public attention. According to Kember and Zylinska, after BBC business editor Robert Peston first reported on the financial crisis at the UK's Northern Rock Bank in 2007, long queues of worried savers formed outside branches of the bank in order to withdraw their cash while bank shares fell. Although Peston argued at the time and after that he was delivering objective facts about a 'real' situation within the bank, rival correspondents and some of the public have suggested that rather than announce it, Peston had actually '*precipitated* a crisis at Northern Rock and in the banking sector more widely' (41-2, emphasis in original). Without endorsing discourses that have attributed economic recession to Peston's report, Kember and Zylinska see in the dispute about Peston's responsibility an opportunity to glimpse the slippery fact that media statements do have 'material consequences'. Virtual in essence, media statements may call 'the real' into being by helping bring about the conditions of possibility for what the statements have described or accounted for. This, the authors say, defines exactly the concept of performativity (49-50).

10 See Judith Butler, *Frames of War: When is Life Grievable* (London: Verso, 2009).

indicates an identity assumption process, in Butler's formulation entails bodily *materialisation*. It is exactly in this sense that the symbolic law must be understood as performative – that is authoritative – as it produces repetitive bodily citations whose accumulation contributes to the law's function as constitutive construction.[11]

In supplement to and in a departure from psychoanalytic theories, the Butlerian conception of performativity brings the material human body into the mechanism of identification. The body in Butler's formulation is the channel through which discourse or communication contributes to the production of gender identities as reality. Apart from identificatory theories, this emphasis on bodily mediation connects Butlerian performativity to concerns over biopolitical governance, which in recent studies of media and media technologies has prompted the consideration of media's capacity for body modulation/regularisation. The difference between these two approaches lies in the former's insistent attachment to identity politics. The latter, on the other hand, foregrounds the transmutation of the human species and sees the transmutation as a consequence of media-facilitated biopolitical governing. The emphasis on the 'species' rather than on the individual pertains to the postulate that biopolitical governance targets the population, through the management of which individuals are then collectively disciplined.[12]

Whether via identification, performativity, or body modulation, the fact that communication intervenes in and generates material impact on 'real life' situates the media industry in a suspicious position of power. Sometimes, the implication arises that the media industry functions as an agent of the dominant social force. Other times, the industry itself is deemed the dominant social force. As the producer of films, for example, the film industry's complicity in the patriarchal regime is highly suggestive if, as Mulvey argues, the majority of Hollywood studio-produced movies have served 'the unconscious of patriarchal society' through the mechanism of visual pleasure. Following Butler's reasoning, the complicity would be in the imposition of heterosexuality.[13] Biopolitics, meanwhile, is evidenced to have emerged from the point at which state politics and the market economy

11　Judith Butler, *Bodies that Matter* (New York and London: Routledge, 1993), 12-3.
12　See, for instance, Michel Foucault, *Security, Territory, Population*, eds. Michel Senellart, Franois Ewald, and Alessandro Fontana, trans. Graham Burchell (New York: Palgrave Macmillan, 2007).
13　See, for instance, Angela McRobbie, *The Aftermath of Feminism* (London: Sage, 2009).

meet.[14] In this context, since body modulation via media has been proved essential to the sustenance of capitalism,[15] it has become unimaginable to deny the involvement of the film industry in biopolitical governance.

The discussion that follows, however, will challenge each of these conceptualisations of the film industry-audience relation. Scrutinising other ethnographic findings in addition to Summer's intimate engagement with *Blue Gate Crossing*, I will establish that cinematic communication is neither involved in the solidification of socially categorised identities, nor does it lead to full biopolitical governance. Affective by nature, the impact of cinema, or the effect of cinematic communication, will be demonstrated instead as shaped by *a collective agency*. In practice, this means film experiences are mediated and inflected by numerous physical entities, including bodies and things present within the spectator's immediate surroundings. As much as spectatorial re-enactment of film content may prove the capacity of cinematographic image to prescribe how spectators perceive and act in their everyday lives, from entity mediations/inflections emanate the possibility of spectatorial autonomy and an alternative process of individuation. On the basis of such entity intervention, embodied cinematographic expression – or the spectator's bodily citation of movies – can very much present the spectatorial body in a volatile relationship to regulatory governance, and more specifically to the film industry.

In the remainder of the chapter, this argument is mostly formulated as an ethnographic challenge to Judith Butler's theory of performativity and Pasi Väliaho's theorisation of cinematic affectivity; both underline the capability of (cinematic) communication/discourse to dictate. It is on the premise of a precarious film-spectator connection, nevertheless, that fieldwork materials from this research have indicated a precarious relationship between the audience and the film industry. I shall begin by looking carefully at Summer's remarkable experiences with *Blue Gate Crossing*.

14 See Patricia Ticineto Clough, 'Introduction', in *The Affective Turn*, eds. Patricia Ticineto Clough and Jean Halley (Durham and London: Duke University Press, 2007), 1-33; Jonathan Crary, *Suspensions of Perception* (Cambridge: MIT Press, 1999).
15 See Brian Massumi, 'Requiem for Our Prospective Dead (Toward a Participatory Critique of Capitalist Power)', in *Deleuze and Guattari*, eds. Eleanor Kaufman and Kevin Jon Heller (Minneapolis: University of Minnesota Press, 1998), 40-64.

Identificatory or Existential?

Although not always as fervid, cinematic engagement like Summer's with *Blue Gate Crossing* is by no means unusual. In *Star Gazing*, for instance, Jackie Stacey provides an ethnographic account of what she has termed 'extra-cinematic identificatory practices'. These, in short, refer to the spectator's re-enactment of film-inspired activities. Observing them in regard to the relationship of female audience to female stars, Stacey classifies extra-cinematic identificatory practices into four categories. 'Pretending' involves the spectator's 'imaginary practice' of taking on the identity of a film star while the spectator knows throughout the practice that her identity transformation is nothing but a 'game'. 'Resembling' covers activities where the spectator selects from within herself 'an already existing common quality with the star' to establish an intimate connection between the star and self. 'Imitating' refers to practices in which the spectator replicates particular gestures, speech, personalities, or behaviours as they have been performed by a particular star in a particular film. In so doing, the spectator partially takes on 'some aspect of a star's identity'. Finally, 'copying' describes the spectator's attempted replication of a star's appearance, the practice of which necessitates a transformation of the spectator's physical look to 'close the gap' between the star and the spectator's image.[16]

Whether carried out as the result of conscious calculation or unconscious inclination, extra-cinematic identificatory practices are obviously distinct from that which Stacey terms 'cinematic identificatory fantasies'. The latter 'remain[s] within the spectator's imagination during the viewing of a film', whether occurring in the form of worshipping the stars, losing oneself in 'the fantasy world of the star ideal', or nourishing the desire to transform oneself into the star ideal. The former, argues Stacey, penetrates the spectator's everyday life as 'social practice outside the cinema'.[17]

Due to the influence of psychoanalytic identificatory theories, Stacey has associated extra-cinematic *identificatory* practices with the alteration of the spectator's identity. By copying physical appearance or replicating gestures and behaviours, the spectators 'bring into life' fictional film characters whose identities are entwined with those of the stars, thereby changing the spectators' own identities. Cinema, Stacey says, is productive of the spectator's new/changing identities.[18]

16 Jackie Stacey, *Star Gazing* (London and New York: Routledge, 1994), 159-70.
17 Ibid., 159.
18 Ibid., 171-2.

By and large, Summer might be described as engaged in extra-cinematic identificatory practices. Like many subjects of Stacey's ethnographic research, she was perfectly aware of her tendency to smuggle cinematic fantasy into daily reality and was self-reflectively concerned with the significance of this particular tendency. In fact, just as her deep connection to *Blue Gate Crossing* may give rise to a popular reading through the lens of '(mis)identification',[19] she also analysed her extraordinary passion in terms of self-recognition:

> I remain enchanted by *Blue Gate Crossing* after all these years. I believe that level of enthusiasm has both to do with the film's setting and characterisation. I can easily relate to Kerou. She's lost her father at a very young age, and her mother is always busy. People see her as an independent child, but deep down, she desperately longs for attention and affection. I share her background in many ways [...] I think I know how she feels. I understand her mentality.[20]

In revealing her aspiration for a boyfriend graduating from the Affiliated Senior High School of NTNU, Summer, following a similar logic, explained how the boy could have served as her ticket to ultimately becoming Kerou-like.[21]

Curiously, in Stacey's empirical description, whenever cinematic 'identification' elicits extra-cinematic practices from spectators, the practices ineluctably involve a certain level of 'imitation' through which a spectator pursues similarity to a particular star or film character she adores. Nevertheless, Summer's re-enactment of scenes from *Blue Gate Crossing* appears more haphazard and lacks a clear focus on copying what Kerou does in the movie. Her habitual quotation of the scripted lines covers quotes, for instance, from various characters in addition to those from the relatable tomboyish protagonist. Her obsession with the film sets and preoccupation with the effect of the soundtrack – relevant to, yet hardly suggestive of, specific investment in any particular star or character – indicate an elusive connection that is not entirely appropriate to conceptualise within the frame of identification.

19 Here, the term '(mis)identification' is adopted to evoke psychoanalytic film theory that the spectator's self-recognition in relation to the perceived cinematographic image is a '(mis) recognition'.
20 Summer, email interview, March 1, 2011.
21 Ibid.

Even Summer herself had, in a sophisticated manner, noticed and discreetly addressed the subtle discrepancy between her own interpretative accounts and her actual experiences of 'acting out' the movie. At the end of our first meeting, intrigued by her unusually intense engagement with *Blue Gate Crossing*, I asked whether she would have transformed herself into Kerou if she had been granted a wish. After a short pause, she answered that she had wondered whether being Kerou could be equated with leading a life as leisurely as it seemed to be in the movie. After all, she clarified, what had distinguished *Blue Gate Crossing* in her eyes was the film's delicate soothing esthetics, with all its pleasant presentations of the blue sky, verdant trees, and bright sunshine. According to Summer, the esthetics establish a calming atmosphere in the film, which at once contains the characters' feelings and transcends their anxieties. Life in *Blue Gate Crossing*, as a consequence, appears to move on at a therapeutically comfortable and mellow pace.[22] Hence, instead of turning into Kerou, for once Summer deliberately said in response to my half-playful question, 'Perhaps I want to and could still learn to adopt that same easygoingness just by doing what I have been doing with *Blue Gate Crossing*? Perhaps I already have?'[23]

These accounts by Summer suggest that her cinematic engagement might be existential rather than necessarily identificatory. That is, her relationship to *Blue Gate Crossing* has to a considerable extent altered her perception of everyday life, but has done so by reorganising her daily activities rather than via identity change. Such reorganisation has become possible because Summer has connected to *Blue Gate Crossing* through continuously *embodying* the film in her behavioural patterns and sensory experiences. One may argue that the film has prominently worked as an active factor in modifying not only her bodily consciousness but also her lived reality.

The Cinematographic Machine Inside

Pasi Väliaho's understanding of cinema as a 'milieu' provides an explanatory framework for Summer's existential engagement with cinema. Beyond the mechanism of identification, what is in question is a theory of cinematic *affectivity*. Employing 'organ projection' as the conceptual foundation, Väliaho draws on theories from psychology, biology, and philosophy to establish that the artefact of cinema – like other technological objects

22 Many of my other interviewees shared this observation.
23 Summer, personal interview, July 18, 2009.

– functions as the exteriorised corporeal apparatus in relation to the human organism. As a result, he states, a clean-cut separation can no longer hold between the exteriority of cinema and the interiority of the human body. The organism is thus pictured as embedded by surroundings infused with cinematic technology. The organism's relative inside is 'selected from the screen (the outside)' whilst its relative outside is 'projected by the machine (the inside)', a formulation shaped by Väliaho's borrowing of terms Christian Metz has used in theorising the entanglement of cinematic projection with spectatorial perception. As far as the concept of organ projection goes, the technology of cinema works in the form of a technological milieu, or the encompassing surroundings, which absorbs and penetrates the human organism. Given this context, the technology/milieu itself 'becomes intrinsic of the living organism and an essential feature that determines the species-being'.[24]

Two mechanisms have been introduced to further elucidate the way in which the cinematic milieu has asserted itself to define the human species-being. To borrow from Pierre Janet, the notion of 'automatism' concerns the sensorimotor dynamics to be observed *within* the cinema space. In this case, the sensation created by the cinematic apparatus not only 'immanently instigates a tendency for action' but also physically brings about movements by the human organism. These movements assimilate to the cinematographic image just as the mimetic behaviour makes certain insect species simulate nearby substances so they assimilate into their surroundings. This Väliaho suggests by juxtaposing Janetian automatism with Roger Caillois' 'morphological mimicry'. Thus, in the face of the 'temptation' of the cinematic milieu, the human organism – propelled by pre-individual body affections that precede cognitive mediation – would in 'automatic' action surrender him/herself to the operation of 'the cinematographic machine inside him[/her]'.[25]

Furthermore, as the moving image conveys rhythm, intensity, and dynamic, Väliaho contends that, as a medium of time and movement, cinema shapes temporal contours and structures a meaningful world on the basis of affective changes experienced by the human organism in present moments.[26] Due to cinema's technological capacity to absorb and penetrate the human body, or due to the human body's ineluctable merging into the

24 Pasi Väliaho, *Mapping the Moving Image* (Amsterdam: Amsterdam University Press, 2010), 80-3.
25 Ibid., 84-5.
26 Ibid., 93-5.

cinematic machine, the moving image provides a living being with 'various matrixes of movements, rhythms, intensities and temporal patterns that [the being would] experience as functional, meaningful milieu'. Despite being automatic, this means, actions replicated in a human organism's sensorimotor relation to the cinematographic image are produced to pre-symbolically bear determinate functions 'in a sensible situation'.[27] As a result, cinema as a technology may trigger purpose-ful actions, which are thence capable of generating within the living being (a sense of) *personality* or *agency*. A public source of 'behavior, gestures and expressions', the moving image thus intervenes in the spectator's personal constitution. Being a milieu, it would determine the composition of one's 'personal, phenomenal world' and through automatism prescribe how one acts to claim his/her *self* within that world. Cinema, Väliaho therefore argues, 'fundamentally functions as an existential technology'.[28]

Linwx, another interviewee and focus group participant for my research, once described her cinematic experiences in such a way that her accounts almost approximated Väliaho's theory. That was our second interview. She remarked upon her preference for cinema over other media when it came to watching movies. She underscored the big screen's capacity to completely immerse her in the moving image. When asked whether the enjoyment of immersion equated to that of identification, she responded with sensitivity:

> Take *Blue Gate Crossing* for example. I don't think I had identified with a particular character when I saw the film. But after seeing it, I kept feeling its effect... I wanted to say I felt the effect 'in my heart'. Yet actually, it was not 'my heart' that was feeling. It was *my body*. It was like, once I had seen the film, I became transferred to its time and space, caught up in its atmosphere. The air, the colour, the sunlight and the sounds in the movie all turned into something my body could feel. Even after the film had finished, the sensations stayed with me. Isn't this odd?[29]

She continued to delineate the impact of this experience,

> It felt like I was *living in the movie*. In fact, I found it impossible to bring myself back to real life. Carrying out the daily routine, say, walking out of the cinema after the film, strolling to the bus stop, and getting home,

27 Ibid., 100-3.
28 Ibid., 105-6.
29 Linwx, Skype interview, February 10, 2011, emphasis added.

I felt estranged from my own actions. As though around me there had existed a membrane setting me apart from my moves. As though I had in real life lived through a bizarre dream [...] transplanted to a bizarre environment, stuck with a sci-fi-film-like bizarre feeling.[30]

Unlike Summer, Linwx in the interview did not specify what she had ended up 'doing' since the atmosphere of *Blue Gate Crossing* had permeated her surroundings and impacted upon her body. Her descriptions, however, supplement Summer's physical statements with a verbal outline of the automatic body affections by 'the cinematographic machine inside'. They evidence the function of cinema as an absorbing milieu, whose devouring capacity sets off an affective trajectory to eventually merge the moving image with the operation of the human body.

The Surface Politics of the Body

Väliaho's theory of cinematic affectivity seeks to bypass the question of identification and foregrounds the bodily impact of cinematic com-munication. Linwx's statements seem to have justified this premise. Yet the (perhaps related) questions remain as to why the observable effect of communication is at all relevant and how it has been attained. Formulated with regard to the film experiences of my interviewees, these include the pressing question as to what has brought into being Linwx's sensations of 'living in the movie' and enabled Summer's re-enactment of activities presented in *Blue Gate Crossing*. Are those bodily experiences/expressions tangible consequences of cinematic discourse, as Austin has argued? Or do they, following Väliaho's reasoning, actually emanate from the intimate relationship between the human organism and the cinematic machine? In either case, what do the experiences/expressions at issue incarnate? Could it be Linwx's and Summer's social identity, even though both interviewees have spoken to cast doubt on the mechanism of identification? Or can the bodily materialisation of the cinematographic image constitute a sheer affective, rather than identificatory, process of the discursive performing upon the body? In what way does such a process matter?

The second group of questions, which concerns the functionality of bodily citation, are relatively urgent here, for the answers may illuminate the way the audience has been positioned relative to the film industry. In

30 Ibid., emphasis added.

the absence of film industry studies, Väliaho has explored cinematic affectivity against the backdrop of biopolitical modernity. Exemplified by the medium's engagement in experimental psychology circa 1900, his argument sees cinema as having since its inception served to transpose the power of modern knowledge to the control of the human body. Väliaho cites the work of Jonathan Crary to argue that the reason for biopolitical control as such is 'the productive requirements of contemporary economic development and modern disciplinary states'.[31] The result, he contends, is that eventually cinematic affectivity 'determines the [human] species-being' through its ineluctable intervention into structuring the human 'lived-experience'. That is, the 'subjective world of experience' delimited by a particular organisation of perceptual-behavioural possibilities, which are themselves consequent upon the human organism's definability by the affecting surroundings.[32]

Butler, for her part, has underscored identity politics. Nonetheless, her conception of identity performance does not drastically differ from Väliaho's delineation of the cinema impact. Subject to and (re)produced through the symbolic order, identity has always been rendered by Butler in bodily terms. In order to establish her particular take on constructionism, Butler quotes Nietzsche as early as in the first chapter of *Gender Trouble* to conceptualise gender identity as 'an active *doing*', however one propelled by the regulatory scheme. The well-known quote reads: 'there is no "being" behind doing, effecting, becoming; "the doer" is merely a fiction added to the deed – the deed is everything'.[33] 'The doer' – or in Butler's own terms the identity, the soul, the 'interior essence' of a human being – is a 'fiction' because too often it is misconstrued as the cause rather than the immediate effect of bodily expression. In a later chapter, Butler draws on the argument of *Discipline and Punish*, where Foucault demonstrates through the example of the punished how the human soul has arisen from a material reality produced 'around, on, within' the human body.[34] She further clarifies that identity inhabits 'the *surface* of the body'.[35] It subsists as the product of acts, gestures, and desire, which are themselves performed by the law in order to 'signify the law'. The politics of the symbolic, from which derives the politics of identity, is therefore 'the surface politics of the body'.[36] This

31 Väliaho, *Mapping*, 64-5.
32 Borrowed by Väliaho from Martin Heidegger, the term 'lived-experience' is in Heidegger's original text 'Erlebnis'. Väliaho, *Mapping*, 106-7.
33 The sentence is from *On the Genealogy of Morals*. Butler, *Gender Trouble*, 34.
34 Butler, *Gender*, 184.
35 Ibid., 185, emphasis in original.
36 Ibid., 185-6.

proximity of the symbolic to the body foreshadows Butler's more extreme view taken in *Bodies that Matter* that bodily materiality *is* the materialising effect of regulatory norms.

If bodily materiality as such decides or reflects what a human body can do or must do, including what it can/must perceive, Väliaho and Butler do not thoroughly disagree on the effect of (cinematic) communication. Both authors acknowledge the capability of communication to generate body affections, and both endow communication with the power to (re)define bodily potentialities. By producing films, does the film industry thus dictate the behavioural and perceptual possibilities of the audience's body, with or without imposing a social identity?

As analysed above, Linwx's description of her film experiences testifies to Väliaho's theory of cinematic determination. Had this really been the case, one might then reasonably follow Väliaho's reasoning to (re)evaluate the Butlerian proposition that the specificity of the material body is shaped over the course of communication, and subsequently ponder where the film industry stands in this enterprise of body regularisation. Nevertheless, between Väliaho's argument and Linwx's accounts there subsists a subtle discrepancy, like that between Summer's extra-cinematic practices and Stacey's framework marked by identification.

To Väliaho, cinema asserts itself as a milieu. It operates as a capacity-defining environment. It moulds at the affective level the reality that human beings are ever capable of perceiving, acting upon, or, all in all, living. In short, the cinematic milieu decides the 'lived-experience', the human organism's phenomenal reality.

Linwx's accounts do not suggest otherwise. Her sensation of 'living in the movie' or being 'membraned' from that which she called 'real life' indicates she was taken by what had actually affected her in the cinema; the cinematic milieu permeated and dominated her experienced reality. Yet Linwx described this post-cinema sensation as 'liv[ing] through a bizarre dream' in real life, which, one must argue, is in any case distinct from 'living the real life'. Delicate though the distinction might seem, 'the real' and the cinematographic, however intricately interwoven, do not in Linwx's delineation appear coextensive, equivalent, or identical. Rather, the sensation-sensitive interviewee carefully worked on the differentiation of one from the other.

There has been no indication that the real had existed in Linwx's experience as an alternative state to be reached on the outside of the cinematic ('I found it impossible to bring myself back to real life'). Linwx's so-called 'real life', elusive as it would be as a phrase or concept, was

instead depicted to be the sensible strange. This includes the bodily movements that had remained incongruously patched onto the cinematic milieu, the actions from which she had involuntarily left herself detached ('I felt estranged from my own actions, as though around me there had existed a membrane setting me apart from my moves'). In other words, in her context, the real did not persist in opposition to the cinematic but, on the contrary, emerged alongside perceptual-behavioural practices that remained entangled yet ill-integrated with cinema-initiated experiences. It therefore marks an adulterated 'lived-experience', when 'lived-experience' should in theory be fully determined by the cinematic force.

A Network of Intermediary Vehicles

Linwx's adulterated 'lived-experience' suggests the mechanism of cinematic determination does not fully account for the body affections generated in cinematic communication. The tangible consequences of cinematic affectivity or performativity can apparently be compromised in practice. Where compromise occurs, the cinematographic may be embodied, but only as disrupted real experience. The disruption could undercut the dominance of the experience so conspicuously that, on the sensory level, the embodied cinematographic would seem to have assumed surreality and subsist in a liminal state as physicalised *bodily fantasy*. What could have resulted in such a compromise?

To Butler, who paradoxically (and gladly) acknowledges the possibility of resisting performativity, the opaque involvement of the material body, before anything else, points to a plausible explanation. In the preface for the 1999 reprint of *Gender Trouble*, Butler admits that her theory 'waffles' from time to time between underlining the strength of linguistic conventions and foregrounding the relevance of theatrical embodiment. She uses 'the speech act' as an instance to elucidate why she has thought of the two as chiasmically related dimensions of performative power:

> [...] the speech act is at once performed (and thus theatrical, presented to an audience, subject to interpretation), and linguistic, inducing a set of effects through its implied relation to linguistic conventions. If one wonders how a linguistic theory of the speech act relates to bodily gestures, one need only consider that speech itself is *a bodily act with specific linguistic consequences*. Thus speech belongs exclusively neither

to corporeal presentation nor to language, and its status as word and deed is necessarily ambiguous.[37]

The *necessarily* ambiguous status of speech, as an example, indicates the exertion of performative power entails the mediation of a material vehicle, which in this particular case is the body.[38] In addition to acknowledging the vehicle's participation in the production of linguistic consequences, a more elaborate analysis of the speech act in *Excitable Speech* renders manifest that the body, as an intermediary vehicle for performance, enjoys a tendency to destabilise the efficacy of performativity. Citing Shoshana Felman, Butler argues that this tendency flows from the speaking body which, when 'act[ing] in and through what is said', always also 'acts in excess of what is said'. As a result, the speech and the body, even if inseparably connected by the speech act, are likely to share a 'scandalous' relation marked by incongruity. With the speaking body 'always to some extent unknowing about what it performs', the speech faces disruption from the unknowing body and ends up vulnerable to failed performance.[39]

The proposition on speech's vulnerability is indeed a significant one. Although Butler does not negate a linguistically anchored distinctness of the discursive, in *Excitable Speech* she emphasises that there is neither a clear nor a fixed link between the language deployed and the effects performed. As able as speech is to produce tangible consequences, the consequences produced cannot be predetermined.[40] This is because the material vehicle of the body, through whose facilitation performativity occurs, is liable to destabilise the result of performance.

Thus, it appears, body regularisation via films produced by the film industry may falter on account of the instability of mediation. Comparable to the human body that delivers performative speech, the obvious material vehicle that mediates and facilitates performativity over the course of cinematic communication is the adopted film-viewing technology. The theory of cinematic affectivity, in fact, is put forth on the grounds that

37 Ibid., xxvii, emphasis added.

38 In *Being There*, Andy Clark writes about the power of written language, whose exercise obviously involves material vehicles of a different kind (Cambridge, MA and London: MIT Press, 1997). Denise Riley in *Impersonal Passion*, on the other hand, ponders over the effect speaking language has upon the body of the addresser rather than upon that of the addressee. This suggests speaking language possesses certain materiality and can itself function as the vehicle to elicit bodily action/reaction (Durham: Duke University Press, 2005).

39 Judith Butler, *Excitable Speech* (New York: Routledge, 1997), 10-2.

40 Ibid., 13-5.

technologies as such intervene between the cinematographic image and the audience's bodily citation. In this sense, (Butlerian) performativity and affectivity, already comparable in terms of their relevance to the definition of bodily potentialities, further share a mechanism of regularising the body. Both rely on apparatuses which are not only themselves material but whose effectiveness must be measured by the actual actions they have channelled the material body to accomplish. Within the context of cinematic communication, if one may consider affectivity the interrelationship between the human organism and the cinematic machine, and performativity that between cinematographic expression and bodily citation, the two phenomena are practically entwined and lead up to each other. That is, cinematic performativity is only possible via the facilitation of the cinematic machine, while the effect of cinematic affectivity becomes most observable in bodily assimilation to, or bodily citation of, the cinematographic image.

Together, the two phenomena form a compound process of *affective performativity*. The process echoes Louis Althusser's theory of 'ideological apparatuses', which contends that the existence of ideas and/or spirits 'is inscribed in *the actions of practices* governed by rituals defined in the last instance by an [intermediary] *apparatus*'.[41] This process of affective performativity accurately explains Summer's and Linwx's bodily citation of *Blue Gate Crossing*.

But the effect of affective performativity can be compromised to consequentially hamper complete body regularisation via films and/or the film industry. To extend Butler's highly specified formulation, the compromise is down to the intermediary vehicle for performance. Within the context of cinematic communication, indeed, numerous vehicles as such claim pronounced power to destabilise the result of affective performativity. When Linwx emphasised the specificity of the big screen, quoting its distinctive capacity for full immersion, she also overtly confirmed the relevance of the

41 Louis Althusser, 'Ideology and Ideological State Apparatuses', in *Lenin and Philosophy, and Other Essays*, trans. Ben Brewster (New York: Monthly Review Press, 2001), 115, emphasis added. Butler has also discussed these Althusserian propositions in *The Psychic Life of Power* (Stanford: Stanford University Press, 1997), 125-8. In the history of film theory, similar concerns were first addressed and articulated using apparatus theory. For Jean-Louis Baudry and Alan Williams in the mid-1970s, for instance, the general effects of cinematographic expression could not be theorised without considering the specific characteristics of 'the technical bases on which these effects depend'. Although Baudry and Williams do not really focus on the affective aspect of the effects in question, they do state in accordance with Althusser that the neutral-seeming optical/cinematographic instruments modulate visual perception to provoke ideological consequences. See Jean-Louis Baudry and Alan Williams, 'Ideological Effects of the Basic Cinematographic Apparatus', *Film Quarterly* 28. 2 (1974-1975): 39-47.

cinematic apparatus to the experience of affective performativity. Besides the cinematic apparatus, affectivity resides in other platforms for film consumption, too.[42] To Linwx, different platforms affect the body dissimilarly. Comparing streaming online to theatrical screening, for instance, she said, 'the larger the screen is, the more engaged I tend to be. Huge screens absorb your whole being. They also make it harder to recover from the physical impact of a movie'.[43] The distinctive qualities of a film-viewing technology, in other words, influence the effect of cinematic performance, which occurs 'around, on, within' the spectatorial body.

What is more, Linwx, who appeared rather sensitive to the perceptible agency of technologies, likewise underscored the difference that could be made by the quality of the cinema space. The fact that she could temporarily reside in the immersive darkness, she said, decides for her the superiority of the theatrical space and, by extension, the superiority of the cinematic apparatus. In this case, the darkness better sustains the requisite concentration for assimilated physical reactions. Unfortunately, the strength of the darkness varies according to context. 'I always hesitate over popular movies or blockbusters', Linwx thus confessed, 'A big crowd in the theatre breaks the magic of the lonely darkness. I felt I could not *feel* a film properly when I was surrounded by a large audience'.[44]

Hence, as Linwx delineated how the varied conditions of cinematic apparatus might bear on her physical connection to a movie, she has also inadvertently brought forward the relevance of factors other than, yet related to, the actual apparatus. The size of the audience, for example, is an external element that acts on the film-viewing and film-receiving conditions. Once the spectator's body has departed the screen, it seems external elements as such may have an even stronger influence on the effect of cinematic performance. Outside the cinema is a world 'full of distractions', commented Black Black, yet another interviewee and focus group participant. However dominant at emergence, film-initiated sensations gradually alter or disperse, she argues, if one fails to amplify and prolong them in time.[45]

For a fuller, longer affective subjection to the moving image, many of my interviewees and focus group participants recalled the attempts to manipulate film experiences. Linwx, for example, declared she preferred

42 Summer, notably, never saw *Blue Gate Crossing* on the big screen in a movie theatre.
43 Linwx, Skype interview, February 10, 2011.
44 Ibid., emphasis added.
45 Black Black, Skype interview, February 7, 2011.

going to the cinema alone and would, for as long as possible, avoid conversations after seeing a movie. This is because seclusion from people 'prevents feelings from dissolving'.[46] Black Black, who was in her late twenties at the time of the focus group discussions, revealed she had been a fan of *Blue Gate Crossing* since her high school years. Over the past decade, she has made a habit of collecting stills from her beloved films, including *Blue Gate Crossing*. 'I cannot exactly say why', she elucidated:

> I think it is most likely for the reason that stills are often visually stunning. They could easily evoke memories of the movies. Having them saved on my iPod makes it possible for me to re-experience films constantly, or to go through the films' dramatic moments over and over again.[47]

Summer and Chun-yi, on the other hand, emphasised the potency of soundtracks and published scripts, characterising both as having aided the retention or evocation of cinema-generated sensations.[48]

The occurrence of cinematic performance, as outlined above, entails the mediation of material vehicles that could effectively elicit bodily citations via generating body affections. Inside the cinema space, the strength of the elicitation depends on the variable conditions of the material vehicles in question. Outside the cinema, it appears, the maintenance or dissipation of successfully generated affections relies on a comparable process of mediation. Just as contact with another human being may disrupt film-initiated affections (according to Linwx), mobilisation of technologies (digital film stills saved on iPods) or other material and immaterial substances (CDs plus movie soundtracks; published scripts and their content) can conserve them. Conceivably, under different circumstances the former might preserve while the latter diminishes a film-spectator connection brought into being by varied levels of affective performativity. Lan, for instance, recalled growing numb to, and even becoming sick of, a beloved romantic comedy after she had relentlessly listened to the original soundtrack over the course of a few days.[49]

This suggests to achieve fullness of affective performativity requires consistent support from a widespread network of intermediary vehicles, located in various bodies and things apart from the body of the audience and the

46 Linwx, Skype interview, February 10, 2011.
47 Black Black, Skype interview, February 7, 2011.
48 Summer, email interview, March 1, 2011; Chun-yi, Skype interview, February 1, 2011.
49 Lan, focus group discussion, August 15, 2010.

cinematic apparatus. Where inconsistency arises, however, compromised effect of cinematic performance may lead to adulterated 'lived-experience', whose emergence has generated this section's discussion.

Volatile Connections to a Movie

In theorising cinematic affectivity, Väliaho has drawn on the Deleuzian notion to describe the sensorimotor connection of the spectator to cinema as an 'organism-machine assemblage'.[50] As it turns out, the actual connection in question exceeds the interrelationship between the spectatorial organism and the cinematic machine, but subsists as an organism-machine-object assemblage. Here, 'organism' represents organic beings including, but not limited to, the spectatorial body, while 'object' refers to a collective of inorganic entities that mediate cinematic performance on top of the cinematic machine. Since this organism-machine-object assemblage can at once facilitate and hinder affective performativity, it indicates a cinema-spectator relation that can be volatile as a result of body or object intervention. On the basis of this volatile relation, biopolitical control stands precarious, either sought or buttressed by the film industry through mobilising cinematic technology.

Lisa Cartwright's theoretical engagement with Melanie Klein and Donald Winnicott is in line with my ethnographically informed understanding of cinematic performance, whose effect is negotiated within a network of intermediary entities. Joining the psychoanalytic to a materialist approach, Cartwright uses Klein's concept of 'projective identification' to argue that in film viewing, more types of psychic investments subsist than that of (self-) recognition or identification. The connection between the cinematographic image and the spectatorial (re)action, meanwhile, is not limited to either a close correspondence or the resistance to correspondence. Rather, the connection takes multiple forms on account of the operation of various 'transitional objects'. The involvement of a transitional object subjects the cinema-spectator connection to the object's physical capacity, with which the object 'materially channels' a film-engaged human body.[51]

50 Väliaho, *Mapping*, 83.
51 Lisa Cartwright, *Moral Spectatorship* (Durham: Duke University Press, 2008), 33. Trying to locate the specific transitional objects in cinematic communication, Cartwright quotes various examples to illustrate a pair of complementary categories. Where cinematographic (re)presentations mediate 'real-world' social relations, the cinematic apparatus operates as the material object of transition (33). Considering the impact of cinema as a mass medium,

Like the network of intermediary vehicles described above, Cart-
wright's transitional objects enable the intimate relationship between
cinematographic (re)presentations and spectatorial (re)actions. But they
also *refract* or *inflect* such intimacy to eventually *define* the actual impact
of the relation.[52] As a result, the effect of the relationship varies. Apart
from '(not) wanting to know' or '(not) wanting to be', the object-mediated
relation between cinema and the spectator allows space for alternative
desires/investments inspired by '(not) wanting to possess, (not) wanting
to enter, (not) wanting to inhabit, (not) wanting to touch (or be touched
by)', etc.[53] Thus connected to cinema, the spectator's physical (re)actions
may assimilate to and/or differ from cinematographic (re)presentations.
While this connection, or projective identification, between cinema and
the spectator might take the form of a homogenising identification, due
to the object mediation in question, the identification can exist only as 'a
partial aspect, and may not fully be in place'.[54]

Both Cartwright's and my conceptualisation of the cinema-spectator
relationship challenge Butler's postulate that performativity decides bod-
ily materiality. So do they question Väliaho's proposition that cinematic
affectivity determines for the human species its (liveable) phenomenal
reality. However conceivably powerful, (cinematic) communication does not
structure and delimit human bodily capacities singlehandedly. Its strength
and effectiveness are rather contingent upon *a collective agency* shared
among various intermediary bodies and things.[55] Bearing on the level of

Cartwright cites Paul Lazarsfeld and Herbert Menzel's research published in 1963 and finds
transitional objects in the human being. This is, apparently, because Lazarsfeld and Menzel have
observed media reception to be 'filtered through several levels of opinion leaders' (32). Disparate
as they appear to be, Cartwright's two groups of transitional objects allow a vertical integration.
While cinema mediates social relations, the results of its mediation are further mediated by
other entities. Although by citing Lazarsfeld and Menzel Cartwright has foregrounded human
activities as representative of the latter category, her model could easily be extended to suggest
the relevance of any intermediate bodies and things that may bear upon the connection of
cinema to its audience. Amit S. Rai, for instance, writes of Indian movie theatres' art deco
décor (alongside poster design, soundtrack design, the physical locations of theatres, etc.) and
addresses it as one among the numerous 'media' that have converged to shape film reception in
an assemblage. Amit S. Rai, *Untimely Bollywood* (Durham: Duke University Press, 2009), 26-33.

52 Cartwright, *Moral*, 28, 32-3.

53 Ibid., 25-6.

54 Ibid., 30.

55 For a theory of performativity formulated in these terms, see Michel Callon's actor-network
theory. Callon introduces the concept of 'sociotechnical *agencement*' to argue that performativ-
ity is enabled in a harmonious assemblage – 'a combination of heterogeneous elements that
have been carefully adjusted to one another'. Michel Callon, 'What Does It Mean to Say That

the affective performativity achieved, this collective agency has multiple implications in cinematic communication. To follow Väliaho's reasoning, where full affective performativity occurs (if ever), it lays solid foundations for biopolitical control. Where affective performativity is compromised and adulterated 'lived-experience' forms, the collective agency lends its force to a bodily autonomy that may, in a variety of political terms, be construed as audience unruliness.

Since this is the case, how does one then address the question of identity, which in Butler's formulation is so intimately associated with the expression of the body and the efficacy of communication? Can it be, as Patricia Ticineto Clough has argued, that in our era of global/late capitalism, the pursuit of value has so much focused on pre-individual bodily capacities that it eventually 'call[s] into question the politics of representation and subject identity'?[56] Is the production of identities a miscalculation on the part of Butler, who might have missed the progress of the surface politics of the body would ultimately turn the politics of identity obsolete?

Given the above arguments, the answer to the last question need be in the affirmative. The refractions or inflections likely to be introduced by intermediary vehicles do render implausible the Butlerian paradigm, within which primary and coherent social identities could be compulsorily imposed as a result of (cinematic) communication.[57]

Certainly, this does not mean films would stop being understood in terms of subjectification or Althusserian interpellation. Within the industry, the concern over identity politics persisted – for instance, in the case of Yee Chih-yen, the director of *Blue Gate Crossing*. Even though *Blue Gate Crossing* undoubtedly kick-started a new queer romance cycle in twenty-first century Taiwan, Yee said he had nevertheless been more worried about the widening wealth gap than about queer identities. 'Looking back, I've always felt it is rather money than sexual orientation that has segregated the Taiwanese from one another', he recalled. Keen to share his viewpoints through cinematographic image, he created in *Blue Gate Crossing* a scene where the hero Shihao gets into a fight because he mocks a schoolmate for consuming cheap junk food every day. 'Shihao is too class-blind to notice the schoolmate's working class background and how that background has

Economics Is Performative?', in *Do Economists Make Markets?*, eds. Donald Mackenzie, Fabian Muniesa, and Lucia Siu (Princeton: Princeton University Press, 2007).
56 Clough, 'Introduction', 18-25.
57 This of course does not mean Butler herself has not recognised the unstable result of, and the possible resistance to, this imposition. See, for instance, the discussion of the speech act in a previous section and Butler's conception of 'resignification' in *Excitable Speech*, 14-5.

determined his ways of living', Yee elucidated, 'I realise I would sound self-righteous here. But through this particular episode, and through the potential influence of the relatable character Shihao, I did hope to awaken some middle-class kids to class differences. Admittedly, I was one of those ignorant middle-class kids many years ago'.[58]

During post-production, however, senior film editor Liao Ching-Song recommended cutting out the above-mentioned scene, for he thought '*Blue Gate Crossing* is best left refreshing and heartening – a nicely-made little movie'.[59] I asked Liao in our personal interview why he had made that suggestion, and he answered, 'It was simply down to *the gut feeling* of an experienced film editor'.[60] But the gut feeling turned out to be rather convincing at the conference table. In the end, administrations at Arclight Films sided with Liao and persuaded Yee to remove the scene in question. The film was, after all, cleared of class consciousness. 'I regret having done that', Yee revealed in our personal interview, more than seven years after the film's official release.[61]

I will explore in the next chapter what the gut feelings of a film practitioner may have implied to a film industry that seeks to seduce senses and entertain with sensory pleasure. Apparently, in the practitioner's intuition lie various clues to effective sensory communication. For the discussion here, I nonetheless wondered whether Yee Chih-yen would breathe a sigh of relief if he found out his vision of 'awaken[ing] some middle-class kids', either through the mechanism of identification or that of interpellation, might have foundered anyway. The relation between Shihao's experience and the audience's experiential (re)action evades predetermination. Practically speaking, the effect of this elusiveness is never more conspicuously evidenced than when two similar spectators, who may be considered of a same social identity category, (re)act differently to the same cinematographic image.

58 Yee Chih-yen, personal interview, February 5, 2010.
59 Liao Ching-Song, personal interview, August 18, 2010.
60 Ibid., emphasis added.
61 Yee Chih-yen, personal interview, February 5, 2010. Yee later made *Meeting Dr. Sun*, a teen comedy film released in 2014, to communicate his perspective on the wealth gap and class differences.

The Fruits of a Collective Agency

Despite both being female university students in their early twenties, Summer and Linwx spoke of highly differentiable engagement with the street-cycling scenes from *Blue Gate Crossing*. Summer, as detailed above, 'automatically put on the *Blue Gate Crossing* soundtrack' in her head whenever she rode a bike during her high school years. Linwx, meanwhile, said she had safeguarded her physical reactions to such an extent that she ended up 'recomposing' the film scenes:

> I wanted to conserve my feelings so badly that I made myself recollect those scenes all the time. I did not always remember whether it is Kerou that chases Shihao or it is the other way round in the movie. But I recalled the atmosphere of the cycling scenes, each time adding something new to the image, sometimes adjusting the lighting or other technical details. Eventually, the shot in which Shihao looks back on his bike became so unreasonably long and dazzling in my memory. I did not realise what I had done until I finally brought myself to watch the film again. Then, I was very surprised the actual cycling scenes did not look so fascinating in the movie.[62]

Asked later whether she had recomposed the cycling scenes by reflex, Linwx denied it and immediately identified the influence of an online review. 'The film review was so beautifully written. It sealed my feelings for me', she remembered.[63] The review in question is by Hou Chi-jan, who meticulously rendered in words the atmosphere he had experienced with the same street-cycling scenes.[64]

In the light of Cartwright's theory, Summer's and Linwx's must be read as different connections to the same movie. Penetrating the volatility in projective identification, Cartwright objects to the possibility of a definite, socially categorised identity being brought forth via cinematic communication. Instead, she proposes 'empathy' to be the pertinent concept:

> In my empathy with you, in thinking I know how you feel, I do not need to know about you or identify with you (or any given object of my attention

62 Linwx, focus group discussion, January 24, 2010.
63 Linwx, Skype interview, February 10, 2011.
64 See 'A Mirage in Heavy Traffic', *The Database of Taiwan Cinema*, accessed June 17, 2013, http://cinema.nccu.edu.tw/cinemaV2/squareinfo.htm?MID=15.

such as an image of you). I do not see from your position […] I do not identify with myself in a state of self-perception, to recall Metz's famous concept […] Rather, in empathy, I will propose, my knowledge comes from the force of the object ('you', the image, the representation), and my reciprocal sense that *I recognize the feeling I perceive in your expression.* 'You' move me to have feelings, but the feelings may not match your own.[65]

This is how psychical and physical investments apart from that of '(not) wanting to know' or '(not) wanting to be' may come into being over the course of cinematic communication. To Cartwright, a communicative process as such opens up an 'empathetic field' that is a 'potential space'. Within the space, the spectator can be physically affected yet non-isomorphically active, so that s/he may '*act*, or not, in ways that are unpredictable and based on the set of […] forces introduced in the empathetic field of action'.[66]

In this sense, the 'middle-class kids' Yee Chih-yen very earnestly imagined awakening might all have (re)acted dissimilarly after seeing the scene in which Shihao fights his schoolmate, had the scene not been cut out of *Blue Gate Crossing*. One cannot be certain whether all the (re)actions would match that which Yee had assumed to distinguish the kids' middle-class identity.

However, since the 'empathetic field' allows each spectator the potentiality to (re)act differently with regard to the received cinematographic image, I would argue the difference in (re)actions also indicates the emergence of an individuated existence, the possibility of a unique self among the seemingly similarly affected population. Recognisable in Summer or Linwx, for example, this *self* at issue is distinct both from Butlerian identity and the self Väliaho has considered a spectator could claim on the basis of purpose-oriented automatic action. Unlike Butlerian identity, its generation does not pertain to the rise of distinguishable social categories from discourse-governed bodily qualities. In contrast to Väliaho's so-called self, it does not (only) represent a self-consciousness, an inner sense of personal agency that has in actuality arisen from collectively bred sensorimotor tendencies. Stemming from perceptible variations in the effect of affective performativity, the self one may outwardly observe in Linwx or Summer has a more singular stance. It reflects dissimilarity in intermediary vehicles and the result of that dissimilarity. On the most noticeable and straightforward

65 Cartwright, *Moral*, 24, emphasis in original.
66 Ibid., 34, emphasis added.

level, the formation of Summer's and Linwx's respective selves points to a distinct fact: Linwx's body remained engaged with the street-cycling scenes from *Blue Gate Crossing* through the inspiration of a written text, whereas Summer repetitively acted out the same scenes by deploying an actual bike and virtual soundtracks. The two spectators' individuated 'identities' as such are little less than the fruit of a collective agency, peculiar to the particular combination of intermediary bodies and things that are involved in an individual spectator's reception of a specific movie.[67]

Bodily Fantasy

Cinema, or the cinematographic image, performs 'around, on, within' the spectatorial body via the facilitation of material intermediary entities, so the body tends to feel, perceive, and act in certain ways. The power of cinema/the cinematographic is in this sense prescriptive. However, it does not fully determine the quality/potentialities of the human body, because the power itself is subject to inflections by pertinent intermediary entities, which include miscellaneous bodies and things. Inflections as such emerge singularly as consequences of the variable combination of intermediary entities in each particular case of film reception, involving a specific spectatorial body and a specific movie. In their singularity, the inflections form the basis of a spectator's individuated identity, as they result in conspicuous uniqueness in the spectator's affective connection to the cinematographic image.

Brian Massumi's theory about the 'moving-through' of expression pin-points in different terms the same mechanism of affectivity/performativity in (cinematic) communication. Likewise, Massumi underlines that the force of expression 'strikes' the material body. To thus 'strike', expression passes through 'the flesh' to trigger alterations in a body.[68] The body in turn captures the force of expression, processes the force through the multiple layers of its own affective constitution, and ultimately determines the

67 Having thus escaped strict body regularisation and/or identity imposition by the film industry via affecting movies, arguably the audience can be more, rather than less, caught up in a late-capitalist process of value production – one that bypasses identity formation and rigid body regularisation in order to pursue maximal value by encouraging (false) freedom and optimising any bodily potentiality, if one brings Clough's formulation to mind ('Introduction', 25). I will dispute comparable arguments in Chapter 6.

68 Brian Massumi, 'Like a Thought', in *A Shock to Thought*, ed. Brian Massumi (London and New York: Routledge, 2002), xvii.

significance of expression by revealing expression's affective effect.[69] The determination only lasts momentarily, as expression moves on to striking other bodies. Momentary determinations as such are defined by singularity, since their forms vary as diverse results of variable bodily processing, which present the determinations as 'chance inflections' of expression.[70]

The significance of expression is the effect of expression, whilst the effect of expression manifests itself in singular body affections. In such a formulation, expression and the experience of expression merge into one. Consequent upon expression, the experience becomes expression's definition, which technically speaking, *is* the expression. Paradoxically, the same theorisation also indicates expression and the experience of it are two. What detaches one from the other is the transience of their mergence. At points of convergence, the body and expression interfere in each other's continual transformation. Beyond these points, each is on its separate trajectory of change.

This being the case, a film experience, consisting of the affective effect of cinematographic expression, constitutes a momentarily determined 'chance inflection' of the expression. To Massumi, who follows Deleuze, the chance inflection is a joint effort, achieved by a specific film-viewing body in connection with various human, non-human, and/or non-organic entities.[71] The body incorporates influences from surrounding substances to temporarily determine, and be determined by, cinematographic expression.

As Janet Harbord writes in *Film Cultures*, 'our experiences of film begin with waiting at a bus stop on the way to the multiplex', one of the most pedestrian processes of film consumption.[72] These same experiences will then wander in different directions within the multiplex and from there continue metamorphosing into our world beyond the bus stops. Anyone, anything, and/or any text encountered on this journey may contribute to

69 Throughout his body of work, Massumi, in a highly specific manner, defines 'affect' as degrees of intensity withheld at a visceral level, a nonqualified and yet-to-be-actualised bodily potential for action, or a primal physiological tension that could later be registered as emotions or feelings. See, for instance, *Parables for the Virtual* (Durham and London: Duke University Press, 2002). Later in Chapters 4 and 5, I will draw upon this particular definition when I discuss sensorimotor communication in different contexts. Apart from where specified, however, I do not overall share Massumi's conception of 'affect' in this book. That which I refer to as 'affective' points more generally to bodily sensations in their various forms. Some are more recognised and articulate-able; others remain less distinct on the edge of awareness.

70 Massumi, 'Thought', xxx.

71 Ibid., xxix.

72 Janet Harbord, *Film Cultures* (London: Sage, 2002), 2.

the experiences' evolution. In this way, films themselves lose control over their actual production of sensations, (re)actions, and feelings.

Cinematic determinism, as maintained by Väliaho and suggested as a rule by Butler, is therefore 'paranoid', to borrow Wendy Chun's expression. Meant to stand as more diagnostic than futuristic, their theories have excessively 'overestimated' the deployment of communication and communication technologies.[73] Cinematic communication does bear on the human organism as an inducive and penetrative social force. Yet among numerous other forces like itself, it does not dictate bodily materiality or the human species-being. Rather, Summer's and Linwx's experiences attest to Luciana Parisi and Tiziana Terranova's contention that in contemporary societies, the human body is a turbulent 'process of composition'. It takes on 'differential elements' from its surroundings as it opens up to extensive environmental dynamics.[74]

As a result, the possibility of a cinema-immersed 'lived-experience' is slim, if not completely out of the question. As clarified above, its occurrence necessitates consistent support from a broad network of environmental factors. If ever (seemingly) materialising, it could not either guarantee full cinematic dominance due to the environmental/object-ive/bodily intervention already in place. Instead, a *bodily fantasy* most likely arises. As Linwx perceived in her engagement with *Blue Gate Crossing*, a bodily fantasy represents the ambiguous consciousness caused by incomplete cinematic performance. On the one hand, body affections that spring from cinematic communication endow the movie/the cinematographic with a physicality/reality beyond the screen. On the other hand, film-initiated sensations and/or actions remain otherworldly and *dream-like* because the sensations/actions are at best *nearly* integrated with the spectator's lived mundane reality.[75]

73 Wendy Hui-Kyong Chun, *Control and Freedom* (Cambridge, MA and London: MIT Press, 2006), 9.

74 Luciana Parisi and Tiziana Terranova, 'Heat-Death', accessed May 10, 2013, http://www.ctheory.net/articles.aspx?id=127.

75 The theory put forward here might call to mind Donald Winnicott's concept of 'transitional phenomena', which are induced via transitional objects and concerned with the intermediate space between an individual's perceived inner and outer reality. The multifaceted relevance of Winnicott's concept to media/film consumption has been explored in the volume *Little Madnesses*, edited by Annette Kuhn (London, New York: I. B. Tauris, 2013). Likewise highlighting the intricate constitution of media/film experiences, my understanding of bodily fantasy, by comparison, further foregrounds the sensory aspects of these experiences and renders manifest that the ambiguous consciousness involved in media/film consumption has a materialist root in physical entity intervention.

Operating to sustain the emanation of bodily fantasies, the film industry takes part in the governance of the spectatorial body. Through the mechanism of entity-mediated affective performativity, however, the participation of the industry does not feed into the generation of socially categorised identities. Nor does it lead to full control of the body. Rather, its impact varies 'around, on, within' individual bodies, marking a precarious relationship between the spectator and the film industry. The detected precariousness characterises the industry-audience relationship throughout this book. In Chapter 6, it is discussed with regard to the ways in which the Internet medium has interfaced spectators and the film industry.

4 Sensory Linkage

The Politics of Genre Film Making

Years after the release of *Blue Gate Crossing* in 2002, Fran Martin compared the film with Taiwan New Wave Cinema in an analysis of that which she terms '(trans)national Taiwan cinema'. She concludes that *Blue Gate Crossing* has successfully detached itself from the New Wave Cinema's 'rigorous and austere esthetics', which are characterised by 'the challenging long takes, implacably static framing, departures from classical narrative form, and ruthless hyper-realism'. By comparison, *Blue Gate Crossing* is said to be marked by an 'up-beat and accessible style'.[1]

The accessible style can be problematic if interrogated with respect to national identity. To elaborate her point, Martin writes:

> In contrast with the politically loaded emphasis in the New Wave films of the 1980s on the intricate detail of the Taiwanese local, [*Blue Gate Crossing*'s] story seems to take place in a *generic* East Asian city [...] In sharp contrast to the close attention to the material and affective experience of (post)modern Taipei City in the urban films of Edward Yang or Tsai Ming-liang, the use of shallow focus cleanses [*Blue Gate Crossing*'s] mise-en-scene of any identifiable vestiges of the geographic and architectural particularity of Taipei City. In place of the unflinching focus on Taipei as post-'economic miracle', all but post-human metropolis in recent films by Yang, Tsai, and others, [Yee Chih-yen's] use of telephoto lenses creates a soothing and *generic* fantasy cityscape in the more or less international language of modern buildings, traffic, trees, sidewalks, shop-fronts, etc.[2]

Undefined, the adjective 'generic' appears twice in the quoted passage and has been used by Martin in two senses. On the one hand, it indicates qualities that are generally shared rather than specific, as in 'a generic East Asian city'. On the other, it refers to cinematographic expressions that conform to conventional formulae, as in 'a soothing and generic fantasy cityscape in the more or less international language'. In either case, Martin suggests

1 Fran Martin, 'Taiwan (Trans)national Cinema', in *Cinema Taiwan*, 135.
2 Ibid., 140, emphases added.

that *genericity* has bred a compromised depiction of the local reality, within which lies the key to Taiwan specificity.

Concerned with transcultural commodity flow, Martin clarifies that in both senses of genericity having adopted a Japanised 'pan-Asian' cinema esthetic, *Blue Gate Crossing* blurs Taipei's locational particularity to instead construct a de-specified cityscape for the 'maximum degree of extra-local translatability'. That is, the maximum degree of transnational marketability.[3] Following this logic, she then describes the telephoto lens Yee Chih-yen has applied as 'a tool of visual deterritorialization'.[4] The lens, she says, defocuses the 'undesired colors and shapes' of the Taipei cityscape to 'facilitate the film's passage overseas'.[5] Fortunately, the local audiences tend to actively associate the cinematographic image with personal memories. It is their decoding that eventually helps re-specify the geo-cultural coordinates in *Blue Gate Crossing* to compensate for the blurred locality.[6]

Martin's concern has been raised in relation to a rather specific production context: to overcome the difficulties in financing and selling local productions, Arclight Films strategically capitalised on investment from the French company Pyramid Films in order to make *Blue Gate Crossing* and in an attempt to cater for the overseas market. In practice, nevertheless, genericity has since the turn of the new century been considered the requisite remedy even for the sale of locally financed Taiwan movies.

Michelle Yeh, co-producer of the legendary *Formula 17*, is an outspoken enthusiast of genre film production. After the box office success of *Formula 17*, 3 Dots Entertainment, which she co-founded with Aileen Yiu-Wa Li, moved on to producing ghost horror *Heirloom* (Leste Chen 2005), the action comedy *Catch* (Chen Yin-jung 2006), and the romantic comedy *My DNA Says I Love You* (Lee Yun-chan 2007). In justifying her approach, Yeh underlined the audience needs that she had perceived locally as well as globally. 'Culture nowadays cannot be confined within the bounds of a particular country', she said, 'Any local film produced in the new century must target the global market, and around the globe, film audiences are

3 Ibid., 140. Darrell William Davis, meanwhile, contends that *Blue Gate Crossing* has incorporated Japanese television drama as an extra-cinematic inter-text so that the film may capitalise locally on an extra-cinematic audience formation that is already in place. See Darrell William Davis, 'Trendy in Taiwan', in *Cinema Taiwan*, 149.
4 Martin, 'Taiwan (Trans)national Cinema', 140.
5 Ibid., 140.
6 Ibid., 140-1.

likewise after pleasure, excitement, and gratification'.[7] To her, generic formulae extracted from commercially successful movies lead the way in satisfying these universal needs.[8]

Hsu Hsiao-ming, co-producer of *Blue Gate Crossing*, is also a supporter of generic formulae, regardless of whether they facilitate overseas sales. His rationale, meanwhile, underscores the needs of the film industry:

> A commercial business cannot afford to tolerate sheer unpredictability. In business, you pursue effective models. You find rules in the totality of previous experiences. You figure out why a particular film sells, and how to make a sellable movie. A producer has the responsibility for conducting fruitful research. The resultant knowledge then helps the industry establish sets of guiding principles, according to which industry workers proceed with production plans and their execution.[9]

To Hsu, generic formulae constitute a very specific set of the guiding principles in question. Claiming that he did not take predictability to be the ultimate goal of the film business, Hsu nonetheless maintained the stated premise that genericity is by all accounts necessary for the film industry to operate efficiently.

Because of the collapse of the local film industry in the 1990s, industry workers in the new century are left with few commercially successful films as available case studies. Both Yeh and Hsu cited Hollywood productions when asked to elaborate on their so-called generic formulae. In this sense, their optimistic faith in genericity confirms the unease first delineated by Martin about the lost (re)presentation of local specificity. Either by attending to the needs of the market or fulfilling the interests of the industry, it seems the adoption of generic formulae is in the current context of Taiwan film production inevitably equivalent to the adoption of a 'foreign' cinematographic language.

Besides risking a dissolving or diluted national identity, cinematographic detachment as such indicates to other critics a deep crisis of creativity. Renowned for his unique cinematographic style, for example, the Taiwan New Wave master Hou Hsiao-hsien once conveyed worries over recent trends in Taiwan filmmaking. Regretfully, he said, rising filmmakers had

7 Ya-Feng Mon, 'Michelle Yeh: Pursue the Smart Money', *Eslite Reader Magazine*, January 2007.

8 Ibid.

9 Hsu Hsiao-ming, Skype interview, Mar 3, 2010.

engrossed themselves so excessively in generic language that they missed out on everyday reality. Having previously argued that creativity stems from a good grip of reality, Hou harshly remarked that losing hold on reality reflects 'weak wills' on the part of newcomers. Those who are strong enough to develop and assert their original viewpoints 'would have followed their guts' instead of generic conventions.[10]

It might nonetheless surprise Hou that the newcomers he has deemed too obsessive about generic formulae do consider themselves to follow their 'guts' despite the prevalence of formulaic language. To cite one exemplar, Cheng Hsiao-tse has provided an explicit illustration of this.

Saturated in Hollywood movies, Cheng admitted in our personal interview that he had a personal preference for delicate production design. Setting off on a search for viable film sets, at the back of his mind he already had the ideal look of the potential spaces. The look might not necessarily slot into place as a clearly framed image. It would, however, quite frequently be reminiscent of sets in Hollywood productions. During the actual search, he stated, the adequacy of a potential filming location was constantly evaluated in relation to his mental image by referencing his 'gut feeling'. To illustrate this, he described the way in which he had decided on a set in his debut feature film *Miao Miao* (see Chapter 5 for the film synopsis and production details):

> The script said an aquarium shop in the city of Taipei. But the actual scenes were filmed at an aquatic plant nursery in Yilan.[11] Before we started filming, I had been to a few aquarium shops in the city. My gut feeling told me they could not have worked for me [...] Those places would not have given off the exact atmosphere I had pictured for the scenes and the film as a whole. Since we had failed to find a suitable location in Taipei, the crew took me to Yilan and showed me the plant nursery. I knew at first sight that it would be a 'wrong' choice to go with, because it had by no means matched the premise of the story. Ironically, I felt I could make it work there – the size and the arrangement of the space made an impression on me. Unlike a real aquarium shop inside the city, the plant nursery was less packed out and more ready for use. It was, to me, also much more capable of evoking emotion.[12]

10 Hueihsien Chiang and Ya-Feng Mon, 'Making Films for Pleasures', *Eslite Reader Magazine*, December 2006.

11 Yilan is a rural county located to the east of the city of Taipei.

12 Cheng Hsiao-tse, personal interview, July 30, 2010.

Demonstrating strong will or not, these accounts show that post-2000 Taiwan filmmakers may have so profoundly engaged with generic cinematographic language that communication via formulaic expression to them is more or less a reflex action.

It is perfectly conceivable that this engagement with generic language could cause recent Taiwan cinema to be criticised for a lack of authenticity or creativity. A severe diagnostic reading of Cheng's confession could even condemn the young director for being conditioned thoroughly by his uncritical acceptance of spectacular Hollywood productions. On the other hand, Cheng's account has also brought out a novel aspect of generic communication. That is, the employment of cinematographic formulae does not always pertain to calculable marketability, which concerns Martin and interests Michelle Yeh or Hsu Hsiao-ming. Through the actual practice of filmmaking, filmmakers can develop a highly specific relationship to generic formulae, and through this relationship they might introduce an altered connection between the audience and the film industry.

Departing from Martin's analysis that associates generic film production with market-driven strategies, the remainder of this chapter follows the experiences of filmmakers to present a different understanding of genre film production and the implied industry-audience relation. It will demonstrate how the film industry has (consciously or unconsciously) utilised bodily capacities of filmmakers, who used to be spectators. This process does not, however, engage filmmakers in a mechanical (re)production of formulaic movies. Rather, the spectator-turned-filmmaker brings about transformation on top of repetition. Within the transformation lies the potential for innovation and an alternative definition of genre.

To unpack this argument, I shall first review existing theories of (film) genericity. With its focal point shifting gradually from textual properties to linguistic affectivity, this brief review will provide the foundation for my analysis of (genre) filmmaking.

Genre, the Existing Theories

In Jacques Ranciere's formulation, the notion of genre has emerged in art history as a product of 'the poetic regime'.[13] Having traced the poetic regime to 'the Aristotelian elaboration of *mimesis*' and 'the privilege accorded to

13 Jacques Ranciere, *The Politics of Aesthetics*, trans. Gabriel Rockhill (London: Continuum, 2004), 21.

tragic action', Ranciere contends the regime has given arts their autonomous substance through establishing as normative the principle of imitation. Thus, in 'arranging actions that represent the activities of men', art first distinguished itself as a valid category in 'a classification of doing and making'.[14] Ultimately, the principle of imitation 'develops into forms of normativity that define the conditions according to which imitations can be recognised as exclusively belonging to an art' and assessed as such.[15] It is these forms of normativity that then shape the definition of 'genre' as we know it. At the level of textuality, concerns about adapting forms of expression to subjects of representation provide the foundation for genre distinction. At the level of contextuality, 'the hierarchy of genres according to the dignity of their subject matter, and the very primacy of the art of speaking' figure into an analogy with 'a fully hierarchical vision of the [genre-producing/receiving] community'.[16]

Construed as such, genres have a double nature. They are normalised fabrications that imitate real life, which means that what stands as 'generic' must remain at the same time textually fabricated and reflective of social context. This explains why, in most of the existing literature, film genre analysis tends to be twofold. On the one hand, the concept of film genre is bound up closely with rhetorical knowledge regarding icons, syntax, and semantics. On the other hand, there exists an engagement with semiotics. Judith Hess Wright's analysis in 'Genre Films and the Status Quo' typifies this approach. To account for the success and attraction of popular film genres, she examines each genre in detail, specifying the standard narrative structure, common character types, tacit behavioural codes, and, ultimately, their ideological implication.[17]

14 Ibid., 21, emphasis in original.

15 Ibid., 21-2.

16 Ibid., 22.

17 The popular genres examined by Wright are the western, the science fiction, the horror film, and the gangster film. Wright associates the popularity of these genres with their social functions. The western justifies yet confines the practice of violence with a well-defined moral code. According to the code, 'absolute guilt and innocence are possible'. Science fiction provides solutions to the intrusion of 'the other' and promotes isolationism. Hence, in a science fiction film, the need to eradicate alien danger always outweighs the 'possible advance in knowledge gained from communication'. The horror film resolves the disparities between rationality and irrational commitments to traditional beliefs. Yet it tends to favour the latter, which at every turn privileges a dominating upper class. The gangster film addresses the contradictory feelings 'aroused by attempts to achieve financial and social success'. It does so by associating success with vulnerability so as to repress the desire for social mobility and defend class lines within a hierarchical society. See Judith Hess Wright, 'Genre Films and the Status Quo', in *Film Genre*

This widely shared approach to film genre studies, however, does not prevent genre definition from dividing film theorists and film theories. The first conundrum in genre analysis concerns a tautology, in which a particular generic corpus can only be defined with a definite description of genre characteristics while the characteristics only become describable once the corpus itself is defined.[18] Apart from this, debates have developed over variable genre characteristics and fluctuating generic boundaries. Diverse methods have been suggested to overcome these difficulties.

Seeking a textual solution, Steve Neale turns to Russian formalist theory and suggests that each film genre has involved a 'dominant' aesthetic device or ideological element. Hence, instead of only constituting genres 'in which given elements, devices, and features occur', film genres should be recognised as categories in which the elements, devices, and features 'play an overall organizing role'. In view of this, although the theme of romantic love may be found in a large number of movies, it is not sufficient to make all cinematic works romance films. Rather, a distinct aesthetic device can dominate each movie.[19] Rick Altman, on the other hand, follows French semioticians and distinguishes between semantic and syntactic approaches to film genres. The semantic definitions stress the elements that make up the genre and therefore 'depend on a list of common traits, attitudes, characters, shots, locations, sets, and the like'. The syntactic definitions, meanwhile, play up constitutive relationships between semantic elements. Altman proposes combining the two approaches, in acknowledging *the necessarily dual nature of any generic corpus*. '[N]ot all genre films relate to their genre in the same way or to the same extent', he states. Some build semantic connections, some share syntactic structures, and still some form various mixtures of the two. Therefore, only a combination of the semantic and the syntactic definition serves as an adequate approach to measuring different levels of genericity, he maintains.[20]

Reader III, ed. Barry Keith Grant (Austin: University of Texas Press, 2003), 42-50. This article was originally published in *Jump Cut* 1 (1974).

18 The conundrum is best captured in Andrew Tudor's frequently quoted passage: 'To take a genre such as a "western", to analyse it, and list its principal characteristics, is to beg the question that we must first isolate the body of films that are westerns. But they can only be isolated on the basis of the "principal characteristics" which can only be discovered from the films themselves after they have been isolated'. In Barry Keith Grant, *Film Genre: From Iconography to Ideology* (London: Wallflower, 2007), 22.

19 Steve Neale, 'Questions of Genre', *Screen* 31.1 (1990): 65-6.

20 Rick Altman, 'A Semantic/Syntactic Approach to Film Genre', *Cinema Journal* 23.3 (1984): 10-2, emphasis in original.

The context considered, Neale introduces 'institutional discourse', which he identifies with 'the discourses of film-industry publicity and marketing' as well as those of the press and television.[21] Genre analysis, he demands, cannot be separated from features that define a genre's public circulation. Features as such include, among others, 'the fact that genres comprise expectations and audience knowledge as well as films; and the fact that these expectations and the knowledge they entail are public in status'.[22] Admitting that 'generic expectations and knowledge do not emanate solely from the film industry and its ancillary institutions', Neale nonetheless emphasises the significance of institutional discourses 'in the public formation and circulation of genres'.[23] To define film genres in these terms, he therefore formulates an idea of 'intertextuality', which relates film genres not only to film works but also to their advertisements, reviews, posters, and other forms of institutional discourses.[24]

Where genre films are concerned, institutional discourses are indeed productive of definitions. In fact, their productivity can sometimes stand so dominant that the 'intertextual' relationship of the discourses to film texts takes the form of tension rather than integration. In post-2000 Taiwan, for instance, *Heirloom* director Leste Chen has been widely quoted as saying that he was worried his producer Michelle Yeh and her colleagues at 3 Dots Entertainment had, on various occasions, defined *Heirloom* in problematic terms. They might have overplayed the horror film conventions, he said, at the cost of the film's true characteristics.[25]

To take into account the manifold relations of various discourses to the film text, Christine Gledhill proposes treating film genres and genre definitions within the dynamics of a genre's 'triple existence'. Not only an industrial mechanism, a genre to her is also an aesthetic practice and an arena of cultural-critical discourses. Changes in the signification and significance of genre, she suggests, result from disparate interventions – filmmakers cut across generic codes, critics reclaim generic commercial films for serious appraisal, academics analyse genre films as 'reflections' of mass consciousness, studio heads endeavour to 'claim respectability for

21 Neale, 'Questions of Genre', 48-9.
22 The argument has been put forward against Altman's suggestion, made in *The American Film Musical*, that genre definition is derived mainly from analytic work. Neale, 'Questions of Genre', 51.
23 Neale, 'Questions of Genre', 52.
24 Ibid., 52-6.
25 See Ya-Feng Mon, 'Leste Chen: Listen to the Audience', *Eslite Reader Magazine*, December 2006.

the industry', etc. Interventions as such inform genre production and reception. They have repeatedly reinvented genres and genre definitions, in the evolution of which, Gledhill contends, lies genre's foremost productivity.[26]

Janet Harbord, however, does not think film genres should anymore be defined exclusively by textual properties or explored with regard to discursive formation. She associates the productivity of film genres with the productivity of film marketing and instead argues that in the current environment of film production and consumption, film genres might well be appropriately understood in terms of 'lifestyle'. This is because rather than marketed to a potential audience with respect to recognisable textual properties, films nowadays tend to be sold 'as the primary product in a range of related commodities'. That is, as the consequence of a marketing practice that revolves around tie-in products and ancillary markets, films now address their audiences as 'the cohering factor in a range of lifestyle products'.[27]

Genre, the Fruit of Bodily Mediation

Harbord's concern with film genre is addressed in relation to the issue of 'taste' and social distinction. In this regard, her conception of genre does not overstep the boundaries of the Rancierian 'poetic regime', within which is differentiated not only each genre's significance but also the sensibilities of their actual audiences.[28] Since she has pushed back the frontier of film genres to inclusively count a film's 'related commodities' as constitutive of genre definition, Harbord's theory has nevertheless also connected film genres with what Ranciere has delineated as 'the aesthetic regime'. Linking the function of art to the function of the human body, the definition of genre developed below in relation to the Rancierian 'aesthetic regime' will inform the discussion of (genre) filmmaking in subsequent sections.

To outline its breakaway from the poetic regime, Ranciere describes the aesthetic regime that has characterised the modern age in the following terms:

26 Christine Gledhill, 'Rethinking Genre', in *Reinventing Film Studies*, eds. Christine Gledhill and Linda Williams (London: Arnold, 2000), 222-36.

27 Janet Harbord, *Film Cultures* (London: Sage, 2002), 82-3.

28 Jacques Ranciere, *Aesthetics and Its Discontents*, trans. Steven Corcoran (Cambridge: Polity, 2009), 30-2.

> The aesthetic regime of the arts is the regime that strictly identifies art
> in the singular and frees it from any specific rule, from any hierarchy
> of the arts, subject matter, and genres. Yet it does so by destroying the
> mimetic barrier that distinguished ways of doing and making affiliated
> with art from other ways of doing and making [...] The aesthetic regime
> asserts the absolute singularity of art and, at the same time, destroys
> any pragmatic criterion for isolating this singularity. It simultaneously
> establishes the autonomy of art and *the identity of its forms with the forms*
> *that life uses to shape itself.*[29]

In practical terms, every (ordinary) individual as well as every physical entity
could, under this aesthetic regime, be the object of art. Re-contextualising
commonplace objects, this trend in art creates 'situations apt to modify
our gazes and our attitudes with respect to [our] collective environment'.
As an immediate result, the common world and the art scene merge.[30] The
aesthetic regime sees the distinction between art and ordinary life blur.
Therefore the paradox, as Ranciere has it, is that 'in this regime, art is art
insofar as it is also non-art, or is something other than art'.[31]

 In political terms, a 'new form of distribution of the sensible' synchronises
with the rise of the aesthetic regime. This, according to Ranciere, is a form
that suspends the ordinary experience of domination. Under the poetic
regime, the hierarchy of genres, which corresponds with the hierarchy of
genre audiences, recognised 'the power of educated senses' over that of
'unrefined senses'. It also recognised 'the power of the class of intelligence'
over that of 'the class of sensation'.[32] Yet in equating art with everyday life,
the aesthetic regime has emerged to promote art in a revolutionary sense
as 'the expression of a free community', that is, 'a community whose lived
experience is not divided into separate spheres'.[33] There are no longer two
distinct lives (or humanities) under the aesthetic regime: one characterised

29 Ranciere, *Politics*, 23, emphasis added.
30 Ranciere, *Aesthetics*, 21. In Ranciere's study of literary history, this is evidenced by Stendhal's
nostalgic writing about his childhood memories. As quoted by Ranciere, the writing features
mundane details, such as the noises made by a banal water pump, a flute, and the church bell
(4-5). This literary/aesthetic characteristic could also be supported by reference to the humble
protagonists in novels by Honoré de Balzac, Gustave Flaubert, and Jean Hugo (32). Citing also the
example of the Dada campaign and the recent practice of relational art, Ranciere acknowledges
within the aesthetic regime a tendency towards 'redisposing the object and images that comprise
the common world' (21).
31 Ibid., 36.
32 Ibid., 31.
33 Ibid., 35.

by active intelligent understanding, the other by passive, externally trig-
gered sensation. Rather, there is one single, unitary type of life, with art
made into *'an autonomous form'* of this particular life. Despite its autonomy,
Ranciere insists, art in the aesthetic regime presents 'a moment in life's
process of self-formation'.[34] Thereby, life progresses in the regime through
art and vice versa.

Linking films to lifestyles, Harbord's observation reflects this entangle-
ment between life and art. To Ranciere, however, the intimate connection
between art and life is inseparable from the function of language. On the
(political) effect of art after his so-called 'aesthetic revolution',[35] his conten-
tion closely concurs with the theory of performativity:

> Political statements and literary locutions produce effects in reality. They
> define models of speech or action but also regimes of sensible intensity.
> They draft maps of the visible, trajectories between the visible and the
> sayable, relationships between modes of being, modes of saying, and
> modes of doing and making. They *define variations of sensible intensities,
> perceptions, and the abilities of bodies.* They thereby take hold of un-
> specified groups of people, they widen gaps, open up space for deviations,
> *modify the speeds, the trajectories, and the ways in which groups of people
> adhere to a condition, react to situations, recognize their images.* They
> reconfigure the map of the sensible by interfering with the functionality
> of gestures and rhythms adapted to the natural cycles of production,
> reproduction, and submission. Man is a political animal because he is a
> literary animal who lets himself be diverted from his 'natural' purpose
> by the power of words.[36]

By 'the power of words', Ranciere means, of course, more than the power
of written words. Cinematographic expression features prominently in his
discussion of art and language.[37] In this regard, there subsists a consonance
between his conception and Pasi Väliaho's understanding of cinematic
affectivity.

Both Ranciere and Väliaho agree that cinema reconfigures human
perception and conditions situational action. It is thus capable because

34 Ranciere, *Politics*, 24, emphasis in original.
35 Ibid., 36.
36 Ibid., 39, emphases added.
37 Arguing for the linkage between poetic artificialism and historical reality, he discusses for
example Chris Marker's *The Last Bolshevik*. See Ranciere, *Politics*, 38.

in modulating bodily rhythms or physical gestures, cinema governs the distribution of sensible intensity. After cinematic intervention as such, the human species is no longer defined by its 'natural' disposition. Unlike Väliaho, however, Ranciere remains reluctant to underline the consequence of technological devices.[38] In his formulation, the body-defining capacity of cinema arises as a result of an 'inter-penetration' of the logic of cinematographic language and the logic of life/history.[39] The inter-penetration indicates the subjection of man to the aesthetic potency. However, such subjection, Ranciere explains, is 'at once the condition and the effect' of the circulation of actual aesthetic expression.[40] Here, Ranciere encounters a materiality that could bring forth a contradiction in his theory of the aesthetic regime. This is the materiality of the human body, whose subjugation to aesthetics, according to Ranciere, conditions the circulation of an aesthetic language.

How does the human body condition the circulation of an aesthetic language? What does 'circulation' mean? In *The Politics of Aesthetics*, Ranciere writes that aesthetic expressions 'take hold of bodies and divert them from their [natural] end or purpose insofar as they are not bodies in the sense of organisms, but *quasi-bodies, blocks of speech* circulating without a legitimate father to accompany them toward their authorized addressee'.[41] This is to say, the circulation of a language entails the circulation of human bodies that, despite their static organic composition, are charged with the impact of language. If this is the case, do the bodies, or quasi-bodies, not circulate to reiterate and hence reproduce the circulated language? Will this reiteration/reproduction not ultimately contribute to the establishment of 'forms of normativity' that serve as the conditions for *genre* formation? Will the aesthetic regime not in this sense end up circuitously buttressing the poetic regime?

In the sense that bodies take on, display, and circulate the impact of actual aesthetic expressions, they do reiterate and reproduce languages. As a consequence, they also make possible the emergence of repetitive patterns, which provide the foundations for aesthetic formulaity or genericity. Yet in contrast to genres formulated under the poetic regime, whose principle of mimesis prescribes forms of expression to subjects of representation,

38 See Ranciere, *Politics*, 31-4.
39 Or, in Ranciere's own words, it is the inter-penetration of 'the logic of facts' and 'the logic of fiction'. *Politics*, 38-9.
40 Ibid., 39.
41 Ibid., 39, emphases added.

genericity forms as life progresses under the aesthetic regime. The mediation of the human body endows aesthetic formulaity with affective reality, which corroborates the Rancierian 'inter-penetration' of aesthetics and history.

This is apart from those quasi-bodies that circulate 'without a legitimate father' – the bodily impact of aesthetic expressions arises singularly. For this reason, each bodily reiteration of language may not collectively lead up to full reproduction of aesthetic expressions. Instead, Ranciere contends, 'the circulation of these quasi-bodies causes modifications' in the relationship between language and the distribution of its sensible effect. In this way, quasi-bodies 'contribute to the formation of enunciative collectives' that call into question the normative functions of language.[42] Quasi-bodies, this suggests, have in the aesthetic regime at once facilitated a specific type of genericity and destabilised the effect/effectivity of aesthetic formulae.

Meta-theoretically, this Ranciere-inspired conception of genericity casts light on the inevitability of debates over film genre definition, specifically those debates revolving around variable genre characteristics. Assuming the above-formulated theory of linguistic formulaity is applicable to cinematographic language under the aesthetic regime, film genres are the fruits of bodily mediation. This subjects cinematographic genericity to modifications caused by quasi-body circulation, and therefore to constant variation. Variations as such raise questions about individual innovation or creativity, particularly if those involved are identifiable human bodies. Since the circulation of quasi-bodies is argued to have enabled 'inter-penetration' of life and language, the re-conception of genericity also opens the way for reconsidering the relationship between generic communication and everyday reality.

In explaining his decisions on set selection, Cheng Hsiao-tse has in a previous quote provided corroboration for a filmmaker's bodily engagement with cinematographic expressions. In the next section onwards, a detailed analysis of my interviews with filmmakers will further examine that engagement with regard to the reproduction of cinematographic language. The post-2000 Taiwan filmmakers' accounts of filmmaking will reflect but also forward the discussion of linguistic formulaity and variation. Through the lens of their practice, the remainder of this chapter locates the formation of film genericity in order to address the related issues of authenticity, creativity, and, ultimately, the implied relationship of film production to film consumption.

42 Ibid., 39-40.

Realism in Aesthetic Intervention

Due to the conspicuous difference in their aesthetic preferences, it did not come as a surprise that in my personal interviews with the directors of post-2000 Taiwan queer romance, all the interviewees declared, one way or another, the necessity to bid farewell to the Taiwan New Wave aesthetic tradition. Yee Chih-yen, who made *Blue Gate Crossing* and helped kick-start the queer romance cycle of the 2000s, said for example that even if the expectations remained vague by the time they began shooting *Blue Gate Crossing*, his team had at an early stage of the production agreed on drawing distinctions from the New Wave films:

> This is not to say we considered ourselves special back then. Nor did we hypnotise ourselves with the ambition to open up whole new vistas for the Taiwan film industry. Our reasoning was simple, pretty much swayed by intuition in fact. We did not think the New Wave aesthetics would suit our story well, because our characters don't *feel* what the New Wave characters felt. Their life problems differ from the New Wave characters'. And that is it.[43]

Not so much afflicted with his characters' as his own feelings, Cheng Hsiao-tse, on the other hand, admitted to being underwhelmed when first offered the opportunity to direct *Miao Miao*. On his first glance at the script, he said, it seemed to him quite 'off-putting' since 'it felt too much like a New Wave movie'.

> I don't see myself as a fan of lyricism. There is no chance of me making an attractive film out of a script stripped of dramatic accents, where all the characters do is walk about leading their ordinary life. Give me the script of *Dust in the Wind* or that of *Taipei Story*.[44] I assure you the resulting film would be nothing but hypnotic. Master directors like Hou Hsiao-hsien, Edward Yang and Tsai Ming-liang know the key to the delicate New Wave style only too well. As for me, it's a shame I haven't shared that same sensibility.[45]

43 Yee Chih-yen, personal interview, February 5, 2010, emphasis added.
44 *Dust in the Wind* is a critically acclaimed early work by Hou Hsiao-hsien, released in 1986. *Taipei Story* was made by Edward Yang in 1985, one year before the release of his worldwide celebrated New Wave masterpiece *The Terrorizers*.
45 Cheng Hsiao-tse, personal interview, July 30, 2010.

Unlike Martin, neither Yee nor Cheng hinted that they would associate the New Wave aesthetics with (more) accurate depictions of the local reality. Rather, both filmmakers restricted their comments to dealing with the specificity of film aesthetics. Yee made an issue of the difference in characterisation. But he did not in socio-political terms extend the comparison between his scripted characters and the New Wave characters to a comparison between 'nowadays' and 'back then'. Cheng, generalising about its aesthetic features, categorised the New Wave films in terms of lyricism, which, in contrast to realism, foregrounds the filmmaker's subjective viewpoint instead of that of the objects of depiction.[46] Overall, it seems Yee and Cheng have not concerned themselves with the prominence of 'reality' as they have done with the effect of cinematographic language. This, however, is not true.

Asked about the relation *Blue Gate Crossing* has to 'the real world', Yee Chih-yen replied ambiguously:

> I don't think my works are completely realistic. But I would like to believe they are all grounded in genuine observations about people [...] Landmarks are easy to capture; challenging to grasp would, however, be the way people are. To misconceive *people's emotions* is a dreadful mistake to make. It happens only when a filmmaker is in lack of intimate knowledge about people [...] Anyone having trained in filmmaking would have learnt to treat 'respect for people' as the essential principle. What has led my camera is the reality of the people, whose story I tell.
> Having said that, for the sake of *visual effects*, I ought to also intervene and orchestrate scenes – arranging the camera angles, cues, the actors' movements, etc. These arrangements must be plausible while inevitably, they need be subject to artificial design. To design is to assure that seeing the film, the audience would easily get the point. Certainly, any effort that helps the audience 'get the point easily' should hardly be considered realist any more. But it has to more or less become expressionist.[47]

Is this to say that Yee would only pursue realism to the degree that it captures the reality of people and does not compromise the effect of his chosen language? Or did Yee mean to say that artificial design may reign to the point where he does not violate the principle of 'respect for people'?

46 As a matter of fact, Hou Hsiao-hsien has also described his style as lyrical rather than realist. See Chiang and Mon, 'Making Films for Pleasures'.

47 Yee Chih-yen, personal interview, February 5, 2010, emphasis added.

As Yee has focused on people's *emotions* in his specific translation of reality, aesthetic imposition does not in his formulation necessarily stand in tension with a realist's integrity. In response to the criticism that *Blue Gate Crossing* is visually appealing at the cost of narrative plausibility,[48] Yee defended his work:

> Some have said the film looks so neat that it could pass for a fairy tale [...] They also said it is flimsy that in the film, parents barely have a role to play in relation to the teen characters. In point of fact, my parents weren't particularly influential when I was younger. It was not that they had left me, but that they were always the last to know what had happened to me. Some things they might even never get to know [...] Even though they were there, my parents seldom participated in my teenage life. If I were to present my own experiences in a film, how would I introduce my parents as prominent characters when they did not actually 'have a role to play' throughout my teenage years? It would only look natural if they were made absent from the film. This same logic applies to composition and visual design. Objects disappear from the set if they do not take part in the action of a scene, which leads to the neatness much criticised of *Blue Gate Crossing*.[49]

Thus, rather than apologise for betraying his accentuated respect for people, Yee pleaded *experiential* reality for the employment of aesthetic distortion. Neatness might have been the visual effect he sought, yet the effect was preferred for the reason that it would reflect a subjective view of people. Anything that does not 'take part in the action' could plausibly be omitted from a scene because it might well be neglected by the characters, from whose viewpoints the story is meant to be told. The 'artificial design' that renders Yee's works 'expressionist' is in this sense justified on the premise of true depictions of the states of minds.

In a less sophisticated manner, Leste Chen, who made *Eternal Summer* (2006) in his early twenties, spoke in similar terms regarding directorial

48 Wen Tien-hsiang and Hou Chi-jan are the most widely read among the critics who have delivered such a criticism. Neither film critic has, however, disapproved of the film. Hou, for example, describes the implausibility as merely a 'regrettable flaw'. See Wen Tien-hsiang, 'Crossing the Gate to a Moved Mass Audience', *The Liberty Times*, September 29, 2000; Hou, Chi-jan, 'A Mirage in Heavy Traffic', *The Database of Taiwan Cinema*, accessed June 17, 2013, http://cinema.nccu.edu.tw/cinemaV2/squareinfo.htm?MID=15.
49 Yee Chih-yen, personal interview, February 5, 2010.

intervention when talking me through his thoughts on realism and the depiction of reality:[50]

> Honestly, I am not into realism. Maybe it is that I love films, and that I studied graphic design before making movies. I've barely found appealing the realist sensibility [...] A film presents the director's perspective. Fair enough some filmmakers should be after realism. But then in the movie theatre, the audience might wonder, what is the point of a film being realistic? In my opinion, some films are realistic at the price of *decent visual effect*. You can't always explain away the deficiency by raising the budget issue. When it comes to films, it always matters how things look. Say, a coffee shop. What must a filmmaker think when he thinks of a coffee shop? Is it the shop where a man once spent a whole afternoon with his lover? What did the shop look like on that particular afternoon? It might have been a cloudy cold day when everyone else in the shop felt miserable. But since the man was madly in love, he could have seen the shop differently, he could have seen the place filled with thin sunlight for reasons of his mentality [...] Depicting the coffee shop as it was *in the man's eyes* might lead to an unfaithful rendition of reality. But there is nothing peculiar about such a rendition. Even a layman would understand the logic behind the aesthetic. The unreality would not in any case result in implausibility.[51]

No doubt the history of aesthetic manipulation is too long for most film viewers to feel puzzled in its presence. Even in the early years of cinema, according to Siegfried Kracauer, a simple recognition of the discrepancy between a cinematographic expression and 'common knowledge' would immediately bring forth the realisation that the aesthetically manipulated manifests 'reality as it appears to a [specific] man'. 'Unreal', as the effect of the manipulation, Kracauer understands the unreality as 'extreme realism in the fantastic'. It presents hallucinations that 'also picture reality'.[52]

50 *Eternal Summer* tells the story of Kang Cheng-hsing, a young gay man who struggles with his romantic feelings towards his childhood friend Yu Shou-heng. As Shou-heng eventually falls for a girl, Cheng-hsing suffers from unrequited affection. Having earned NT$ 5.3 million ($ 180,000) in Taipei, the film is the second highest-grossing local feature production in 2006.
51 Leste Chen, personal interview, August 10, 2010, emphases added.
52 Siegfried Kracauer, *Theory of Film* (Princeton: Princeton University Press, 1997), 91-2. In Kracauer's discussion, however, extreme realism is more often than not associated with uncommon perceptions that emerge under extraordinary circumstances – a *madman*'s peculiar sensations, for instance. This renders it ambiguous whether Kracauer would have applied the

The Enterprise of Homage

If immediacy, as observed by Kracauer, has characterised the spectatorial grasp of aesthetically manipulated expressions, the question then arises as to whether the filmmaker would as conveniently make sense of a particular character's mentality. The answer might appear simple on a first glance at the transcriptions of the filmmaker interviews. The link Yee Chih-yen established between his teenage memories and the neat look of *Blue Gate Crossing*, for instance, indicates that the experiences of the filmmaker have mediated the translation of character mentalities into cinematographic expressions. To capture a character's subjective perception, in this case, entails the projection of the filmmaker onto the character and the subsequent communication of the filmmaker's subjective perception.

Where the experiences of the filmmaker fail to meet those of the character, *imagination* steps in to perform the tricks. Fu Tian-yu, the director of *Somewhere I Have Never Travelled* (2009), revealed how, being a city dweller, she had pictured the viewpoints of her main characters residing in the countryside:[53]

> I would always have already visualised a story at the moment I finished reading a text. The images come to me in a flash of intuition. By the time I reached the last page, I would have known what the characters look like and have got a good grip on the general setting [...] To actualise my mental images, I prefer to, however, obscure temporal and geographical details [...] As long as the visual images stay consistent, I take it as the true aim of my filmmaking to capture, as accurately as possible, the atmosphere I have experienced in my imagination.[54]

Thus, the undertaking of imagination involves primarily immersion in conjectured experiences, which creates in the filmmaker a subjective perception that would thence mediate the translation of a character's mentality into cinematographic expressions.

notion of extreme realism to any cinematographic rendition manipulated with respect to any subjective view. Leste Chen, on the other hand, did support the broad application of the concept.

53 *Somewhere I Have Never Travelled* tells the story of a colourblind girl, Ah-Guei, and her older male cousin Ah-Xian. Ah-Guei is attracted to Ah-Xian, while Ah-Xian falls for boys of his own age. Growing up in a small rural town by the sea, the two youngsters long to travel far and to resettle in places where they do not suffer angst about visual deficiency or sexual orientation.

54 Fu Tian-yu, personal interview, August 14, 2009, emphasis added.

Yet how exactly has imagination managed to emerge 'in a flash of intuition'? According to Fu, the filmmaker owes his/her mental images to cultural consumption:

> I have loved Tsai Ming-liang and his works. Yet at the same time, I am crazy about cheesy Japanese Junai romance and crappy silly comedies.[55] I have confidence in my knowledge, on the basis of which I believe my imagination has positioned my work properly within the aesthetic spectrum of films [...] The imaginary atmosphere I have intuitively experienced should introduce to my film a suitable language that could convince the general audience as well as it has convinced me.[56]

The 'flash of intuition', in other words, is infused with cultural knowledge or, more specifically, cultural knowledge of typology and genericity. For the appropriate imagination to emerge, a filmmaker depends on spectatorial experiences that help 'intuitively' associate a certain character's viewpoint with particular deployments of cinematographic language. This association would be reminiscent of genre rules bred in the Rancierian poetic regime if Fu had not from the outset stressed the intermediary role played by her sensate body ('the atmosphere I have *experienced* in my imagination').

In relying on knowledge-based intuition instead of solid observations, Fu has risked misconceiving 'the way people are', a 'dreadful mistake' with regard to filmmaking according to Yee Chih-yen. Intriguingly enough, Yee has himself employed a similar method in his pursuit of visual effect via 'artificial design'. Speaking of the neat visuals in *Blue Gate Crossing*, he admitted to influence from classic Hollywood directors, such as Billy Wilder, Joseph Mankiewicz, Preston Sturges, and Ernst Lubitsch. 'Their works are neat for the best effect', said Yee, 'The outcome acted on me more than my own deliberation or any anticipated audience reaction'.[57] Besides this, he highlighted two shots from *Blue Gate Crossing* to identify the inspirations behind their planning:

> I dolly in on the seated characters in the scene where Kerou asks Shihao to tell her a secret. The way the shot was handled could have been a homage

55 *Junai* is a subgenre of romance film. As the term 'junai' in Japanese means 'pure love', a typical *Junai* romance features a young teenage couple sharing an innocent love. With the hero or the heroine suffering an incurable disease, the loving relationship usually ends tragically, leaving the surviving protagonist bathed in sad memories.
56 Fu Tian-yu, personal interview, August 14, 2009.
57 Yee Chih-yen, personal interview, February 5, 2010.

to Godard. Having struggled to shoot the scene, I tried to imagine one after another how different master filmmakers might have done it. Then a scene from *Weekend*[58] came up. It is the one after the film's opening, shot with the camera steadily moving closer to the heroine, who sits against the light, delivering a sensational story.

The scene in which Kerou and Shihao fight in the school stadium, where the two of them push each other and crash into the stadium seating, was shot with Hou Hsiao-hsien's legacy in mind. Details of the shot only began to fall into place when I thought of Hou's films. I realised it was not so much violence but a deep sense of helplessness that I had meant to convey through that fighting scene. And the proper expression for a sense as such has long found home in Hou's handling of violent scenes.[59]

Whether it is the sensation of a secret or the profound sense of frustration bursting into a helpless act of confrontation, the depiction of sentiments to Yee is the pursuit of visual effect. The production of such effect, meanwhile, engages in an enterprise of homage.

Hence, with or without the intervention of imagination, the search for felicitous cinematographic expressions is navigated by the filmmaker's spectatorial knowledge. Appreciative of the guidance his knowledge had hitherto provided, Yee thus conceptualised cinematic creativity:

> Creativity springs from learning, or even imitation [...] I strive for original-
> ity, but do not exalt originality to be the only virtue in filmmaking [...]
> Consciously or unconsciously, I must work under the influence of film
> works I have seen.[60]

Ironically, the common definition of creativity does not consist in the practice of imitation. In fact, to be creative on most occasions means first and foremost not to imitate but to produce something new and innovative. In order to address this discrepancy, Yee elaborated on his reasoning:

> True learning entails digestion. As with food, you bite, you chew, you
> swallow, you absorb the nutrients, and eventually you *transform* what
> you have absorbed into energy for your own action. Crude filmmaking

58 Jean-Luc Godard, 1967.
59 Yee Chih-yen, personal interview, February 5, 2010.
60 Ibid.

puts creativity at stake when the filmmaker recklessly 'spits up' before the intake has been properly *processed* within the body.[61]

More straightforwardly than the accent Fu has – in a rather descriptive manner – put on her intermediary body, Yee's use of ingestion as a simile brings back Ranciere's theory of the quasi-body. This figurative device employed to capture the acquisition and application of cinematographic language also brings to mind Cheng Hsiao-tse's testimony that cinematographic expressions are selected by his bodily dispositions.

The body takes in the effect of cinematographic expressions, imbues itself with the effect, and circulates the effect in the form of a quasi-body. This, according to Ranciere, constitutes at once the condition and the effect of the circulation of cinematographic expressions. I have argued above that this process of language circulation enables the emergence of cinematographic genericity. Yet because bodily mediation modifies the effect of generic formulae – to follow Ranciere's formulation – the genericity thus brought into being is subject to instability while film genres are, by the same token, susceptible to exceptions and variations.

Yee's account of cinematic creativity recapitulates in figurative terms the intricate relations between bodily mediation and genre (de)formation. Expression through cinematographic language in his view involves learning, or imitation, whose prospective connection to formulaic repetition paves the way for generic communication. Filmmaking in this sense is always and already, to some extent, genre film making. However, the indication that a filmmaker's body actively processes the learnt language points to the possibility of a variable formulaity. The possibility underlies Yee's conception of cinematographic innovation.[62]

Of course, Yee's figurative speech should not be read literally. In itself, however, the account does attest to a filmmaker's active role in the circulation and reproduction of cinematographic language. In spite of Ranciere's theory, Yee's statement, alongside Cheng's and Fu's testimonies, still begs the question as to *how* the filmmaker's intervention actually comes into play over the course of film production.

61 Ibid., emphases added.
62 When situated in the broader context of theorising sociality and social activities, Yee's conception is also reminiscent of Gabriel Tarde's theory, which sees variation/innovation as an essential feature of imitation. See Gabriel Tarde, *The Laws of Imitation*, trans. Elsie Clews Parsons (Henry Holt and Company, 1903), and Harald Wydra, 'Passions and Progress: Gabriel Tarde's Anthropology of Imitative Innovation', *International Political Anthropology* 4.2 (2011), 93-111.

Sensorimotor Communication

In a self-reflexive fashion, Chen Yin-jung, the novice director of *Formula 17*, provided clues to the question raised above. An avid supporter of Hong Kong and Hollywood genre films, Chen has been marked by her frequent use of 'generic formulae'.[63] To account for this, she made the following comments:

> I like imposing generic formulae on daily reality. I *genre-ise* everyday trifles to make films. Trifles are made of life's intimate but banal details. When you genre-ise them, you approach them from an unusual angle. They then turn into something funny, something attractive. This is the magic of framing. To frame the mundane is to underscore and elevate it one way or another. Doing it with the assistance of generic conventions, I show people *what I have observed from my perspective*. If what I have observed would somehow make me cry or laugh, seeing it, people would probably cry or laugh, too.
>
> I didn't realise it, to be honest with you. It was only when I contrasted my works with fellow directors' that I noticed how realistic their grasp of things could be, or how generic mine had always been. I'm curious as to why some directors could make realism happen while I never know the way to do it [...] Doing my kind of work, on the other hand, is not trying at all to me. I do not study 'know-how' to bring in or fit together generic formulae. *They have come to me as soon as I registered my perception.* I have never made extra effort to design anything.
>
> I believe each one of us perceives a different world. I do not see my perceptions as generically exaggerated. It was only learnt later in life that my tendency to generic expressions might be *attributed to the films I have so far loved to see*. I need generic formulae to know I have handled a scene properly. Without them, I would not know how to measure the validity of my rendition.[64]

With her view echoed by Cheng Hsiao-tse, Yee Chih-yen, and Fu Tian-yu, Chen's statements stand out by substantiating an intricate connection between spectatorial knowledge, cinematographic expression, and the

63 Here, the phrases 'Hong Kong and Hollywood *genre films*' and '*generic* formulae' are used in reference to the conventional work of textual typologies. I have quoted the expressions from the press and from Chen herself. However problematic in nature, the typologies referred to seem to remain effective in terms of communication. Otherwise, Chen and her reporters might not have presumed a general understanding of both terms.

64 Chen Yin-jung, personal interview, January 17, 2008, emphases added.

filmmaker's sensory perception. A theoretical framework discussed in Chapter 3 may prove worth revisiting, before I analyse such connections and answer the question as to how filmmakers intervene in the (de)formation of genericity. What I have in mind is the theory of cinematic affectivity.

To account for Summer's re-enactment of scenes from *Blue Gate Crossing*, in Chapter 3 I concurred with Pasi Väliaho's argument that cinema functions as an existential technology.[65] It does so not only because it generates pre-individual affections and induces physical actions that assimilate to the cinematographic image. Neither does it so because it has originated a distinctive mode of communication, by transmitting rhythm, intensity, dynamics, and all their observable shifts. This specific mode of communication may have provided the spectator with a meaningful world, within which a sense of purpose arises from sensations generated by films. However, cinema is argued to have defined the spectatorial existence mostly because it operates as an encompassing 'milieu'. Into such a milieu merge the sensorimotor trajectories of the spectator. Technological in its essence, Väliaho contends, the cinematic milieu thus delimits the perceptual and behavioural potential of the spectator. Therefore, it determines the specific world a human organism is ever capable of knowing, living in, and acting upon. The subjective experience of a world as such constitutes the human organism's phenomenal reality.[66]

As defined above, extreme realism communicates a genuine or imaginary 'experiential reality', whose cinematographic rendition necessitates aesthetic manipulation. This experiential reality shares a few attributes with the phenomenal reality cinema may have determined. Both regard subjective perceptions and are on intimate terms with the effect of cinematographic language, except that the phenomenal reality is a result of cinematographic communication, whereas the experiential reality initiates a filmmaker's aesthetic intervention. Ideally, cinematic communication would engage experiential reality, including the employment of suitable cinematographic expressions, and prescribe the phenomenal reality. Since a cinematographic rendition of the experiential reality involves the mediation of the filmmaker's spectatorial knowledge, as delineated above, the practice of filmmaking circularises the communicative process by joining the experiential reality to the phenomenal reality.

Had Väliaho accurately grasped the mechanism of cinematic affectivity, spectatorial knowledge would have defined a filmmaker's phenomenal

65 Pasi Väliaho, *Mapping the Moving Image*, 105.
66 Ibid., 104-7.

reality, that is, the only reality the filmmaker is capable of perceiving and knowing. This is to say, the specific filter of cinematographic expressions, which had delimited the filmmaker's phenomenal reality, would have logically qualified any genuine or imaginary experiential reality s/he might seek to render cinematographically. The filmmaker's genuine or imaginary 'experiences', in other words, would have been so substantially structured by his/her cinematic experiences that the experiential reality would have always already been 'aestheticized' with cinematographic language.[67] Were this the case, it is no wonder that to some filmmakers cinematographic rendition of experiential reality should arrive effortlessly 'in a flash of intuition'.

Considering intuitive cinematographic rendition as *an automatic act* of cinematographic communication, one may further associate film production with the theory of cinematic affectivity. In Väliaho's formulation, cinema-generated body affections not only delimit the spectator's perception but also establish behavioural patterns via the mechanism of automatic assimilation. It is arguable that communicating intuitively through particular aesthetic devices belongs to these patterns, which makes the action of filmmaking a product of sensorimotor affections. This means that a filmmaker intuitively deploys cinematographic formulae just as a spectator (like Summer) involuntarily re-enacts on-screen activities. Both act in concordance with the films they have seen, and both do so as a consequence of cinematic affectivity.

In their own ways, Cheng, Fu, and Chen all associate generic expression with sensory experiences or automatic bodily (re)actions.[68] The verified linkage between cinema-shaped dispositions and intuitive communicative actions now 'actualises' Yee Chih-yen's figurative formulation of body intervention. The filmmaker's body takes in the effect of cinematographic language before bringing the effect out again for further circulation. In so doing, the body enables reiteration of cinematographic expressions, allows genericity, and facilitates the flow of the aesthetic in the channels of affections, perceptions, and expressive actions.

67 See Ranciere, *Politics*.

68 Besides the 'gut feeling' underlined, the plant nursery's capability to evoke 'emotion' pertains as well to Cheng's cinema and otherwise modulated affective inclinations. 'Emotion is qualified intensity', states Brian Massumi. Intensity, meanwhile, is external impact 'embodied in purely autonomic reactions most directly manifested in the skin – at the surface of the body, at its interface with things'. Cheng's 'emotional' connection to the plant nursery, in this sense, bears also affective implications. See Brian Massumi, *Parables for the Virtual* (Durham, London: Duke University Press, 2002), 25-8.

An example of sensorimotor embodiment, the practice of filmmaking is nonetheless distinguished from other, more typical examples by the considerable time lag between the emergence of body affections and the actual re-enactment of cinematographic expressions. This distinction poses a challenge to the sensorimotor understanding of film production. After all, without an observable immediacy, what will evidence the actuality of automatic assimilation?

Paradoxically, sensorimotor automatism pertains to dormant bodily tendencies even in Väliaho's theorisation. It is in his discussion of *Uncle Josh at the Moving Picture Show* (Edwin S. Porter 1902) that Väliaho suggests the probable dormancy of sensorimotor affections. The film discussed shows a spectator, Uncle Josh, dancing along when he sees a woman dance on the screen and fleeing as he sees a train approach in the moving image.[69] A film as such could easily induce laughter from the audience. For this reason, Väliaho states, Thomas Elsaesser has read *Uncle Josh* as a cinematic intervention to impose self-censorship on spectators. In laughing, it is deduced, the audiences of *Uncle Josh* must distinguish themselves from the silly main character in the movie and 'internalize a mode of self-control with regard to their own behaviour and actions in the viewing process'.[70] This plausibly explains why a cinema space does not usually turn into a dance hall when an upbeat musical is being shown. Despite widely experienced body affections, a crucial commonality among film spectators is their restraint from actual actions in the presence of affective instigation. Hence cinema's behavioural modulation is in itself a preliminary cultivation of potential actions.

In Brian Massumi's terms, dormant tendencies for action translate the body's encounter with cinema into 'a muscular memory of relationality'. With the corresponding actions deferred, a human organism charged with tendencies as such is merely active at the muscular and ligamentous level. The body abides in a state of passivity until the actualisation of the potential actions.[71] But what actualises the potential actions? In this premise and within the context of film production specifically, what might bring about actual citations of cinematographic expressions?

According to Massumi, both a 'cue-call' and a 'rig' are necessary to induce the actualisation of existing tendencies.[72] With filmmakers, this is to say, tendencies towards cinematographic citation may linger until

69 Väliaho, *Mapping*, 83.
70 Ibid., 86.
71 Massumi, *Parables,* 58-9.
72 Ibid., 62-3.

they take the 'cue-call' to make movies and utilise the rig of filmmaking facilities. Filmmakers' (self-)expression through cinematographic language, being canalised by the flesh, mobilises for cinematic communication the 'muscular' memories translated from their encounter with other movies. Therefore their 'enterprise of homage', as stated respectively by Chen Yin-jung and Fu Tian-yu, subsists on the basis of either *effortless* citation or *intuitive* imagination.

The Transmission of a Modified Language

However effortless or intuitive, the enterprise of homage does not guarantee accurate (self-)expression. Even automatic citation does not always replicate the effect of the cited language. On a personal level, puzzles surrounding the altered effect of generic formulae first struck me during a focus group discussion, where all participants objected when I stated that *Blue Gate Crossing* and *Miao Miao* share multiple textual properties. Citing Altman, I explained how the similarity is as much semantic as it is syntactic: both films are set in high schools and end with voiceover monologues, the main characters all ride bicycles, the major twists to the stories involve love triangles within which a teenage girl falls for another teenage girl while the latter girl is attracted to a boy, etc. The group participants denied the resemblance regardless, arguing that the two films convey disparate 'feel-ings'.[73] To elucidate the difference, Grace claimed, 'I feel *Blue Gate Crossing* has been coloured blue, whereas *Miao Miao* has been coloured yellow. Their atmospheres evoke different emotions'.[74]

Ultimately, the objections cast new light on Cheng Hsiao-tse's comments about genericity, made two weeks before the focus group discussion. Asked whether he saw *Miao Miao* as a 'genre film', Cheng in quick response con-fessed his worries over its noticeable formulaity. 'I dreaded that people would think I was following the cycle started by *Blue Gate Crossing* and continued by *Eternal Summer*', he said, 'Or they might as well think I was copying *Hana and Alice*'.[75] As I would later do with the focus group, he justified his worries by pinpointing the semantic and syntactic similarities

73 Focus group discussion, August 15, 2010.
74 Grace, focus group discussion, August 15, 2010.
75 Cheng Hsiao-tse, personal interview, July 30, 2010. *Hana and Alice* is a 2004 Japanese film by director Shunji Iwai. It tells the story of two high school girls, Hana and Alice, whose intimate friendship turns sour when they fall for the same boy.

between *Miao Miao* and the named movies. A while later, however, he changed his tone of voice:

> Once the production had begun, I came to realise I could never make a film like theirs. The sets, characters, icons, and plots may seem alike. But my approaches to them must be unique [...] Formulaic elements come as results of 'design', if you like. For the sake of practicality and profitability, the work of designing a film can prove impersonal and instrumental. To carry out the results of design, on the other hand, requires investments that are completely personal. I could only use formulaic elements when I have found a way to engage with them. Engagement is through life experiences, *through things I feel, and through things that make me feel.* Those things should help create my style.[76]

At least to some extent, the focus group's verdict confirms Cheng's comments. 'Formulaic elements' do appear to have been mobilised for dissimilar effect. In their observations, the group participants completely negated the textual formulaity that had at the very beginning driven Cheng to associate *Miao Miao* with *Blue Gate Crossing*.[77]

The fact that Cheng attributed his unique 'style' to personal engagement with cinematographic formulae, and the personal engagement to experiences or feelings, indicates three possible aspects of modification in genericity. Construed in relation to his further elucidation, all three aspects come down to the function of the mediating body. At its most basic level, Cheng's delineation suggests the body itself functions to define a filmmaker's engagement with formulaic expressions and may for this reason inflect the effect of the cited formulae, since the pivotal engagement arises partly under the command of *things he feels*. To elaborate on the engagement in question, he conceivably raised the subject of filmic influences, restating the point that his spectatorial experiences have shaped his sensory and

76 Cheng Hsiao-tse, personal interview, July 30, 2010.
77 On a related note, some participants in the focus group mentioned they had their individual taxonomies of fiction films. Black Black, for example, described metaphorically how her film memories had been classified and stored in distinctly labelled 'boxes', which she imagined to be distinct mind segments. In the system, lesbian romance *Candy Rain* (Chen Hung-yi 2008) and (heterosexual) romantic comedy *Hear Me* (Cheng Fen-fen 2009) are grouped together with *Eternal Summer*. A thorough textual analysis may show the three films to be as much similar as they are dissimilar. To Black Black, however, they belong to the same category because they share 'a romantic air' that she has experienced as being alike. Black Black, Skype interview, February 7, 2011.

communicative tendencies, which to his knowledge have differentiated his cinematographic expression. Through this lens, he pinned down the 'contrast' between *Blue Gate Crossing* and his feature debut, despite their seemingly shared textual properties:

> You do see director Yee tends to *feel* deeply for his characters, don't you? Characterisation dominates his use of film language. In my case, the *urge* resides more in plotting and production design. The *inclination* is obviously there. I cannot easily change.[78]

In this regard, the accounts echo the theory of cinematic affectivity, where cinema reconfigures bodily capacities and decides the body's relationship to its surroundings. However, given this reconfiguration, the theory of affectivity underlines the re-definition of the human species while Cheng finds his path to individuation – his personal 'engagement' with the cinematographic language, which would allow him his signature in the face of formulaic citation.[79]

But in order for Cheng's signature to materialise, he must also deploy *things that make him feel*. In a previous quote, Cheng explained how he had been led by his 'gut feeling' to breach the premise of *Miao Miao*'s script and decide on a film set located outside Taipei. To him, he said, the chosen set is 'more capable of evoking emotion' and more able to give off 'the exact atmosphere' he had pictured for the movie. Because Cheng himself has understood his choice as inseparable from his 'inclination' towards Hollywood-reminiscent production design, the anecdote provides a concrete case in which, to recall Massumi's theory, a suitable 'rig' is required to actualise a filmmaker's communicative tendencies. Body mediation at this level brings out, in the context of film production, the relevance of object mediation, which Chapter 3 demonstrated as capable of destabilising the seemingly prescriptive relations between the cinematographic and its bodily citations.

Creative Despite Imitation

After all, the immersive cinematic milieu does not thoroughly define the spectator's perceptual or behavioural potential. Väliaho's theorisation has

78 Cheng Hsiao-tse, personal interview, July 30, 2010, emphases added.
79 The above quote by Chen Yin-jung suggests the *Formula 17* director concurred with this view.

not been accurate. Rather, the effect of the cinematographic is subject to refraction and inflection, since miscellaneous 'things', alongside the spectator's body, intervene in the process of cinematic communication. The filmmaker's citation of cinematographic expressions, as a result, is most likely to lead to modifications in the effect of the cited expressions.

Apart from Ranciere's theory of the quasi-body, I have in a previous section discussed the implication of these probable modifications with regard to body intervention. That is, while cinematic embodiment does prompt the emergence of cinematographic genericity, variations in the effect of the cited language, caused by the mediation of the body, destabilise generic formulaity and open up film genres to incessant interrogation. It is on these same terms that I have also read Yee Chih-yen's paradoxical statement on creative imitation. To dig further into unstable genericity and its (possible) connection to creativity, I shall now look more closely at the practice of filmmaking as 'rig-mediated' communicative action.

'Rigs' of various natures are no doubt necessary for filmmaking. Grasped with regard to the conception of cinematic performance developed in Chapter 3, rigs represent the intermediary vehicles that at once facilitate and diversify the bodily impact of cinematic communication. These vehicles subsist in extraordinary or mundane spaces, residing in both human beings and non-human entities. Throughout the process of film production, where a spectator-turned-filmmaker communicates via sensorimotor affections, these intermediary vehicles obviously include everything that exists on set. Filming equipment, decorations, props, crewmembers, and the cast are all on the list. Considering pre-production and post-production, there is the relevance of administrators, screenwriters, editors, and various technological tools. Ideally, these intermediary people and things would cooperate in a massive assemblage, as if they were effectively organised prostheses, in order that they assist the filmmaker in his/her deferred completion of a cinema-initiated sensorimotor communication. Nevertheless, in practice, the network of diverse vehicles diverts the communicative actions. In this sense, to many filmmakers, filmmaking pertains more to active error prevention than to the realisation of a particular vision.

An illustration of this came from Yee Chih-yen. Recalling the filming of the street cycling scenes that many spectators had considered to have distinguished *Blue Gate Crossing*, he expressed a certain resentment:

> I hate the sight of standardised yellow taxis. Against the background of a blue sky and verdant green trees, their yellow colour is irritatingly dominant but contributes nothing to the effect of visual composition.

Back then, we however had no right to block streets for filming. It drove me crazy that we were constantly avoiding yellow taxis.[80]

In the case of *Somewhere I Have Never Travelled*, the ordeal was less avoidable. After deciding on a 'perfect' major location for the movie, Fu Tian-yu realised the little village in southern Taiwan had been scheduled for demolition. 'It was heartbreaking to see the beautiful buildings disappear little by little', she remembered, 'Every time I went down there for pre-production, there would be more missing from the scene. In the end, it was just impossible for us to use the place for a set anymore'.[81]

For Cheng Hsiao-tse, the situation was perhaps the most upsetting:

Before we started filming, the line producer had told me that Jettone Films[82] would not give me the final cut privilege. It was fair enough. Few novice directors were ever awarded that privilege, especially if they were expected to make profitable movies. Then, I did not know the change they were to make would be so dramatic. The editor[83] ruthlessly produced a 78-minute version of *Miao Miao* out of my 110-minute-long rough cut. I requested a revision. But ultimately, the film was released in an 83-minute version. I did not really have control over the situation.[84]

The rendition of experiential realities may lose its accuracy when 'things' go wrong, be they the random intrusion of a bright colour, a non-negotiable urban planning policy, a changed landscape, the sensibility of an unfamiliar editor, or an industry tradition. Sometimes, it is possible to pin down the wrong things. Other times, they remain mysteries. Cheng Hsiao-tse, for example, experienced a puzzling embarrassment when sitting in the cinema and realising his audience did not find funny a scene he had handled in a formulaic comical fashion.[85] For filmmakers with or without knowledge of the faulty details, it is equally heart-rending if the inaccuracy ends up characterising their use of formulaic language.

Fortunately, some renditions can turn out to be fitting, even though when they happen, the filmmaker also does not always know how 'things' have come right. For instance, the pan-Asian cinema esthetic that Fran Martin

80 Yee Chih-yen, personal interview, February 5, 2010.
81 Fu Tian-yu, personal interview, August 14, 2009.
82 See Chapter 5.
83 William Chang Suk Ping, who is also a production designer and art director in Hong Kong.
84 Cheng Hsiao-tse, personal interview, July 30, 2010.
85 Ibid.

endows *Blue Gate Crossing* with was more obvious to Japanese director Shunji Iwai than it was for Yee Chih-yen himself. Having seen *Blue Gate Crossing* by chance, Iwai requested a meeting with Yee during a visit to Taipei. In a celebratory tone, Iwai said Yee had deployed cinematographic language so beautifully that he thought he could have been watching his own movie when he sat through *Blue Gate Crossing*.[86] 'I took it as a touching compliment', Yee smiled on recalling the occasion, 'But to be honest with you, I have never been crazy about his works, not to mention studying his techniques. I don't think he has influenced me more than Hou Hsiao-hsien, Shinji Somai, or many classic Hollywood directors'.[87] Commenting on his heavy application of the telephoto lens, whose remarkable effect, Martin has argued, blurred the Taiwan locality and facilitated his film's 'passage overseas', Yee on the other hand admitted he had not noticed his apparent reliance on the tool, or at least 'Not until [he] was asked about it at a post-screening Q&A session'.[88]

Whether Yee had intended it or not, 'things' have worked in an assemblage to give *Blue Gate Crossing* a unique position on the spectrum of genericity. These include the fact that he had seen and potentially been affected by Iwai's movies; that he had, perhaps, in a more subtle fashion drawn on the Taiwan New Wave aesthetics; and that, among other tools, he found the telephoto lens useful in aiding his cinematographic expression. From a spectator's perspective, the generic quality of *Blue Gate Crossing* indicates the film's connectivity as much as its departure from generic formulae. This observation was put forward by Leste Chen, who spontaneously compared Yee to Iwai and opined that *Blue Gate Crossing* is '*noticeably better*' than Japanese romance movies. The Taiwan queer romance, to Chen, turns out to be more relatable because Yee has 'dropped concerns with dramatic tension' in favour of a 'delicate rendition of interpersonal relations'. The cinematographic result not only communicates but also evokes profound personal feelings. Chen associates this merit with the Taiwan New Wave tradition and the ineluctable impact of its relatively realist approach. Yet he also differentiates *Blue Gate Crossing* by Yee's adoption of a more intimate language. *Blue Gate Crossing* in his eyes is innovative and unconventional, despite being simple and viewer-friendly. For this reason, it is to a fellow (junior) director at once inspiring and encouraging.[89]

86 Yee Chih-yen, personal interview, February 5, 2010.
87 Ibid.
88 Ibid.
89 Leste Chen, personal interview, August 10, 2010, emphasis added.

What Chen depicts in *Blue Gate Crossing* is the highly desirable, much desired creativity emanating from an enterprise of homage, which Yee has otherwise described as creative imitation and Cheng as individual style via personal engagement with generic formulae. Made possible by an intricate mechanism that allows a filmmaker to communicate individuated experiences by citing existing cinematographic expressions, the emergence of such creativity, as demonstrated above, is contingent upon the totality of interventions by miscellaneous intermediary vehicles and the filmmaker's body. To subsist, the creativity requires spectatorial recognition, like that of Leste Chen with regard to *Blue Gate Crossing*. The act of recognition depends to a further extent on more comparable interventions from a distinct network of bodies and things. This then subjects the pursuit of cinematic innovation to a double nexus of human and non-human forces. When identified, as in the contribution made by Yee's telephoto lens, various examples illustrate that creativity is the product of a collective agency, brought into being by co-operation among diverse object and human agents. In Chapter 3, the same type of agency is theorised to have allowed individuated identity.

Sensory Linkage

In this chapter, I delineate the practice of filmmaking from the filmmaker's viewpoint to on that basis (re)conceptualise the film industry-audience relation. A detailed analysis of filmmaker interviews leads me to argue that filmmaking is a communicative act bred in the course of cinematic embodiment. The act takes the form of automatic citation, through which a filmmaker re-enacts previously embodied modes of cinematographic expression. Two processes are consecutively involved to bring about re-enactments as such. Firstly, the filmmaker consumes film works as a spectator and contains cinema-initiated body affections for future actions. Once given the opportunity to make a movie, s/he then communicates under the command of the preserved affections, replicating existing cinematographic formulae as if the act of communication was an immediate realisation of sensorimotor suggestion.

Since sensorimotor affections frame perception alongside prescribing acts of communication, to filmmakers, automatic citation translates genuine or imaginary experiential realities. They replicate cinematographic formulae to express their phenomenal/experiential perspectives, which are shaped by their spectatorial histories. As the replication enables the reproduction of cinematographic language, it likewise allows self-expression.

Self-expression via repeating cinematographic conventions forms the basis of generic formulaity, which renders filmmaking to some extent genre film making.

Paradoxically, the self-expressive repetition of generic formulae may well result in innovation, given that automatic citation as a consequence of sensorimotor affections is first of all achieved through body mediation, and the intervention by the filmmaker's body modifies rather than fully transmits the effect of the cited language. The practice of filmmaking, in addition, necessitates contribution from rigs, ranging from technical equipment to industrial administration. Being the intermediary vehicles, these rigs also refract the effect of the adopted generic formulae. Received, the modified/refracted effect of generic expressions goes through further body/object mediation to attain spectatorial recognition. When deemed 'innovative', the modified/refracted effect as aesthetic innovation therefore represents a joint effort by various bodies and things.

In this view, the issues raised at the start of this chapter concerning authenticity and creativity are both inappropriate for post-2000 Taiwan (genre) filmmaking. The adoption of generic formulae does not necessarily lead to compromised presentation of the national, as long as the filmmakers and their experiences are considered local. Originality remains possible, meanwhile, despite the use of generic language. To director Hou Hsiao-hsien's disappointment, however, originality is not completely ascribable to a filmmaker's 'will'.

Construed as such, cinematographic genericity in post-2000 Taiwan has emerged and existed beyond the calculation of marketability or Martin's so-called 'extra-local translatability'. Its emergence pertains (more) to an inevitable desegregation of film consumption and film production. Filmmakers, who integrate spectatorial reception with productive actions, sustain film genericity via subjection to cinematic embodiment. Their actual participation in (genre) filmmaking redefines genre and re-organises the film industry-audience relation.

In providing modes of expression for citation, the generic language circulating as a result of sensorimotor communication operates like a network system. Within the system, the bodies of filmmakers work as network nodes, which collect, inflect, and (re)distribute the effect of miscellaneous cinematographic expressions. The bodies of spectators, meanwhile, work also as network nodes, which collect, inflect, and accumulate tendencies to (re)distribute the effect of cinematographic expressions. Simultaneously, more network nodes are found in other bodies and things, whose intervention in the collection and (re)distribution of language effect further

inflects the effect. Circulated via all these nodes and taking effect when generating body affections, generic cinematographic language functions like a canal system for flowing, constantly mutating sensations. A film genre, coextensive with all the possible effect of its formulaic expressions, is in this sense a *sensory linkage* among various bodies and things that collectively qualify cinema-initiated sensations in generic communication. So long as the language effect is susceptible to body and object intervention, film genres are subject to variable definitions, from which arises also the potential for aesthetic innovation and cinematic creativity.

Exempt from problems of authenticity and creativity, (genre) filmmaking as sensorimotor communication nevertheless raises questions regarding film prosumption, where spectatorial agency is mobilised for industrial production. It is with respect to these questions that one may (re)problematise cinematographic genericity in the context of post-2000 Taiwan film production. As stated, the use of generic language does not hinder a filmmaker from his/her signature, but the signature reflects the filmmaker's spectatorial history and by extension his/her specific bodily capacity for cinematographic communication. In post-2000 Taiwan, obviously some film producers have admitted to concerns with audience satisfaction and predictable business operations. As a consequence, they have also admitted to an interest in generic formulae that are reminiscent of Hollywood productions. Under these circumstances, it is indeed no accident that those same producers have declared a preference for working with young spectators-turned-filmmakers, who had shown inclinations for Hollywood aesthetics and were considered ready for their debut productions.[90] In this case, the politics of post-2000 Taiwan (genre) filmmaking stands, once again, beyond the calculation of marketability. It revolves instead around a biopolitical issue, which concerns the measure of labour power. Rendered in terms of film prosumption, the issue pertains more specifically to how the film industry recruits new talents and exploits spectatorial bodily capacities for potentially lucrative film productions. In what way industrial practices as such define the power dynamics between the audience and the industry will be explored in Chapter 6, where industrial utilisation of affective labour is examined alongside attempted control over capital reproduction.

90 Hsu Hsiao-ming, Skype interview, Mar 3, 2010; Rachel Chen, personal interview, August 24, 2010. See also Ya-Feng Mon, 'Make Films for Audiences', *Eslite Reader Magazine*, December 2006.

5 Intimacy*

Internet Marketing as Collaborative Production

Following a chapter that discussed film prosumption with respect to the operation of the moving image, this chapter further explores the film industry-audience desegregation in a case of online marketing. I will examine the official blog of *Miao Miao*, the 2008 queer romance film directed by Cheng Hsiao-tse, and demonstrate the way in which online marketing has turned film production into an industry-audience collaboration. A preliminary sketch will first establish that marketers of *Miao Miao* implemented celebrity-audience intimacy as the film's primary marketing strategy.

In many ways, *Miao Miao*'s blog campaign exemplified trends in post-2000 Taiwan film marketing. In 2008, right before the romantic comedy *Cape No. 7* (Wei Te-Sheng) took the island by storm, Li Ya-mei, a senior Taiwan film marketer, wrote an article to outline the creative strategies Taiwan film practitioners had deployed in the crucial task of marketing.[1] Apart from the tactics used to draw media attention and negotiate theatrical exhibition, Li has foregrounded pre-release question-and-answer (Q&A) tours and blog marketing as the essential new methods/gimmicks to reach out to potential and target audiences.[2] These two methods have been widely adopted for practical reasons, Li contends, namely for their budget efficiency, which suits the operation of financially weak local film companies.[3]

Frequently coupled with post-screening Q&A sessions or on-campus promotional events, pre-release Q&A tours are seen as a marketing strategy

* Part of Chapter 5 is published in *Besides the Screen*, eds. Virginia Crisp and Gabriel Menotti Gonring (London: Palgrave Macmillan, 2015).

1 *Cape No. 7* was released in Taiwan in August 2008. It grossed NT$ 520 million ($ 18 million) in the domestic market and has so far remained the highest-grossing local production in Taiwan film history. See Regina Ho, 'Review of Box Office of 2008 Taiwan Films', in *Taiwan Cinema Year Book 2009* (Taipei: Chinese Taipei Film Archive, 2009), 100.

2 To gain media coverage, local film practitioners have made conscious efforts to maintain and capitalise on personal connections with media workers. Local branches of Hollywood majors, if commissioned to handle the theatrical distribution, could, on the other hand, help attain better agreements regarding screening durations. See Li Ya-mei, 'Creativity and the Impasse', in *Taiwan Cinema Year Book 2008* (Taipei: Chinese Taipei Film Archive, 2008), 115-7.

3 Li, 'Creativity', 115-6.

brought to full potential by the master art-house director Tsai Ming-liang.[4] Having become an iconic auteur in the mid-1990s, Tsai suffered a huge box office failure in 1998 with *The Hole*. The apocalyptic drama-musical grossed merely NT$ 320,000 ($ 11,050) in Taipei despite garnering the FIPRESCI Prize at the Cannes Film Festival.[5] To avoid another fiasco, Tsai first tried his hand at pre-release Q&A tours when promoting *What Time Is It There?* in 2002.[6] Over the duration of the marketing campaign, Tsai and the film's main actors attended more than seventy Q&A events around the island. After the film was officially released, post-screening Q&A sessions were held on a daily basis throughout the screening period. In the end, *What Time Is It There?* grossed NT$ 3 million ($ 100,000), which indicated a breakthrough. Thereafter, Tsai replicated the tactic in marketing his later works *The Skywalk Is Gone* and *Goodbye Dragon Inn*, both released in 2003.[7]

In the meantime, film blogs have often been utilised as 'information distributing centres'.[8] As Li Ya-mei writes, 'official blogs' have often been set up for local productions released in the second half of the 2000s.[9] In addition to their low cost, the medium is also favoured for its communication efficiency. Steve Wang, who marketed the black comedy *Parking* (Chung Mong-hong) and the documentary film *Beyond the Arctic* (Yang Li-chou) in 2008, observes that blogs have facilitated the immediate circulation of newsworthy information because they allow instantaneous updating.[10] Patrick Mao Huang, who produced and marketed *Eternal Summer* in 2006, emphasises the productivity of reader participation and notes that the citing/forwarding function supported by most blog service providers helps

4 Promotional events are held regularly on university campuses because university students are considered a major audience for local film productions. See Li, 'Creativity', 116.
5 See Wang Cheng-hua, '1998 Yearly Box Office Results for Chinese Language Films', in *Taiwan Cinema Year Book 1999* (Taipei: Chinese Taipei Film Archive, 1999), 68.
6 *What Time Is It There?* tells two parallel stories. One involves a street vendor in Taipei; the other features a woman tourist in Paris. The two meet briefly in Taipei before the woman sets off for Paris, and the street vendor sells his own watch to the woman. After that, he cannot help setting every clock he has at hand to Paris time. Jean-Pierre Léaud, who starred in François Truffaut's *The 400 Blows*, has a cameo appearance in the film.
7 Chang Jinn-Pei, 'How Tsai Ming-liang Marketed and Funded His Films', in *Taiwan Cinema Year Book 2004* (Taipei: Chinese Taipei Film Archive, 2004), 56-64.
8 Li Ya-mei in Su Wei-ling, 'The Study of Taiwanese Movie Blog Marketing' (Master's thesis, National Taiwan Normal University, 2009), 202. Su Wei-ling appends to her master's thesis full transcriptions of all the personal interviews she conducted for her research. In this and the next chapter, I refer to the content of these transcripts but not to the content of Su's thesis.
9 Li, 'Creativity', 116.
10 In Su, 'The Study of', 181-2.

extend the influence of blogged materials. The particular function, he says, distinguishes the medium as an effective tool for film marketing.[11]

In an interview with senior journalist Chang Jinn-Pei in 2004, Tsai explained that his fundamental strategy behind the pre-release Q&A campaigns was based on 'physical presence' (*ren yao dao*). As an auteur director, he believed he and his exceptional ideas were his films' unique selling point. Thus his presence and his willingness to elucidate in person the thoughts and feelings he had invested in the films, he suspected, should hold considerable attraction for his potential audiences. If Hollywood superstars have been instructed to remain mysterious, Tsai said, his appeal was, on the contrary, sustained by *closeness*.[12]

Once the marketing strategy is adopted to sell more populist film works, the efficacy of such closeness conceivably extends to the presence of the actors. Aileen Yiu-Wa Li, who produced and marketed 2004's highest-grossing local feature film *Formula 17*,[13] delineated the mechanism in terms that were quite similar to Tsai's:

> Film 'stars' should never attend Q&A sessions or promotional events. Their status depends heavily on a proper distance that breeds their mysteriousness. But we brought the actors to potential audiences, hoping the closeness would breed *affection*. In so doing, we did not help the actors cultivate their stardom. Quite the contrary, we worked to make these public figures seem affably accessible to the public. So the audience would *feel* related to them and might fancy seeing a film featuring them.[14]

With little intention of modifying or supplementing Tsai's theory, Aileen Yiu-Wa Li has conceptualised Q&A events as an *affective* promotional gimmick rather than an intellectual one. As Tsai has understood it, further elucidation of filmic concepts might help draw the audience to certain films. Li, on the other hand, suggested the strategy of closeness could prove fruitful, if only for the reason that Q&A events physically eliminate the distance between 'the public' and 'public figures'. The elimination of distance is apt to produce on 'the public' an effect that can translate into emotions, feelings, or attitudinal change. Such affective reactions then enhance the potential for film consumption.

11 Ibid., 188.
12 Chang, 'How Tsai', 55-6.
13 *Gift of Life*, the top-grossing local production of 2004, is a documentary film.
14 Aileen Yiu-Wa Li, personal interview, September 10, 2009, emphases added.

Speaking of blog content management, both Wang and Huang also deem that the optimal execution involves evoking affection and creating a sense of closeness. Technically, Wang finds that direct interaction enabled by the widely used commenting function has drawn the marketers a lot closer to blog readers and vice versa. Such closeness, if carefully maintained, may work to deepen communication and cultivate a strong sense of identification in the readers.[15] Huang, who is more concerned with operative strategies, underscores the efficacy of personal narratives. He observes that blog posts adopting a more personal or intimate tone are more able to bring the readers closer. For this reason, those posts are also more apt to 'affect', to generate comments, and subsequently to prompt film consumption.[16]

Through their use of Q&A tours or blog marketing, it seems that Taiwan film marketers, limited to tight budgets, have in the last decade consciously implemented a strategy to capitalise on the audience's predilection for *intimacy* with the film industry. While using the same tactics over the years, marketers appear to have learnt that a feasible way to successfully market through intimacy is via affective connection.

Q&A events and blog marketing, however, are not separate tactics based on the same strategy of intimacy. In fact, ever since Tsai's campaign for *What Time Is It There?*, Internet-mediated intimacy with 'public figures' – or 'celebrities', to use a fashionable term – has been regularly integrated with face-to-face intimacy in marketers' attempts to achieve effective marketing.[17] Hence, as the director and actors hit the road for Q&A tours, shooting diaries or production notes claimed to have been kept by them turn up online in order to preview the intimate thoughts to be shared at face-to-face promotional events. Occasionally, Internet users also gain opportunities to 'converse' with the filmmakers, the actors, or even the crewmembers via blog commenting or instant messaging. That is, in a drastically different setting, they may well enjoy a metamorphosed Q&A session.

It takes little effort to see that the virtual presence of the director and/or the actors constitutes the highlight of blog marketing campaigns. The posts containing the production diaries by director Wei Te-Sheng, for instance,

15 In Su, 'The Study of', 181-2.
16 Ibid., 192-3.
17 When *What Time Is It There?* was released, blogging had not yet become a communication phenomenon. An official website was therefore set up for the film. The operation of the website in many ways resembled that of later films' official blogs. Not only did Tsai publicise his production diaries on the website and activate the message board for public commenting, but he also engaged himself in a one-hour real-time chat room conference, where he took questions from the website readers.

dominated the official blog of *Cape No. 7* when the blog was first launched. Likewise, director En Chen's personal posts on the blog of *Island Etude*, 2007's dark horse at the box office, received up to 278 comments even four months after the film's theatrical release.[18] Internet-mediated intimacy with film celebrities, like face-to-face intimacy, holds tremendous attraction. While the communication value of Q&A events and that of blog marketing converge, it nevertheless remains obscure as to how Internet-mediated intimacy has worked alongside face-to-face intimacy in local practitioners' means-specific project of affective marketing. Is computational-networked communication able to achieve the level of intimacy face-to-face communication has attained? If, as John Thornton Caldwell has suggested in 'Cultures of Production', face-to-face Q&A discussions work in intermediary spaces that negotiate the boundaries between the cultures of production and the cultures of consumption,[19] would having the discussions mediated by the Internet re-negotiate the boundaries already in negotiation?

Most executive marketers have acknowledged the power of the Internet as a mass medium. In my interview with Patrick Mao Huang, for instance, he claimed that face-to-face Q&A events should never be held solely for 'the hundreds who could actually attend' but instead for 'the hundreds of thousands who might as well participate through reading or watching video clips online'.[20] However wide a reach the Internet medium might potentially achieve, nonetheless, Huang understands the medium's primary capacity as one that can 'broadcast' an event rather than to generate an event. For him, the efficacy of the medium is a by-product. Internet-mediated intimacy, in this framework, functions largely as a supplement, a compensatory service for those who have missed out on or had less access to face-to-face Q&A sessions.

Analysing communicative activities on the official blog of *Miao Miao*, this chapter argues against Huang. Mediation notwithstanding, I would demonstrate the industry-audience intimacy developed on the Internet enjoys certain autonomy from face-to-face contact at Q&A sessions. On its own terms, such autonomy (re)organises the industry-audience relation into a collaborative project of film (value) production, which it does – no

18 *Island Etude* was released in April 2007 and distributed by Warner Bros. Taiwan. The film is about a hard-of-hearing university student's bike tour around Taiwan. It grossed NT$ 8,973,086 ($ 309,500) in Taipei and was the top-grossing local production in the first half of the year. See Wang Cheng-hua, 'Review of the Film Market in 2007', in *Taiwan Cinema Year Book 2008* (Taipei: Chinese Taipei Film Archive, 2008), 141.

19 John Thornton Caldwell, 'Cultures of Production', in *Media Industries*, eds. Jennifer Holt and Alisa Perren (Oxford: Wiley-Blackwell, 2009), 208-9.

20 Patrick Mao Huang, personal interview, August 2, 2010.

less than face-to-face Q&A events – by affectively correlating the audience and the industry.

Miao Miao, the Official Blog

As with *Blue Gate Crossing*, *Miao Miao* tells the story of an unrequited love triangle. In the film, high schooler Miao Miao, played by Ke Jia-yan, is an exchange pupil from Japan. She meets Xiao Ai, played by Chang Yung-yung, on the first day of school in Taiwan, and the two girls become best friends. In a street-striding adventure, Miao Miao visits a second-hand record shop and falls for the shop owner Chen Fei, played by Wing Fan. Xiao Ai, meanwhile, finds herself irresistibly attracted to Miao Miao. As the girls' respective affections grow, Chen Fei's aloofness frustrates Miao Miao, while Miao Miao's crush on Chen Fei torments Xiao Ai. The closet Chen Fei, for his part, despairingly grieves over the tragic death of his secret boyfriend Xiao Bei.

The queer romance is Jettone Films' first production executed in Taiwan after the Hong Kong-based company opened a Taipei office in early 2003. The company, headed by the acclaimed director Wong Kar-wai in partnership with Stanley Kwan, runs a talent agency department that represents Tony Leung and Chang Chen, among other Chinese-speaking actors. The Taipei office was originally set up to manage the agency business in Taiwan but then extended its operation to initiating and handling film projects that feature actors represented by the company. With its production jointly funded by Taiwan's Government Information Office[21] and China's J.A. Media, *Miao Miao* showcased the novice Ke Jia-yan and the veteran Wing Fan from the company's local clientele. Warner Bros. Taiwan once collaborated with Jettone Films in distributing the Hong Kong romantic comedy *Sound Of Colors* (Joe Ma) in 2003 and, as a result, was commissioned to organise *Miao Miao*'s local distribution.[22]

Marketed since August 2008, *Miao Miao* was always considered 'saleable' by Jettone Films and Warner Bros. Taiwan. After the unusual success of *Cape No. 7* in the domestic market, the experience of distributing the coming-of-age film *Orz Boyz* (Yang Ya-che 2008) convinced Warner Bros.

21 The Government Information Office was replaced in 2012 by the Ministry of Culture, which now regulates the film business and formulates relevant policies.
22 Rachel Chen, personal interview, August 24, 2010.

Taiwan of the potential of local productions to receive wider acceptance.[23] In *Miao Miao*'s case, the endorsement from Wong Kar-wai and Stanley Kwan, both among the bestselling directors in Taiwan, was further expected to constitute an effective unique selling point. Besides, *Miao Miao*'s leading actresses Ke Jia-yan and Chang Yung-yung were deemed likable newcomers while Wing Fan had in the previous decade proved himself to be an example of a local pop idol.[24]

Jettone Films and Warner Bros. Taiwan thus believed *Miao Miao* should be promoted 'as a proper commercial film'.[25] Pre-release and post-screening Q&A tours were not considered. The executive director of Jettone Films' Taipei office Rachel Chen explained:

> Many local marketers have shared faith in Q&A tours, but we have always questioned their efficacy [...] On-site (advance) ticket sales, for example, immediately reflect the effectiveness of pre-release tours. And more often than not, after a whole day's traveling, advertising, and poster signing, on-site ticket sales would remain lower than several dozens. Is it really worth the effort? Should marketers not instead devote their energy to the creation of a more accurate marketing scheme?[26]

The resulting marketing campaign for *Miao Miao* hence only adopted familiar strategies like television commercials, newspaper, bus and subway billboard advertising, and cross-industry alliances.[27] Just before the film was released, however, four on-campus pre-release Q&A events were announced. In our personal interview, Rachel Chen said these events had been arranged at the director's request. 'He did not want to miss the opportunity to communicate face-to-face with potential audiences', she said.[28] In addition, an

23 *Orz Boyz* was the second highest-grossing local production of 2008. It was released in September and distributed by Warner Bros. Taiwan in cooperation with 1 Production Film. Within a screening period of 97 days, the film grossed NT$ 35 million ($ 1.2 million). See Ho, 'Review of Box Office', 103.

24 His most popular performances before *Miao Miao* were in the films *Darkness & Light* (Chang Tso-chi 1999), *The Best Of Times* (Chang Tso-chi 2002), *Sound Of Colors* (Joe Ma 2003), and the television series *Crystal Boys* (Tsao Jui-Yuan 2003).

25 Cheng Hsiao-tse, Skype interview, March 5, 2011.

26 Rachel Chen, personal interview, August 24, 2010.

27 Promotional activities were launched in cooperation with different commercial websites. Customers of book.com.tw or ezTravel, for example, were entitled to free film tickets once they purchased selected products through the websites.

28 Rachel Chen, personal interview, August 24, 2010.

economical online marketing campaign was carefully planned and included the film's blog campaign.

The official *Miao Miao* blog provides information that can be divided into six categories. The first category concerns the film itself, the filmmaker and crewmembers, media exposure, and promotion events. This includes an 'About' section that contains the trailer, a collage of press coverage, and profiles of the film, its director, and cinematographer. A section entitled 'My Head Shot' introduces the film's heroine Miao Miao with an album of select film stills and event photos. An 'Upcoming' section lists scheduled on-campus talks, post-screening Q&A sessions, and TV or radio features.

The second category prompts the circulation of opinions. It presents written testimonials from celebrities, positive reviews from fellow bloggers, and a message board upon which the blog administrator would post questions every now and then to elicit discussions.

The third category showcases a selection of video clips from the film. Two mini video series were also produced as the blog's exclusive bonus. One of them shows Ke Jia-yan and Chang Yung-yung learning to bake a chocolate cake, which relates to the film because the main character Xiao Ai enjoys baking. In the other series, the leading actresses give their potential audiences make-up advice, as a scene in the film sees the precocious Miao Miao seek assistance from a cosmetic salesgirl.

The fourth category contains the section entitled 'Secret Diaries', within which both leading actresses posted articles to note key moments in the film. The first few diary posts adopted the viewpoints of the main teenage characters and gave interpretative accounts of the characters' mentalities within major scenes. Then Ke and Chang resumed their own identities and reported on their experiences as they went through the film's various marketing events.

The fifth category invites the blog readers to disclose their 'secrets'. Three sorts of disclosure were solicited. 'To High School Best Friends' invited blog readers to convey intimate messages to their present or past high school best friends. 'Love Confessions' challenged the interested participants to the task of making a love confession by using five music album titles, which resonates with Miao Miao's confession to Chen Fei. 'Diaries on the Map' asked for travel experiences to highlight the marketing campaign's main theme that love/life is a journey. A variety of free gifts were constantly offered to elicit and reward participation from the readers.

The sixth category foregrounds the reflection of the filmmaker and the crewmembers. Both the film's director Cheng Hsiao-tse and project manager Rachel Chen posted articles to voice their thoughts on the film. A local

publication's interview with the film's cinematographer Kwan Pung-leung, who had worked in Hong Kong with Wong Kar-wai, was also reposted on the blog to show his comments on *Miao Miao*'s production. One of Cheng's two posted articles, entitled 'Something about *Miao Miao*', was the most popular item on the blog and garnered around 10,000 views. Thanks to Cheng's fastidious reply to every single reader comment, the article generated 417 comments (including Cheng's own contribution) while the average number of comments for all other articles on the blog was fewer than 10.

The content that falls into the fourth and the sixth category can roughly be classified as 'behind-the-scenes' narratives, or more specifically the 'making-ofs', whose systematic relation to film marketing has been established by Caldwell in *Production Culture*.[29] Yet, if one compares this official blog with *KongisKing.net*, the promotional website of Peter Jackson's 2005 blockbuster *King Kong*, one would find each website has adopted discrete strategies in addressing its potential audiences. The production diaries on *KongisKing.net* are published in video form. They document activities at the production locations, in the post-production studios, on the red carpet, and inside the publicity office. Although the diary footage (91 posts in total) is produced in the name of Peter Jackson, the stories are hardly told from the director's perspective. The actors, assistant cameramen, lighting technicians, production design crews, make-up artists, editors, the special effects team, and publicity officers all have their say. Exclusive interviews are presented to shed light on each profession. Following the diary entries, the users of the website may expect to 'witness' the complete filmmaking process. The information provided, though intimate in tone, is understood to be 'objective'.

Miao Miao's official blog, on the other hand, underlines the key practitioners' *subjective* investment. Take 'Something About *Miao Miao*' for instance. The post appeared on the blog three days after the film was officially released. Cheng states clearly in the opening paragraph he would be writing in response to certain critical comments he had come across in cyberspace. To defend himself against the criticism that *Miao Miao* is but another opportunistic follower of the queer romance fad, Cheng details in the article not only how he ended up directing a queer romance. But he also delineates the help he has had from Stanley Kwan, the film's producer and a veteran director of Asian queer romance scenes. The production process is outlined to support Cheng's declaration that he has devoted himself to *Miao Miao*'s production because he believes in 'love'.

29 John Thornton Caldwell, *Production Culture* (Durham and London: Duke University Press, 2008), 283-90.

At his most passionate, Cheng says in 'Something about *Miao Miao*':

I have loved and been loved. Love is such an unutterable experience, complex with all its sweetness and bitterness, overwhelming with its ineffaceable effects.
My confidence [in making a film involving lesbian and gay love] comes from a strong conviction. That is, love does not discriminate. When it reveals itself, it allows no escape. Discrete personality traits may lead to distinct experiences of love. But the difference lies neither in gender nor in sexuality.
I know what I have been working for. I have made a romantic movie [...] In its bittersweet atmosphere it contains [...] the most innocent of human affections.[30]

Ke's and Chang's 'diary' posts sustain this same subjectivity. Ke, for example, writes after the film's premiere on November 13, 2008:

We have all spared no effort for *Miao Miao*. Every single one of us has grown and learnt. Today, I felt as if I'd seen my beloved daughter getting married. I had mixed emotions and was very touched. At the bean feast afterwards, I couldn't help crying. I'd never thought I would act in a film. But since I started acting, I've begun to know and like whom I am.[31]

As they may constitute engaging 'behind-the-scenes' narratives, these statements could also serve as appropriate content for celebrity journalism, where according to P. David Marshall, the reader glimpses a celebrity's innermost belief. Only in this case, Cheng's or Ke's 'innermost self' bypasses even the intermediation of professional journalists to (assumedly) *speak for itself* through the celebrity's own writing.[32]

As Patrick Mao Huang has suggested, personal narratives bring the readers closer, and closeness sustains intimacy as a prominent appeal of celebrities. Since the medium's emergence, it has been widely assumed and acknowledged that due to direct access, the blog/Internet foregrounds the

30 Cheng Hsiao-tse, 'Something About *Miao Miao*', *Please Show Your Support for Miao Miao*, November 17, 2008, http://miao.pixnet.net/blog/post/22390134.
31 Ke Jia-yan, 'On the Premiere', *Please Show Your Support for Miao Miao*, November 16, 2008, http://miao.pixnet.net/blog/post/22376042.
32 In my interviews with Cheng, he affirmed that he had written all his statements published on the blog. I have, however, never received confirmation that the two leading actresses had also attended to the writing published in their names.

personhood of the celebrity more than other methods or mechanisms that have been engaged to mediate intimacy where face-to-face contact cannot be arranged. While the mechanism for spreading personal narratives does inform the modality of intimacy with celebrities from celebrity journalism to blog posts, the level of intimacy attained does not only concern the celebrity's direct access to the method of mediation. More theoretically and practically compelling are the issues of effectiveness and authenticity. Since the presence of celebrities remains the result of mediation, the availability of direct access still raises questions as to whether there exist 'actual' effect and 'authentic' experiences of mediated intimacy. If the answer is in the affirmative, how do the effect and experiences work in marketing and, by extension, in the formation of the audience-celebrity or audience-film industry relations? To address these issues before further delineating the use of celebrity-audience intimacy in *Miao Miao*'s blog marketing, my analysis commences with a discussion that traces mediated intimacy back to its facilitation by print media, so as to attest to the *actuality* of this intimacy.

The Sensation of Closeness

Intimacy between public personalities and their audiences has long interested scholars of stardom, fandom, and celebrity cultures. In his recent publication *Celebrity/Culture*, for example, Ellis Cashmore introduces the psychologically based term 'intimacy at a distance' to generalise the cumulating effect of celebrity cultures on contemporary media users.[33] The paradox in Cashmore's terminology indicates a commonsensical issue that my adoption of the terms 'audiences' and 'media users' has already illuminated. That is, intimacy with celebrities is (and very often can only be) a closeness from 'afar', simply because the intimacy is a result of mediation.

In contemporary societies, public personalities are most frequently 'experienced' as parts of media content. Be it social, emotional, economic, or political, the significance of these personalities finds most of its basis in the efficacy of media communications. Even if the impact of the intimacy with celebrities proves intense and multivalent only to the most devoted fans, given the ubiquitous interference by media communications, Cashmore argues, intimate interactions with public figures have become ineluctable, even to 'the ostensibly uninterested'. 'Like it or not', he writes, 'we do get the feeling that we "know" celebrities'. Although what we actually 'know' about

33 Ellis Cashmore, *Celebrity/Culture* (New York: Routledge, 2006), 80.

them is 'only what [we have] gleaned from the media', celebrities turn out to be 'so real to us' that we not only 'feel we know something about them' but we also feel their existence, as if they were just *there* with us.[34]

Sharing Cashmore's observation that the audience-celebrity relationship is characterised by intimacy (from afar) and that this intimacy is a consequence of ubiquitous mediation, P. David Marshall and Misha Kavka elaborate the condition of possibility of such intimacy by examining the communicative mechanism of print journalism and television respectively. Marshall traces the rise of what he calls 'celebrity journalism' within a broad Western context back to the early nineteenth century, when the introduction of democracy and consumerism worked to re-organise 'what has later been described as the public sphere'.[35] In place of royalty or the religious leaders of the previous era, Marshall contends, public figures of the early nineteenth century acquired power from the support of 'the crowd and the masses'. As the products of cultural industries that had developed alongside an expanding general literacy, newspapers and other print publications capitalised on the 'democratically inspired' value of the emerging public personalities. They acknowledged the collective interests of 'a wider proportion of the population' and sought to cater to these interests by producing profiles of widely celebrated public figures. Since entertainment industries and electoral politics have also developed rapidly from then onwards, press agentry eventually flourished as a parallel profession to celebrity journalism in order to bridge the industries/politics and the media. It helped entertainment industries promote personalities, allowed politicians to exploit media exposure, and facilitated a self-sustaining circle of communication between entertainment, politics, and media figures. The circle of communication has thence fostered a publicity-driven celebrity culture.[36]

34 Cashmore, *Celebrity*, 80-1, emphasis in original.
35 P. David Marshall, 'Intimately Intertwined in the Most Public Way', in *The Celebrity Culture Reader*, ed. P. David Marshall (New York and London: Routledge, 2006), 316.
36 Ibid., 316-9. In addition to this publicity-centred circle, also at work is a celebrity culture driven by scandal and gossip. In the context of Marshall's discussion, the reportage of scandal constitutes a crucial aspect of celebrity journalism. The relevance of such reportage to the construction of celebrity-audience intimacy is, however, not clarified. Arguing for the persistent validity of celebrity journalism as such, Marshall also maintains in 'New Media – New Self' that the rise of new media, or 'user generated media', has in recent years helped produce a shift in celebrity culture. He argues that the consolidation of celebrity culture used to rely on the 'representation[al]' capacity of what he has named 'traditional media' (i.e. print and broadcast journalism). Nowadays, nevertheless, user-generated new media functions alternatively to support a 'self-presentation[al]' regime that 'has begun to modify the sources of our celebrity'. See 'New Media – New Self', in *The Celebrity Culture Reader*, 634-44.

Despite its apparent instrumentality in politics and cultural industries, celebrity journalism also works in contemporary societies to fulfil rising needs for intimacy. Referencing Emile Durkheim and David Reisman, Marshall underlines the sense of 'disconnection and dislocation' that emerged as a distressing result of industrialisation and workforce migration. The same process, he writes, 'helped create a sense of both anonymity and alienation'. In such context, celebrity journalism ironically presented 'a constellation of recognizable and familiar people', whose profiles provided 'points of commonality' for the masses to 'reconnect both with the celebrities and with each other'. Where the whole world seemed to exist a considerable distance away, celebrity journalism brought public figures closer to enable 'a greater intimacy' with otherwise desolate everyday lives.[37]

Not all media exposure, however, ends up achieving a similar degree of intimacy. In Marshall's analysis of print media, effective celebrity journalism must be more than excessive bombardment of readers with celebrity trivia. It entails a specific style of reportage, which has evolved since the nineteenth century into providing an even greater degree of celebrity-audience connection. In the nineteenth century, he states, profiles of public figures started as 'carefully choreographed studies of public moments involving these people'. Over the course of the century, the profiles then changed to become 'revelations about [the public figures'] private lives and how that intersected with their public lives'. The methods of celebrity journalism in its first decades involved 'reporters piecing together stories from people who knew famous people'. The twentieth century onwards saw the development of what Marshall has described as 'standard structures and motifs' for celebrity profiles, which gradually became sustained by '*direct* interviews with famous people in their *private homes*'. While inevitably subject to publicity, the latter is a journalism committed to revealing the '*true nature*' of the celebrity.[38]

Clearly, Taiwan does not share the historical context in which the celebrity journalism of Marshall's description emerged. The structures and motifs Marshall has detected are 'not quite standard yet' in Taiwan celebrity profiles. Nevertheless, I remember working as a feature reporter for an urban lifestyle magazine during the 2000s in Taipei. A great deal of my energy then was spent on gaining access to my interviewees' domestic

37 Marshall, 'Intimately Intertwined', 317.
38 Ibid., 317-20, emphases added. Marshall's observation of changes is drawn from Charles L. Ponce de Leon's *Self-Exposure: Human-Interest Journalism and the Emergence of Celebrity in America, 1890-1940* (2002).

spaces. Photographs of an interviewee's personal bookshelves, music collection, working desk, studio space or even bedroom decoration were highly valued in the editorial office. Hence, despite perceivable differences in historical background, print celebrity journalism in present-day Taiwan shares with its Western counterpart a major technique of reportage whose deployment is meant to generate celebrity-audience intimacy.

Thus, through written descriptions and pictorial presentations, print media reportage nowadays aims to bring the audience/reader into a celebrity's private space. The reader, in turn, is expected to experience a *sense of re-location*. This mechanism, based on the journalist's efforts to obtain private meetings, the celebrity's consent to self-exposure, and a standard format of reportage, *virtually* re-locates the reader, ushering him/her not only into the presence of the celebrity but into the celebrity's daily life setting. This specific instance of space mediation brings about a sensation of closeness to meet the condition of possibility of celebrity-audience intimacy. As the medium for celebrity journalism evolves into broadcast and then computational-networked media, space mediation as such is achieved via disparate means. Following Steve Wang and Patrick Mao Huang's comments about blog marketing, the sensation of closeness (sustained either by online interaction or via personal blog posts) nonetheless stays at the core of the intimate connection between the audience and the celebrity.

Bodily Virtuality

Broadcast celebrity journalism triggers a parallel sensation by virtually dissolving the distance between celebrity activities and the audience's everyday life scene. Take televisual communication for example. It has been a truism that television 'unites the individual at home with the event afar'.[39] In the 1940s, the US-based DuMont Corporation was already selling its customers the prospect of 'an armchair Columbus'. That is, once a customer had purchased a television set, s/he would have access to information from around the world as if s/he had been well travelled. Believing that television has almost fulfilled its technological promise, Misha Kavka argues that televisual communication provides an experience of 'reciprocal

39 This expression originates from an article TV critic Jack Gould wrote for *The New York Times* in 1956.

transplantation' – it sends 'the viewer into the remote environment and the remote environment into the viewing space'.[40]

By its ability to draw the viewer close, Kavka states, television qualifies as 'a technology of intimacy'.[41] Apart from spatial closeness, moreover, televisual broadcasts also facilitate temporal closeness through live trans- mission. The resultant coupling of temporal urgency and spatial proximity evokes on the part of the viewer a strong sense of immediacy, which consists in senses of reality and intensity. The latter senses help the viewer relate to the event/personality on the other side of the television screen. As a consequence, the sense of immediacy amplifies the sensation of intimacy.[42]

Of course, live broadcasts have for decades been limited to 'news, current affairs and sport' programmes. Generalising about televisual communica- tion, Kavka argues nevertheless that the knowledge of asynchronicity does not necessarily compromise the sensation of temporal closeness, since the generation of such a sensation relies more on faith in real-ness. Kavka finds a particular example of this in reality television. Although most programmes of this kind are taped before being broadcast, she says, they appear no less 'live' to the viewer because when the viewing begins, '[the programme participants] are there, doing what they would do, the cameras are on, and we are watching'.[43] The fact that 'the cameras are on' contributes to a sense of reality, which strengthens the sense of immediacy and the sense of intensity to buttress the sensation of temporal urgency.[44] On this premise, televisual celebrity journalism achieves the sensation of closeness with or without live transmission by virtually collapsing the space-time of celebrity activities with the space-time of the audience's mundane reality.

Reliant either on highly specified communicative techniques or on technological facilities, both print and broadcast celebrity journalism nonetheless raise the question as to whether the sensation of closeness they have generated is sufficient to form the foundation for authentic celebrity-audience intimacy. For Kavka, who addresses the issue with respect to televisual broadcasting, the answer is located within alterations in the audience's *affective* state, which will later prove fundamental to the legitimacy of Internet-mediated intimacy.

40 Misha Kavka, *Reality Television, Affect and Intimacy* (Basingstoke and New York: Palgrave Macmillan, 2008), 15, emphasis added.

41 Ibid., 5.

42 Ibid., 19-23.

43 Ibid., 19.

44 Ibid., 16-9, 23.

Citing theorists from Sigmund Freud to Silvan Tomkins, Kavka understands celebrity-audience intimacy as a result of affective transmission. Within the context of interpersonal interaction, the transmission of affect involves intersubjective exchange/sharing/circulation of physiological tension. Teresa Brennan, who traces the flow of physiological energy, identifies the transmissive mechanism by probing the interplay between human organisms. As a consequence, she suggests that affect, or the physiological tension, travels through two possible routes, one nervous, the other chemical. The nervous transmission of affect, working on a relatively conscious level, allows one nervous system to exert influence on another by touch, sight, sound, gesture, or movement. Rhythm, tone, and other factors that define the quality of the transmitted tension inflect the efficacy of such transmission. The chemical transmission, on the other hand, depends upon the release and consumption of pheromones. Secreted by a body externally into the air, pheromones impact on the physiology of other bodies.[45] Since the affective transmission she means to substantiate is not at all literally 'interpersonal', the challenge for Kavka is to outline a comparable mechanism that would account for television-mediated intimacy between the audience and the celebrity.

For that, she turns to the sensation of closeness and argues in quasi-phenomenological terms that the sensation facilitates affective connection because the responses it enables are physiological as are those enabled when the interaction is interpersonal. The mediated personhood of celebrities, in this sense, does not render false affective communication. Rather, changes in the physiological state of the audience render real the celebrity image. As the fruit of an affective connection, the celebrity-audience intimacy bears affective reality, the real-ness of which is sustained by the audience's felt physiological tension.[46]

This, indeed, reminds one of Väliaho's theory about cinematic affectivity, in which cinema initiates genuine body affections. As these affections nurture what Kavka has defined as affective reality, they also yield dormant tendencies for actual actions. In the construction of the celebrity-audience relationship, dormant tendencies as such point to the possibility of audience intervention. The intervention, however, does not fully come into play until computational-networked communication prevails. Within the strict context of televisual communication, the affections, or the physiological tension generated via the operation of televisual technology, remain by and

45 Teresa Brennan, *The Transmission of Affect* (Ithaca and London: Cornell University Press, 2004), 68-72.
46 Kavka, *Reality Television*, 37-8.

large inward with regard to the building of celebrity-audience intimacy.[47] Consequently, the physiological tension that is genuinely felt as a result of television viewing subsists as a *bodily virtual*, to follow Brian Massumi.

Analogous with that which Väliaho terms body affections, the bodily virtual is theorised by Massumi in contrast to the bodily actual, which one finds in perceivable outward actions. The bodily virtual, on the other hand, is marked by the potential for generating action. It is a state of restlessness contained within the body as an 'activity prior to action', an environment-informed inward tension that is yet to translate into outward acts.[48] Read in these terms, the realness of television-mediated intimacy, as proposed by Kavka, is built upon a bodily virtuality that is capable of turning into actuality.

Acts of Acknowledgement

Since the second half of the twentieth century, the relationship between virtuality and actuality has featured prominently in critical reflections upon media and mediation. Jean Baudrillard pioneered such criticism in his seminal article 'Simulacra and Simulations', which apocalyptically negated actuality outside sign-constructed and media-aggrandised virtuality. The bodily virtuality that buttresses Kavka's affective reality foregrounds a rather specific dimension of media-aggrandised virtuality. Pertaining as

47 This is obviously not to say the audience would not as a result of television viewing *act* to try furthering the intimacy.

48 To clarify the notion of the bodily virtual, Massumi analyses Stelarc's performance in which the Greek-Australian artist 'suspended' his body. He quotes the following description from *Obsolete Body/Suspensions/Stelarc*, published in 1984 by Stelarc and James D. Paffrath:

> The body was contained between two planks and suspended from a quadrapod structure in a space littered with rocks. The eyes and mouth were sewn shut. Three stitches for the lips, one each for the eyelids. The body was daily inserted between the planks and in the evening was extracted to sleep among the rocks. Body participation was discontinued after seventy-five hours.

The performing body was thus 'suspended', Massumi writes, because it could not move, speak, eat, or see. In between the planks, it could also not make itself visible. 'All bodily expression was closed down', and the body was '[d]isconnected from every form of meaningful, need-based, useful function'. However, it was filled with ferment. The force of gravity acted upon it, resonated within it, and the effects of the force were 'infolded in the sensitized flesh'. The body hence received transformative energy and remained in a state of 'suspended animation'. This particular state, argues Massumi, is the primary instantiation of *affect* in the form of physiological tension. See Brian Massumi, *Parables for the Virtual* (Durham and London: Duke University Press, 2002), 105-7.

well to the effect of media and mediation, bodily virtuality does not so much underline symbolic construction as body potentialisation. To initiate virtuality as such, the force of mediation works to act upon the body and generate tendencies for action. In so doing, it enables or catalyses bodily activity.[49]

With *The Medium Is the Massage*, Marshall McLuhan (in)famously underscored and made debatable the relevance of bodily virtuality in the 1960s. The cult publication recapitulates the media scholar's core concern that media technologies exert effect upon the human sensorium through their specific materiality, regardless of the content they have been made to carry.[50] Donna Haraway in her influential 'A Cyborg Manifesto' makes a comparable observation and hence argues for an emergent system of 'world order' that is dominated by communication technologies and biotechnologies. Each of the two technologies 're-crafts' the human body and makes permeable the boundaries between the organism and the machine. With regard to communication, Haraway's major concern is the effective control over the flow of information, and she discusses the system in the following terms:

> Human beings, like any other component or subsystem, must be localized in a system architecture whose basic modes of operation are probabilistic, statistical. No objects, spaces, or bodies are sacred in themselves; any component can be interfaced with any other if the proper standard, the proper code, can be constructed for processing signals in a common language.[51]

It is on this premise that she suggests mind, body, and tool be deemed as being 'on very intimate terms'.[52]

Applicable to all communications, machine-bred bodily virtuality has in the last decade of the twentieth century found a novel, conspicuous expression in computational-networked communication. Jodi Dean compares such communication with 'traditional' mass media (i.e. cinema, radio, television, etc.) and concludes that the former works on the affective level to an ever-greater degree. The reason behind the difference, she suggests, is a phenomenon she terms 'whatever' communication. The word 'whatever'

49 Massumi, *Parables*, 124.
50 Marshall McLuhan and Quentin Fiore, *The Medium Is the Massage* (Corte Madera: Gingko Press, 2001).
51 Donna Haraway, *Simians, Cyborgs, and Women* (London: Free Association Books, 1991), 163.
52 Ibid., 161-5.

is used here in two senses. In its literal sense, it indicates 'total mediality'. Computational-networked communication constitutes 'whatever' communication simply because it promises a reflexive inclusion of 'whatever': '[A]nything can be found, said, seen on the Internet', and '[e]very aspect of contemporary life is reflected upon, criticized, mocked'.[53] In an extended sense, 'whatever' points to a specific modality of communicativity. After examining communicative activities on blogs, Twitter, and the ever-popular Facebook, Dean notes that an abundance of messages have been transmitted online with their content unattended. This is of course not to say networked communicators do not pay attention to exchanged messages. However, splitting a message into content and contribution, Dean observes that a great deal of attention in computational-networked communication has been paid to contribution.[54] That is, the fact of a message being sent has now outweighed the content of the circulated message. This marks computational-networked communication as an affective 'whatever' communication since in vernacular conversation, Dean contends, 'whatever' functions as a response that neither accepts nor rejects a communicated message. Instead, the response leaves the content of the message received but unaddressed, and 'distills the message into the simple fact of *utterance*'.[55] As much as a 'whatever' response may fail to register the content of communication, it does affirm the fact of utterance. So does 'whatever' communication acknowledge the *affective efforts* to accomplish information transmission.[56]

Thus, Dean maintains, when computational-networked communicators post, bookmark, forward, and comment, they are very much caught up within 'communication for its own sake'. This means the communicators are affectively, and actively, engaged in communicative activities where the cause and effect of communication pertain more to physiological tendency than to the attainment of 'symbolic efficiency'.[57]

Dean's analysis as summarised above critically foregrounds the use of bodily virtuality within the specific context of computational-networked communication. For the particular communication to reach full function, it is indeed essential that the communicators involved be constantly propelled into actions that facilitate the uninterrupted circulation of information.

53 Jodi Dean, *Blog Theory* (Cambridge: Polity Press, 2010), 74.
54 Ibid., 101-2.
55 Ibid., 68, emphases added.
56 Ibid., 68-9.
57 Ibid., 77.

Consequentially, the requisite affective efforts (to post, bookmark, forward, comment, etc.) underline the 'corporeal' aspect of the communication. Meanwhile, the human organism acquires its 'machinic' quality, being prompted relentlessly to advance the circuit of information. A machine-organism assemblage as such entails obvious transmutation of inward bodily virtuality into outward bodily actuality. To sustain the flow of communication, the effect of computational-networked mediation must ideally exceed the generation of sheer inward physiological tension.

This explains why, more than two decades after the Internet first emerged, computational-networked communication remains pretty much attached to the physicality of the flesh. This is even more so if one considers recent developments in computer and video gaming. Networked console devices such as Wii or Xbox are products of a painstaking endeavour to engage bodily agency. Their design, in fact, pursues full, immediate completion of the cycle of sensorimotor communication, that is, a smooth, instantaneous transmutation of communication-evoked physiological tension into tension-catalysed physical action. The imaginary quality once so grandly attributed to the Internet, which promised an escape from the constraints imposed by the flesh, has proved false. Far from excluding the participation of the human body, computational-networked communication has necessitated bodily action to confirm the relevance of its mediated message.[58]

This last point distinguishes computational-networked communication as a means of enabling intimacy between the audience and the celebrity. Through official websites, personal homepages, blogs, Twitter, or Facebook, the eager involvement of celebrities in computational-networked communication has, in recent years, arguably enhanced the possibility of celebrity-audience intimacy. The enhancement results partly from the fact that celebrity journalism nowadays is easily 're-mediated' within

58 Instances of such confirmation are readily available in the practice of online shopping. Among them, Debra Ferreday highlights the transaction of 'virtual gifts' trading. All online shopping websites, she states, trade commodities that 'do not exist' until being delivered to consumers. Virtual gift sites, on top of this, push the limit of the 'virtuality' in online transaction and trade commodities that exist only as online images. Their business 'makes visible what is implicit' in all online shopping, Ferreday claims. That is, the desire to buy outweighs the commodity in the promotion of actual consumption. The desire to buy, nevertheless, is not so much a primitive need as an affective result of communication. As virtual gift websites employ communicative strategies to affectively prompt the desire for tradable images, the value of the images peaks at the moment of actual purchase. In a similar fashion, one can imagine, actualised bodily virtuality holds the key to pinpointing the relevance of computationally circulated information. See Debra Ferreday, *Online Belongings* (Oxford: Peter Lang, 2009), 149-58.

cyberspace.[59] Exclusive and more personal information publicised on be-
half of the celebrity also helps smooth the path towards the space-time of
celebrity activities. In 'network society', nonetheless, it is the celebrity's
physical presence at the far end of the network that has ultimately changed
the terms of celebrity-audience relation.

Medium specificity considered, a networked reader/viewer is bodily
potential-ised when accessing celebrity information. A networked celebrity,
for his/her part, is no less a potentialised body in reviewing the audience's
contribution to online communication. Following Kavka's theorisation of
televisual broadcasting, the physiological potential, or the bodily virtual,
acquired can already on each side of this audience-celebrity exchange suffi-
ciently render the virtual presence of the body on the other side as real. With
computational-networked communication, nevertheless, potentialised
bodies may furthermore act, or react, to acknowledge the relevance of one
another's virtual presence. Due to the potentiality for action, various acts of
acknowledgement have emerged in cyberspace to provide a new foundation
for celebrity-audience intimacy. Likewise built upon a physiological state
that Kavka deems adequate to render real the mediated celebrity-audience
connection, computationally facilitated intimacy bears, however, an alter-
native affective reality, one to be 'intimately' mobilised, reinforced, or at
times dismissed, via actions or inactions, by the audience or the celebrity.

The Extra Episodes

According to the above-described premises, a real, action-fostered celebrity-
audience intimacy, implemented on *Miao Miao*'s official blog as a prominent
strategy for marketing, has drawn the audience and the film industry into a
collaborative relationship that restructures the mechanism of film produc-
tion. This novel relationship has emerged as a result of two discrete strings
of communicative activities, one more contrived than the other within the
context of the film's promotion. The first revolves around the marketers'
intention to eliminate the distinction between film actors and their screen
roles. The second features intensive, spontaneous interaction between the
filmmaker and the official blog's readers/commenters. The sections that
follow examine these two strings of activities respectively.

When *Miao Miao*'s official blog was launched in August 2008, 'Secret
Diaries' became the first section to be filled with content for reading. In

59 See J. David Bolter and Richard Grusin, *Remediation* (Cambridge: MIT Press, 1999).

fact, the blog was subtitled 'The Exchange Diaries between Miao Miao and Xiao Ai'. Before the film's profile was updated in October, the main female characters introduced themselves as if they had been two among numerous 'ordinary' teenage bloggers. Their blog reader-commenters also treated them as though this was the case. In response to the post where 'Miao Miao' revealed herself to be an exchange student from Japan, the blog commenters said they were very impressed by her Chinese writing skills. When 'Miao Miao' wrote in another post that she had been wondering where to go sightseeing in Taipei, the commenters replied with various recommendations. One of them even suggested she go to the cinema and see the 2008 top-grossing film *Cape No. 7*. 'Miao Miao', in return, explained how she had learnt Chinese and reported on her sightseeing journeys.

Giving the Baudrillardian simulacrum a physical form, an actor in character is a 'copy' without an original. A script character exists as 'the effect of the sign',[60] while the actor in character acts out a version of that multivalent effect. In Baudrillardian terms, the physical being of the actor cannot alter the relation a script character bears to 'reality', for reality in the age of ubiquitous mediation is either itself the effect of the sign or has been revoked by the effect of the sign. In experiential terms, however, the actor's tangible body tends to sustain the relevance of the script character's sign-constructed virtuality. Or, to push the Baudrillardian theory further, the script character's sign-constructed virtuality tends to outweigh the relevance of the actor's actual being.

In 'On the Set of *The Sopranos*', Nick Couldry confirms the probable dominance of sign effects via the analysis of his fan visit to 'the original locations', where the HBO television series *The Sopranos* was produced. Couldry points out at the outset that the tour he has taken has 'combined three spaces': the space of general tourism which introduces a real region, the space of media tourism which engages real sites of media production, and 'the imaginary action-space' within the fictional narrative, which the space of media tourism sometimes generates. Yet once his journey has begun, he observes of himself and his fellow tourists: 'what we saw of New Jersey [...] was shot through with memories [...] of narrative moments from the series'. Since there was a 'mismatch between the extreme banality of many locations [...] and the narrative significance of the fictional locations they embodied', an incisive sense of irony was shared among the tourists. Couldry and his fellow travellers' investment in 'the imaginary action-space'

60 Jean Baudrillard, 'The Evil Demon of Images', in *Baudrillard Live: Selected Interviews*, ed. Mike Gane (New York: Routledge, 1993), 141.

was nevertheless not to be spoiled. The journey went on, he writes, while they 'were looking back on the space of media tourism, from the space of the narrative'.[61]

This may well be the relationship between the audience, script characters, and actors. Straightforward evidence is available in the case of Lan, one of my focus group participants. She is a huge fan of Kang Cheng-hsing, the main character whose grief derived from unrequited love sets the melancholy tone for *Eternal Summer*. At our first focus group meeting in August 2009, Lan said to other participants' amusement that she would do everything possible to avoid information about Bryant Chang, the actor who had played Kang, so that she could keep imagining Kang in Chang's image without being disturbed by titbits of Chang's less exceptional life.[62] In this case, however, the outweighed 'tangibility' of Chang, whose image gives shape to Kang's otherwise amorphous characteristics, is to Lan also a media effect.

Given this premise of sign-effect dominance, what then happens when an actor is from the outset introduced as a script character, and a script character as embodied in the actor? Will the relevance of the actor be equated with the relevance of the character? Or will the (sign-constructed) virtuality of the character transform the (mediated) tangibility of the actor? How might the audience relate to this actor-character?

One would think the blog reader-commenters' misrecognition of Miao Miao (and Xiao Ai) as more than a script character has resulted from the marketers' effort to 'make believe' and conceal the intention of marketing. In direct contradiction to such an assumption, however, all reader comments appeared after mid-October, that is, after the film's profile had been updated on the blog and the film had started receiving press coverage. Although the lack of efficiency in information transmission might have partly accounted for the situation, a closer look at the reader comments also suggests that the reader-commenters' recognition/misrecognition was multilayered rather than simply misled.

A relatively simple case presents itself in the comments by a reader-commenter named 'rest80526'. His/her first comment posted on November 2, 2008 showed s/he already knew Miao Miao was a film character. Yet the character's diary posts on the blog had confused him/her. Hence s/he asked, 'Are you Miao Miao for real? I didn't know you're an exchange student. How

61 Nick Couldry, 'On the Set of *The Sopranos*', in *Fandom*, eds. Jonathan Gray, Cornel Sandvoss, and C. Lee Harrington (New York: New York University Press, 2007), 143-4.
62 Lan, focus group discussion, August 2, 2009.

come you are writing in Chinese?' After 'Miao Miao' replied that she had learnt Chinese from a young age, rest80526 said on November 14, 'So there is a real Miao Miao, who's an exchange student here. Just like the movie!'[63]

Another reader-commenter 'pei' posted his/her first comment on October 30, 2008. In response to Miao Miao's self-introduction that she was an exchange student from Japan, pei said,

> I surely will go and see your film in the cinema. I've seen *Drifting Flowers* six times in the cinema, so there's no reason to miss yours. Back in high school, I had a schoolmate from Japan as well. She spent all three high school years with us. Not like you. You will only be here for a short semester. Xiao Ai should want to say to you, 'Will you stay? Or will you take me with you?'[64]

Later on the same day, pei replied to Xiao Ai's confession in which the teenage character said she had found Miao Miao very charming and wondered if she would succeed in befriending her. Obviously addressing Xiao Ai rather than the actress Chang Yung-yung, pei wrote, 'I think you should venture to pursue the girl you're attracted to. Don't miss out now and regret it later'.[65] Then, on November 2, s/he responded to Miao Miao's question about sightseeing in Taipei, proposing, 'Why not head to the cinema and see a film? In Japan, do you have ornate theatres of a thousand seats? Have you seen *Cape No. 7* yet?'[66]

There is the possibility that pei, like rest80526, favoured a realist logic and therefore concluded from the information given that Miao Miao and Xiao Ai might have been 'actually' existing people since they had been 'real' enough to answer all the questions posed to them. In addition, since the 'real' Miao Miao and Xiao Ai bear considerable resemblance to the film characters, it might well be the case that the characters had been based on them. Hence when commenting on Miao Miao's and Xiao Ai's blog posts, s/he would have little discomfort in addressing the two girls both as real-life figures and as cinematic characters. As s/he wrote in reply to Miao Miao 'I will surely go and see your film in the cinema', s/he could have simply meant 'I will surely go and see the film based on your stories in the cinema'.

63 http://miao.pixnet.net/blog/post/22058156, accessed May 22, 2013.
64 Ibid. *Drifting Flowers* is a Taiwan queer romance film by Zero Chou, released in August 2008. 'Will you stay? Or will you take me with you?' is a popular quote from *Cape No. 7*.
65 Ibid.
66 Ibid.

Yet pei's comments could also be the product of his/her capitalising on the opportunity to communicate at once with the actors and the characters. The comments indicate neither acceptance nor rejection of the possibility that the actors and the characters are interrelated. Rather, they give a sense of ambiguity that does justice to the marketing tactic's potentiality.

The 'Secret Diaries' section on *Miao Miao*'s official blog prompted a liminal situation in which the distinction between the actors and their screen roles had been eliminated.[67] The implication of such elimination is multiple. In cases like that of rest80526, the elimination of the actor-character distinction causes the screen characters to be considered biographical. Nevertheless, in others the elimination suggests the distinction stops communicating significance. I would argue the latter in pei's case.

Pei could have recognised Miao Miao and Xiao Ai as script characters but treated them as if both had been real-life figures. S/he could also have believed Miao Miao and Xiao Ai were more than the effect of the script and for that reason responded to the trivia of their daily lives. In addition, discrete modes of awareness might have functioned alongside one another, so pei would in one single comment address the actress first and then switch the address to the character. Which (if any) of these conjectures would match pei's mentality does not matter. Above all, the blog's contrived operation has allowed the reader to variously and variably position him/herself in relation to the actor, the character, and the actor-character. In different terms, the blog has potentialised the reader to act or react flexibly to given messages. The flexibility then potentially gives rise to a range of celebrity-audience intimacies.

By commenting on Miao Miao's 'secret diaries', for instance, pei actualised the bodily virtual that had emerged as a result of his/her blog accessing. In so doing, s/he would have as well acknowledged the relevance of Miao Miao's virtual presence and reinforced the realness of their intimate connection. But the virtual presence acknowledged is multivalent. It could refer to the leading actress Ke Jia-yan, the script character Miao Miao, the leading actress Ke Jia-yan who had inspired the script character Miao Miao, the script character Miao Miao who was incarnated by the leading actress Ke Jia-yan, the leading actress Ke Jia-yan who was equated with the script

67 In a sense not necessarily preferred in the context of this discussion, the elimination could only be possible in a playful manner. For before *Miao Miao*, both Ke Jia-yan and Chang Yung-yung had acted in other less heavily marketed local films. Since their photos appeared alongside the diary posts on *Miao Miao*'s official blog, their respective mergence into Miao Miao and Xiao Ai might have proved less convincing to some of the film's potential audiences than to others.

character Miao Miao, and many more. As a blog reader and commenter, pei could have consciously or unconsciously shared intimacy with a subject whose identity is multiple and mutable. It is no wonder that when addressed, the subject would often appear indefinite and unstable.

Thus, the marketing tactic employed for the 'Secret Diaries' elicits manifold investments in the celebrity-audience relation. Ideally, each time a reader actualises communication-evoked bodily tension, the actualisation leads to investments in both the actor-audience relation and the character-audience relation. Each is subject to variation, according to the level of their interrelation. At the risk of corroding the relevance of the actors, this two-fold/manifold connection between the audience and the celebrity, sustained by the sensation of intimacy, allows the reader-commenter to participate in the marketed film's production. This is because the ambiguous presence of the actor-character renders each online conversation with the reader-commenter a potential extension to the story of the script character or the actor-character. After reporting on her sightseeing journeys on the blog, for example, 'Miao Miao' would have supposedly been to Tamsui, The Riverside Park, The Shilin Main Presidential Residence, and other tourist attractions in Taipei, following the suggestions made by the reader-commenters.[68] Like other narratives that are facilitated by reader-commenters and assist the development of actor-characters, 'Miao Miao's' travel narratives constitute *extra episodes*, which the marketed film can be easily connected to but will never include. The reader-commenters would, however, *live through* the production of these episodes in a way that is comparable to how film productions have been experienced by a production crew. This is the case as the reader-commenters' participation through computational-networked communication is also genuinely affective and perceptibly active.

What is more, since the content of the extra episodes has stemmed from the intimate interaction between a reader-commenter and the actor-character, the episodes could turn the marketed movie into a subsequent addition to the reader-commenter's own memories. Here emerges a pronounced example of the art-life relationship conceptualised in regard to the Rancierian 'aesthetic regime', where experience tends to be highly aestheticised as life and art progress intertwined. This connection explains why the reader-commenters would likely be drawn to the marketed movie, and hence pins down the potential effectiveness of the marketing strategy deployed.

68 http://miao.pixnet.net/blog/post/21994335, accessed May 23, 2013.

Q&A's Virtual Doubles

After being officially released on November 14, 2008, *Miao Miao* nonetheless grossed only NT$ 770,000 ($ 26,550) in Taipei over its first weekend. 'Project managers from both Jettone Films and Warner Bros. Taiwan dropped their jaws', Cheng Hsiao-tse remembered.

> By then, they knew it could not be helped at the box office anymore. It was I that would not let go. I thought *Cape No. 7* would not have become the highest-grossing Taiwan film ever if Wei Te-Sheng had not relentlessly engaged himself in Q&A tours. Naively, I felt confident the same strategy should also work well for us. Warner Bros. Taiwan did not agree but yielded to my zeal anyway.[69]

Hence as of November 21, Cheng set off on his Q&A tour. Until *Miao Miao*'s screening period ended on December 11, he attended three on-campus promotional events and twenty-two post-screening Q&A sessions in three different cinemas around Taipei.[70]

About the same time, Cheng also began responding to every reader comment that was addressed to him on the official blog. He compared his devotion to computational-networked communication with his dedication to Q&A tours and explained:

> At Q&A sessions, I strove for the effect that a few among the audience would end up writing on their personal blogs about their experiences at the sessions. Or, I endeavoured to make an impression, so some among the audience might at least bother talking to their friends about my movie. The online communication usually took the form of one-on-one interaction. But I hoped the impact would expand its reach in cyberspace. I aspired to touch those who had not seen the film, and always kept my fingers crossed that once they had read my comment replies, the film might suddenly become of interest to them.[71]

69 Cheng Hsiao-tse, Skype interview, March 5, 2011.
70 Actress Chang Yung-yung joined him at all three on-campus events and most of the Q&A sessions taking place in November.
71 Cheng Hsiao-tse, Skype interview, March 5, 2011. By 'one-on-one interaction', Cheng meant that in his replies he would address each commenter and respond to each of his/her comments separately. The networked communication between him and his blog reader-commenters was open for public viewing but never took the form of group discussion. In fact, Cheng's reader-commenters hardly reacted to one another's contribution.

To a certain extent, the result of Cheng's efforts met his expectations. Some who attended the Q&A sessions did blog about the film or recommend it to their friends. This could only become known because a number of those who had helped advertise *Miao Miao* after attending Cheng's Q&A sessions turned into the most enthusiastic commenters on the young director's blog post. Through commenting, they usually were eager to publicise their personal involvement in the film's promotion.[72]

A quick browse through the comment pages may be sufficient for one to notice the close connection between the Q&A sessions and the networked interaction. The majority of the comments addressed to Cheng, all posted in response to the blog entry 'Something About *Miao Miao*', appeared after November 21, 2008, that is, after Cheng had started his Q&A tour. Most first-time commenters specified which particular Q&A sessions they had participated in. Often, they would even give specific descriptions about what they had done, said, or asked at those sessions, so as to remind Cheng of who they were. Many of them kept returning to the cinema, saw the film over and over, took part in the post-screening Q&A sessions, and came back on the blog to report on their observations, reflections, and feelings.

Explaining the motivation behind his repeated attendance at Q&A sessions, the reader-commenter PoninG underlined his emotional attachment to the film. He wrote in his comment posted on November 28, 2008 that

[...] *Miao Miao* has reminded me of my school years – all the ended friendships, lost love, and other occasions of farewells. It has made me want to go back to the past, even though I know it is not possible. Every time I left the cinema and returned to the real world, I would treasure the present more. As I am writing now, I feel like seeing the film again.[73]

Other reader-commenters, on the other hand, were more conscious of the relevance of post-screening Q&A sessions. Two of them, for instance, posting on November 29 and December 3 respectively, stated:

Tomorrow!!! I will attend one of the three '+Q&A' screenings tomorrow and see *Miao Miao* for the fourth time [...] I just want to be there to

72 In the end, nevertheless, *Miao Miao* attained a final box office toal of NT$ 2,320,000 ($ 77,330) in Taipei. See Regina Ho, 'Review of Box Office of 2008 Taiwan Films', in *Taiwan Cinema Year Book 2009* (Taipei: Chinese Taipei Film Archive, 2009), 100-8. The meagreness of the box office gross indicates the tension between intensive affective labour and efficient economic value production, which I will address in Chapter 6.
73 http://miao.pixnet.net/blog/post/22390134/2, accessed May 23, 2013.

support director Cheng, Chang Yung-yung and Ke Jia-yan [...] *Miao Miao* is a touching film. But what had touched me even more were the director's and the actors' effort, and the stories they shared about what had happened behind the scenes. Director Cheng and Yung-yung, you've both been working so hard!!![74]

To participate in *Miao Miao*'s Q&A events is what I am into now [...] I don't want to miss anything you would say about your film. Besides, I would like to applaud you wherever possible, to show you my support.[75]

In return for the reader-commenters' enthusiasm, Cheng also managed to remember quite a few frequent attendees. Thus in his comment replies, he regularly encouraged them to converse with him in person after each Q&A session.

Intimacy in celebrity-audience relations is undoubtedly featured in this case as the primary marketing strategy. Rather than merely constituting a product of mediation, the intimacy was also encouraged within the context of physical, interpersonal communication. What is intriguing, however, is the way in which Cheng's most enthusiastic reader-commenters were keen to embrace his virtual presence, even if repetitive participation in the Q&A sessions had earned them a good opportunity to enjoy Cheng's physical presence. How did Cheng's physical presence fail to eradicate the relevance of his mediated virtual presence if intimacy is a primitive sensation that springs from physical, close-distanced interaction? I would argue networked interaction here serves as an extension of face-to-face Q&A sessions.

The extension may appear most obvious where the event attendees, via blog commenting, posed questions they had not been able to bring up during the Q&A sessions. When so doing, some apologised for the fact that the questions only occurred to them after they had left the events. Others regretted that the limited event time had not allowed them to satisfy their curiosity. Either case could at first glance suggest computational-networked interaction with Cheng was instrumental, a viable remedy for the unfulfilled promise that Q&A sessions answer the audience's need of elucidation. Ironically, it would only take a second glimpse to unveil the situation that the more eager the reader-commenters were to attend Q&A

74 Posted by Wing, http://miao.pixnet.net/blog/post/22390134/2, accessed May 23, 2013.
75 Posted by Gu Dan Fei Sing, http://miao.pixnet.net/blog/post/22390134/2, accessed May 23, 2013. Although the comment was addressed to Cheng, the second-person pronouns in the sentences are plural ones, referring to Cheng and the actress Chang Yung-yung.

events repeatedly, the more frequently they would return to the blog with additional questions. This indicates that reader-commenters did not engage with the networked interaction only for further enquiries, since they could always have their questions answered at the next event they attended. Rather, they engaged in order to release and reveal the 'virtual' that had been generated by a Q&A event's 'actual'. Or, they engaged to communicate what had been conceivable or experience-able but not outwardly perceptible on the occasions of Q&A sessions.

Additional questions constitute just one example of the revealed virtual. What is more common in the reader comments are descriptions of 'feelings' inspired at Q&A sessions. In some cases, the feelings were expressed by succinct exclamations. Siao Wun, for instance, wrote on November 24, 2008:

> Director Cheng, you are such a nice guy!
> You rarely repeated yourself at Q&A sessions.
> Those sessions were marvellous! Well done![76]

In other cases, the feelings were conveyed self-reflexively. As Wing commented on November 28, after s/he had seen *Miao Miao* for the third time:

> Having seen the film and participated in the Q&A sessions for so many times, I've come to know many scenes had been cut from the movie. Although to edit is to present a film in its best version, cutting is much to the regret of the director, the actors, and the crewmembers. I am eager to know about every cut scene. Yet once I get to know about them, will I still relate to the film as much as I did? I am struggling with mixed feelings.[77]

With different sensibilities, Gu Dan Fei Sing also confessed on December 2 that:

> On recalling the university years, you seemed a little emotional. Did you shed a few tears, director? On your face and in your eyes, I saw true enthusiasm for filmmaking [...] I envy you having the chance to pursue your dreams![78]

76 Ibid.
77 Ibid.
78 Ibid.

These linguistic renditions of the reader-commenters' 'inward activities' often mingled with selective delineations of what had 'actually' happened at the corresponding Q&A events. Cheng, who also divulged feelings aroused at the events, would supplement the delineations in his replies.

These 'actual' online exchanges require fostering from affective responses engendered at Q&A events. They highlight, then again, the distinctive use of the Internet in buttressing full completion of the cycle of sensorimotor communication. Where the physiological tension evoked by face-to-face contacts cannot be entirely and immediately converted into tension-catalysed physical actions at Q&A events, the medium serves as a convenient means of channelling the residual tension into acts of mediated communication.

Ultimately, the expressed feelings and the event descriptions built up unfamiliar *virtual doubles* of Q&A sessions on *Miao Miao*'s official blog. They would appear unfamiliar because the doubles contain excess information about the events. These doubles are by nature virtual because the excess information contained is not about the outwardly actual at the events but also because the doubles exist as 'the effect of the sign' in cyberspace.

Thus, Cheng and his reader-commenters documented their common participation in Q&A sessions. The documentation, in creating unfamiliar virtual doubles of the events, provides 'behind-the-scenes' narratives when exposing and foregrounding the outwardly imperceptible dimension of Q&A sessions. Buttressed by computationally mediated intimacy, a sense of *togetherness* could have emerged to render irreplaceable the networked communication, in comparison to face-to-face interaction. After all, to be close to Cheng in his physical presence at a Q&A session was to support a director as an audience member when the director industriously shared 'behind-the-scenes' secrets about his works. To be close to Cheng in his virtual presence within cyberspace, nevertheless, could be to take one step further on the path of the filmmaker-audience relationship – that is, to produce, as a colleague of the filmmaker's, 'behind-the-scenes' stories of Q&A sessions.

Collaboration on Production

In *Production Culture*, Caldwell specifies 'producers-as-audience' and 'producer-generated-users' (PGU) as prominent phenomena in the current operation of media industries. The 'producers-as-audience' phenomenon is witnessed where industrial practices 'work to merge audience identification

with industrial identity'. It is noticeable especially when producers base product/production designs on personal experiences of media consumption or when production personnel circulate professional knowledge publicly.[79] The 'PGU strategies', on the other hand, encompass diverse practices within which media producers seek to 'perpetuate production's conceptual frameworks *as* viewing frameworks'. These include deliberate exposure of the 'making-ofs' or the 'behind-the-scenes', and lead to active employment of various media formats for viral marketing.[80] To elaborate the latter category, he writes,

> The widespread network/studio practices [...] of planting faux personal videos by 'fans' on MySpace.com and YouTube.com in order to virally market forthcoming features, or of harvesting antagonistic personal video 'mashes' on the same sites as part of 'anti-marketing' campaigns, provide merely the latest evidence [...] Producers generate faux-amateur content, buy and distribute amateur content professionally, provide on-line learning in film/video aesthetics, spin blogs and online discussions, spoil ostensible show secrets as stealth marketing, snark and defame competitors, pose as fans, award fans, and *are* fans.[81]

This indicates that media practitioners nowadays have learnt to incorporate reflexively the perceptions and communicative habits of the audience. Not only this, but they have also intentionally engaged the audience to interpret or understand media from the perspectives of the industry when they carry out product designs and marketing campaigns. Both actions work to 'desegregate professional and audience activities'.[82]

Blog film marketing, as analysed above, demonstrates several features that Caldwell has specified of the industry-audience desegregation. Firstly, blog campaigns require film practitioners to mobilise the blog medium in a way the audience has already done, so as to concomitantly achieve a contrived outcome. Besides, blogs circulate 'behind-the-scenes' and 'making-ofs', serving as platforms for industry insiders to disclose details about the film business. Yet instead of identity fusion or framework exchange, my case study underlines a desegregation that is marked by affective participation in collaborative (value) production.

79 Caldwell, *Production Culture*, 334-6.
80 Ibid., 336-8, emphasis in original.
81 Ibid., 338, emphasis in original.
82 Ibid., 333.

I have argued in relation to *Miao Miao*'s marketing campaign that the blog interface enables audience participation in film production. As blog reader-commenters, (potential) audiences either add extra episodes to the promoted movie or formulate 'behind-the-scenes' narratives for face-to-face Q&A sessions. Such participation comes as the consequence of blog-mediated celebrity-audience intimacy, which is implemented as the film's primary marketing strategy. Following industrial initiation, both the audience and the film industry (represented by individual celebrities) have engaged blog communication affectively to build up an intimate connection with each other on the basis of sensorimotor communication. Due to this affective engagement, blog-mediated celebrity-audience intimacy bears a certain reality. For the same reason, the intimacy-facilitated audience participation in film production is comparable to professional film production.

Not only does the participation render Internet-mediated intimacy irreplaceable and autonomous, but it also distinguishes intimacy as an authentic means of industry-audience desegregation. As the product of a marketing campaign, the specified audience involvement is potentially capable of augmenting the value of the promoted movie. As a result, the affective audience participation in film production is rather genuine. Like professional filmmaking, it contributes to *value generation* and therefore constitutes a case of prosumption. In this sense, intimacy-oriented blog/Internet marketing has fruitfully or un-fruitfully turned film (value) production into audience-industry collaboration. Not unlike the (genre) filmmaking discussed in Chapter 4, it has on the basis of this premise also rendered the industry-audience connection a biopolitical mode of power relation, which sees the film industry mobilise the audience's bodily capacities for value production. In the next chapter I will discuss the power dynamics in the industry-audience relationship as outlined above.

6 Indeterminacy

Control and the (Un)productive Body

In Chapter 4 I have argued that film production is in essence affective film prosumption. Chapter 5 has also associated the practice of blog film marketing with affective investment, and concluded that the audience and the film industry have, via the mediation of the Internet, collaborated on film value production. In this chapter, I will discuss further the execution of film marketing in relation to online activities, so as to clarify how and what 'value' has exactly been produced as the relationship between the film industry and the audience transmutes through the prosumption that has prevailed. This enquiry has been conducted in order to answer the related questions of consumer exploitation and capitalist domination. Acknowledging the inevitable power dynamics, I aim to address the issue as to whether participatory communication has dragged film audiences into deeper submission to industrial manipulation.

As the chapter unfolds, I will argue with regard to film marketing in twenty-first-century Taiwan that labour within or without the film industry has undermined the late capitalist control by being ambiguously conducive to capital reproduction. This is because both late capitalism and labour have, in the late capitalist economy, become dubious factors of indeterminacy. Only when determinable and thence determined will they prove productive to the overall economy.

This argument developed in the summer of 2010, when during an interview with Cimage's executive director Helen Chen, I happened to witness an incident marked by such indeterminacy. It was a usual weekday morning in Cimage's undersized office. The film distributor who had marketed Hou Hsiao-hsien's *Café Lumière* (2004) and the well-received documentary film *Let It Be* (Yan Lanquan and Zhuang Yizeng 2005) was then busy selling a high-school-targeted curatorial package of recent Taiwan films.[1] Its small

1 Hou directed *Café Lumière* for the Japanese film studio Shochiku as a homage to Yasujiro Ozu, with reference to the late director's *Tokyo Story* (1953). The plot revolves around Yoko Inoue and her relationship to her family. Young and single, Yoko is pregnant but unwilling to reveal the identity of the baby's father. *Let It Be* is a documentary film about the lives of several happy-go-lucky farmers in Tainan, Taiwan. It grossed NT$ 4,257,370 ($142,000) in Taipei and was the top-grossing locally made documentary of 2005. See Wang Cheng-hua, 'Review of the Film Market in 2005', in *Taiwan Cinema Year Book 2006*, http://www.taiwancinema.com/ct_54271_219, accessed September 12, 2013.

group of employees started off the day's work by checking the results from an online audience survey conducted by Yahoo! Taiwan. Designed like a fun quiz, the survey was intended to indicate 'the most anticipated locally made films [and] the most attractive local actors' of the summer. With local pop idols starring in them, it was expected that romantic comedies such as *Close to You* (Cheng Hsiao-tse), *In Case of Love* (Lin Hsiao Chien), *Love You 10000 Years* (Toyo Kitamura), and *Love in Disguise* (Leehom Wang) would top the 'most anticipated film' list.[2] Their respective male leads, Eddie Peng, Tony Yang, Vic Chou and Leehom Wang, meanwhile, were voted the most attractive actors. A surprise, nonetheless, was *Mr. Bedman* (Dai Tai Lung) – the relatively low-budget comedy, casting a commercial comic actor as its lead, landed the second-place position on both lists.[3] Bewildered, Cimage's in-house marketers could not wait to interrupt my interview and update Helen Chen on the astonishing news. As Chen asked to be shown the survey result page, my instantaneous reaction to the reported news was one of suspicion. 'I would not take the statistical figures too seriously', I ventured, 'I myself mess around with online surveys all the time'. 'But you never know', was Chen's answer on the spot. 'The market changes from day to day. To catch up, I must take the possibility into account that young people's taste in films could suddenly mutate into something beyond my comprehension', she later explained.[4]

Mr. Bedman, as it happened, did not manage to sell.[5] The survey results that took the Cimage office by storm pointed to a false possibility and brought to light a marketer's predicament regarding the probable misreading of online information. If the risk of misreading suggests the incapacity *to read and to (re)act* properly, it certainly typifies a control-seeking capitalist system's ultimate restriction. It points to the pending exercise of capitalist power, which in the late capitalist economy depends to a considerable extent on proper mobilisation of affective labour. This inefficiency in the late capitalist control brings into sharper focus the role of the body in mediating

2 All four movies listed are about young people in love. *Close to You* is set in a university boxing club. *In Case of Love* tells the love story between an art school student and a rock musician. *Love You 10000 Years* is about a rock musician who hires a contracted girlfriend but ends up falling in love with her. *Love in Disguise*, directed by singer-songwriter and former pop idol Leehom Wang, tells the story of a famous singer who conceals his identity in order to pursue a music student in university.

3 The comedy is set in 2008, against the backdrop of the global financial crisis. The story is about the absurd extra-marital affair of a shy and unlucky bed salesman.

4 Helen Chen, personal interview, August 3, 2010.

5 The film grossed approximately NT$ 700,000 ($ 23,000) in Taipei. See http://blog.yam.com/fa88/article/41139917, accessed July 26, 2012.

the industry-audience relation, given, for example, that entering, accessing, and (re)acting to online surveys all necessitate affective investment, according to the argument put forward in Chapter 5. It casts light on the active unproductivity intrinsic to the potentially productive body, which features so prominently in Internet film marketing via affectively engaged communication.

Moving away from the incident witnessed at Cimage, the remainder of this chapter analyses a late capitalist industry's struggle for economic value production. Evidence of the struggle will be located in post-2000 Taiwan film marketing and developed with the assistance of computational-networked communication. Through the analysis, I present the Taiwan film industry's arduous journey into capital reproduction. The argument weaves together studies of distinct schemes, by means of which the film industry attempted but failed to control value production. Following the same line of enquiry, I will also interrogate the vision of a body-based social revolution.

Participatory Productivity

As Joshua Green and Henry Jenkins observe, in the past couple of decades the Internet medium has facilitated various industrial activities, such as monitoring audience response, incorporating individual or collective insight, generating public awareness, consolidating audience identification, identifying potential markets, prolonging product lives, and recruiting new talent.[6] While all these aspects contributed to the revitalisation of the Taiwan film industry in the 2000s, to many local film marketers, computational-networked communication first of all – and at a very basic level – serves as an open field for information exchange. Rachel Chen, the project manager of *Miao Miao*, once celebrated the medium for its particular promise in this regard:

> With online information flowing at an unprecedentedly high circulation rate, market survey nowadays is as good as a piece of cake. Just about a decade ago, market-related details were so strictly protected that one must be ready to kill for simple box office numbers. Even the Theatre Association would sometimes publish confusing artificial box office results. But now, all one needs to do is get on the Internet, and the

6 Joshua Green and Henry Jenkins, 'The Moral Economy of Web 2.0', in *Media Industries*, eds. Jennifer Holt and Alisa Perren (Wiley-Blackwell, 2009), 216-9.

@Movies website has all the most up-to-date figures for reference [...]
On the other hand, once you get a grip on the composition of the PTT
regulars, you have no difficulty observing the particular group's reception
of most film productions.[7]

The enhanced information flow also improves the circulation and produc-
tion of promotional materials. As senior film marketer Steve Wang has
suggested, immediate, intensive, and in-depth communication to potential
audiences has been at individual marketers' disposal more than ever since
the emergence of cyberspace.[8] It is on the basis of such communication
that the industry-audience intimacy, featured in Chapter 5's discussion, has
been implemented as a marketing strategy.

Prior to the prospering of Web 2.0, and despite the ongoing debate over
the Internet's actual capacity for 'user interactivity', marketers have realised
through personal experiences that the main advantage of computational-
networked communication lies in the potentiality of 'user participation'.
This is especially the case in successful viral advertising. *Eternal Summer*
marketer Patrick Mao Huang clearly observes the same:

> Seldom will one bother to ring ten or more friends about an impres-
> sive film trailer s/he happens to see on television [...] Yet at discovering
> something online, whether it is funny, scary or moving, one would most
> likely share it via forwarding, commenting, or any other actions s/he is
> allowed to take by the website's configuration. A single viewing [of a web
> page] might hence lead up to numerous viewings [...] so long as the web
> page's content manages to make an impression.[9]

As analysed in Chapter 5 with regard to *Miao Miao*'s blog marketing, in
addition to increased exposure, loosely guided online interaction between
film practitioners and general Internet users also adds value to films.
Measurable or not, the positive effect of involving the online population
has been so widely noted that *Eternal Summer* director Leste Chen claimed

7 Rachel Chen, personal interview, August 24, 2010. The 'Theatre Association' refers to Taipei
Theater Association. The *@Movies* website can be accessed at http://www.atmovies.com.tw/
home/. Founded in 1995, PTT has been the largest Bulletin Board System (BBS) in Taiwan (with
more than 1.5 million registered users), and so far the most popular among young adults.
8 In Su Wei-ling, 'The Study of Taiwanese Movie Blog Marketing' (Master's thesis, National
Taiwan Normal University, 2009), 182.
9 In Su, 'The Study of', 188.

in our personal interview that 'Productive film promotion now generates participation'.[10]

Nevertheless, in practice the Internet's foremost strengths are bound up with its greatest weaknesses. As Patrick Mao Huang has stated, one of these weaknesses concerns the very difficulty in generating participation:

> An advertisement may impose itself, with subway billboards targeting random travellers, television commercials seducing couch potatoes, etc. Where we invest in [traditional] media buying, we have a chance of forcing attention. Internet communications are, however, less forcible. They require very high degrees of spontaneity.[11]

To cross this fundamental threshold of spontaneity, efforts must be made to entice potential Internet users into online participation. Common methods include spectacular blog/web page design and emotionally charged web page content (such as intimate celebrity diaries/confessions). Popular service providers (e.g. blog service providers with huge numbers of registered users) often help bring traffic to the promotional blog/site. Otherwise, web portal advertising might prove efficacious. On the other hand, Huang admitted, traditional media buying still has the advantage of attracting fortuitous attention, which could then, by a convoluted process, result in a boost in web page viewing.[12]

I concluded Chapter 5 by arguing that Internet film marketing prompts Internet users to invest affectively in computational-networked communication. As delineated above, the methods for eliciting online participation provide further evidence of the relevance of bodily capacities. To be effective, it appears, online marketing entails a complex process of sensation evocation via spectacular blog/web page design, intimate web page content, web portal advertising, and/or traditional media buying. The seemingly 'spontaneous' actions of information forwarding and/or commenting, consequently, could in fact be the fruits of intensively regulated attention.

The affective, and active, participation thus elicited contributes to *film value generation*, which Chapter 5 argued was a collaboration between the film industry and its (potential) audiences. Both are involved in Internet film marketing via computational-networked exchange. From the perspective of the film industry, the value in question is preferably financial value,

10 Leste Chen, personal interview, August 10, 2010.
11 In Su, 'The Study of', 188.
12 Patrick Mao Huang, personal interview, August 2, 2010.

that is, profit. 'Box office receipts reflect the efficacy of Internet marketing', Rachel Chen declared unequivocally.[13]

In this regard, one could hardly read too much into the suspicious 'collaboration' online marketing helps bring about. The banal (but nonetheless true) critical diagnosis is that since the benefit of the collaboration is available to the industry, collaborative value production indicates little more than audience exploitation. Of concern here is not just the possibility that due to the prevalent appropriation of computational networks by corporations, self-submissive affective participation might doom the network-using public to stage its own entrapment by a capitalist process seeking power in ever-pervasive communication.[14] Likewise, what is worrying is that late capitalist economies have absorbed all aspects of social life. That is, the productive force of labour is exploited not only within the boundaries of industrial production nowadays, but also within the processes of social reproduction, which includes the process of consumption. Besides the case of Internet film marketing, I have also demonstrated in Chapter 4 that filmmaking is an example of productive consumption, or 'prosumption'.

It has been noted that value production is, in the present stage of capitalism, divided indiscriminately between working 'producers' and leisure-seeking consumers. In fact, with 'fun', 'pleasure', or 'play' in the workplace being promoted, even the distinction of consumption as leisure-seeking has become obsolete. The extraordinary Google office design, which has attracted media attention worldwide, is emblematic of the trend. Witnessing the existence of a music room, a gourmet restaurant, a gym, and camping tents within the technology company's Toronto office, CBC reporter Havard Gould wondered whether he had discovered 'a new way to work'.[15]

Little of the work-play distinction still holds in the face of late capitalism, as our present world experiences and mobilises consumption as production and production as consumption. It is in this context that Tiziana Terranova discusses 'free labor' against the backdrop of post-Fordism in general and the Internet economy in particular. Post-Fordism indicates 'the end of factory', she writes, and sets off the operation of 'external economies'. The theoretical rendition of external economies highlights a growing phenomenon, where 'the production of value is increasingly involving the capture of productive elements and social wealth that are *outside* the direct

13 Rachel Chen, personal interview, August 24, 2010.
14 See Dean, *Blog Theory*.
15 http://www.cbc.ca/player/News/TV+Shows/The+National/Canada/ID/2304580017/, accessed July 20, 2015.

productive process'.[16] Diffuse value production, Terranova suggests, blurs the boundaries between production and consumption, which ultimately leads to a lack of distinction between labour and culture. The end of the factory, on the other hand, not only 'spelled out the marginalization of the old working class', but it also 'produced generations of workers who have been repeatedly addressed as active consumers of meaningful commodities'.[17] Culture-sensitive, these worker-consumers thus act out 'a desire for affective and cultural production'.[18] This desire by itself is an adequate extractor of free labour. To Terranova, free labour sets forth 'the moment where [...] knowledgeable consumption of culture is translated into excess productive activities that are pleasurably embraced and at the same time often shamelessly exploited'.[19] In the post-Fordist age, free labour emerges from the overlap between external economies and the worker-consumers' dedication to production.[20]

The industry-audience collaboration on Internet film marketing exemplifies the use of free labour extracted from (potential) film consumers. Unlike the prosumption in filmmaking, the problematic of this mode of film value production lies, obviously, in the consumers' contribution being 'free', unpaid, under-compensated, and hence exploited. Appropriately considered the epitome of late capitalism, Terranova states, the Internet economy exposes the way in which post-Fordism 'both sustains free labour *and* exhausts it'. Sustenance and exhaustion co-exist symptomatically in one and the same value-extracting project because productive processes are now 'not created outside capital and then reappropriated by capital'. Rather, they constitute 'the results of a complex history where the relation between labor and capital is mutually constitutive, entangled and crucially forged during the crisis of Fordism'.[21]

16 Tiziana Terranova, *Network Culture* (London: Pluto Press, 2004), 75, emphasis in original. The quote is cited by Terranova and taken from Antonio Negri's *Guias/Guides*, published in 2003.
17 Ibid., 78.
18 Ibid., 77.
19 Ibid., 78.
20 Ibid., 75-8.
21 Ibid., 94, emphasis in original.

Soft Control

In 'Value and Affect', Antonio Negri contends that 'labor finds its value in affect, if affect is defined as the "power to *act*"'.[22] In order to create and harvest value as such, global/late capitalism mobilises and utilises affect by propelling people into action. With both production and reproduction at capital's disposal, all human actions (as diverse as making saleable goods, paying attention to advertising billboards, and forwarding online messages) are economically relevant in the current economic system. Since all capacities and tendencies for action are allowed, or imposed with, the potential for value generation, to act or *to want to act* under the late capitalist regime is to perform preliminary labour and to acquire or to be endowed with value relevancy. Such is the labour-capital relation that Terranova labels 'mutually constitutive'. It shows also the extent to which the 'desire' to labour matters in the late capitalist economy.

Under these circumstances, for the fruitful mobilisation of affect, very few things would interest online film marketers more than the accurate measurement of their efforts' effectiveness. When asked what they would think of a substantial Internet marketing revolution, both Patrick Mao Huang and Steve Wang pictured the outlook for viable online activity tracking. Wang mused:

> Say, a marketing blog with an average daily traffic of a thousand viewings suddenly generated five thousand viewings in one day, what could explain it? [...] In cases like this, ideally, film marketers would like to know for sure which of their marketing strategies had affected the increase in traffic, so as to run the campaign more efficiently. On top of that, effective route tracking of each connection with the blog could further help specify the advertised film's potential audiences and their Internet usage habits. Successful online marketing relies on nothing more than accurate analysis of online activities as such.[23]

In other words, the marketers would like to map the flow of affective power, including the ways in which affective power is triggered and those through which it is channelled, since each online activity represents an affect-initiated, profit-viable action. Given the already high and rising

22 Antonio Negri, 'Value and Affect', trans. Michael Hardt, *Boundary 2*, 26.2 (1999): 79, emphasis in the original.
23 In Su, 'The Study of', 184-5.

Internet penetration rate, Huang was optimistic to suggest in respect of this mapping that powerful service providers like Google, through continuously processing user profiles and web analytics, would one day become the actual definer of modern life. With the extensive knowledge about 'what we do, what we read, what we type [...] and ultimately what we like when we engage ourselves with the Internet', Huang argued, dominant service providers would become ever capable of motivating people, influencing their behaviours, and transforming their lifestyles.[24]

Huang's sanguine vision corresponds with a governance system Deleuze ascribes to his so-called 'societies of control'. It is not accidental that in his article 'Postscript on the Societies of Control', Deleuze identifies computers to be the type of machine that matches the operation of control societies. To Deleuze, control is surveillance masquerading as freedom.[25] In a society of control, he restates the Guattarian scenario, 'one would be able to leave one's apartment, one's street, one's neighbourhood, thanks to one's (dividual) electronic card that raises a given barrier'. The correspondent control mechanism in the society is 'the computer that tracks each person's position – licit or illicit – and effects a universal modulation'.[26] The notion and practice of *modulation* distinguish control societies from the Foucauldian disciplinary societies. In the latter, it is stated, a governed subject is made to move from one space of enclosure into another, from family to school, to barracks, to factory, etc. Each of these spaces has its own laws, while all of them aim 'to concentrate; to distribute in space; to order in time' so as to eventually compose a productive force 'whose effect will be greater than the sum of its component forces'.[27] In contrast to the disciplinary environment of enclosure, control societies manage their subjects in 'open circuits'.[28] If '[e]nclosures are *molds*, distinct castings', Deleuze writes, control is a modulation, 'like a self-deforming cast that will continuously change from one moment to the other, or like a sieve whose mesh will transmute from point to point'.[29] The subject of control, instead of being regulated in confinement, is set off in an undulatory orbit, constantly motivated for

24 Ibid., 197.
25 See Wendy Hui-Kyong Chun, *Control and Freedom* (Cambridge, MA and London: MIT Press, 2006), for further analysis of the trade-off between control and freedom. Chun discusses the issue in relation to security considerations and technological initiatives.
26 Gilles Deleuze, 'Postscript on the Societies of Control', *October* 59 (1992): 7.
27 Ibid., 3.
28 Ibid., 6.
29 Ibid., 4, emphases in original.

actions and continuously tracked to assure appropriate adjustment to the self-transmuting control mechanism.[30]

If through web analytics Patrick Mao Huang has glimpsed the possibility of marketers canalising consumer behaviours for the purpose of profit making, the best-case scenario of Internet film marketing exemplifies the control mechanism in question. 'Control' craves for a tight grip on the movement of the subject, insomuch as the mechanism of modulation is obliged to self-transmutation. This explains why a good grasp of actual affect flow is essential for Internet marketers. The measure of self-deforming/transmutation must be taken with respect to the subject's (re)action. Attesting to Michael Hardt and Antonio Negri's conviction that labour today is 'a social force animated by the powers of knowledge, affect, science, and language',[31] control in Internet film marketing optimises itself when it mobilises affect via discursive, aesthetic, and technological strategies formulated with the assistance of surveillance knowledge.

Marketing campaigns implemented in a control society are nonetheless more open than the words 'control', 'grip', and 'surveillance' may imply, providing one remembers the initial strategy introduced on the official blog of *Miao Miao*. On the blog, marketers eliminated the distinction between *Miao Miao*'s leading actors and their screen roles. As a result, they allowed blog readers to communicate freely with the actor-characters and thus to negotiate their relationships to the promoted movie. Far from being prescriptive, this campaign offered an ambiguous realm for imaginative (audience) participation. It indicates that to sustain affect mobilisation via self-transmutation, control has yielded up full command in exchange for flexibility. Terranova's description of 'soft control' vividly captures the essence of this specific mechanism against the backdrop of a 'networked' capitalist society.

Terranova likens the operation of contemporary networks – computational or otherwise – to the use of cellular automata (CA) systems in biological computing. She defines the former as a 'grand mesh', a form able to accommodate all variations and mutations. Seemingly filled with randomly interrelated happenings, a CA system, meanwhile, functions in 'a multitude of simultaneous interactions performed by a potentially infinite population' of cells structured in networks. Within the system, 'every cell reacts exclusively to the state of its neighbours and it is on this

30 Ibid., 6-7.
31 Michael Hardt and Antonio Negri, *Empire* (Cambridge, MA and London: Harvard University Press, 2000), 357-8.

basis that it changes'. In this ultra-dynamics, the outcome of a CA system computation cannot be predetermined or planned in its entirety. Rather, it remains unpredictable and is susceptible to new 'useful and pleasing forms' emerging.

Not unlike a CA system, a computational network sees all sorts of changes – including variations and mutations – stem from incessant interactions. Patrick Mao Huang understood the operation as 'an unrelenting process of inter-seduction'. Elucidating the use of this process in film marketing, he said, 'Marketers who designed marketing campaigns used to attempt a strong hold on the moviegoers' feelings. Today, moviegoers seduce one another with innumerable types of exchanges that bring forth innumerable types of reactions'.[32] As a consequence, the computational network finds its most capital-benefiting productivity in dynamics-prompted, unpredictable interactions, so long as the unpredictable interactions bring about 'useful and pleasing' changes.[33] To Huang, obviously, the most productive online inter-seduction increases the desire for film consumption.[34]

The late capitalist soft control, implemented in cyberspace and/or other networks for the purpose of capital reproduction, does not in this case concern strictly programmed production of intended results. Instead, it conducts the measures to 'facilitate, contain, and exploit the creative powers' likely brought forth in unpredictable networks.[35] The gearing towards such control involves efforts at several levels. Specified in terms of CA system computations, these include the production of rules that regulate local relations between neighbouring nodes, the determination of initial conditions for system operation, and the construction of aims that sieve changes in the search for the 'useful and pleasing'.[36] Under such governance, variable networks test the capacity of control mechanisms to effectively 'mould the rules and select the aims'.[37]

It does not take much deliberation to see the irony in soft control. After all, the success of the control mechanism paradoxically depends on the same mechanism's capacity to allow uncontrollability. Keen to mobilise online participation, Patrick Mao Huang as a consequence is also alarmed at the unpredictability of networked interactions:

32 Patrick Mao Huang, personal interview, August 2, 2010.
33 Terranova, *Network Culture*, 110-4.
34 Patrick Mao Huang, personal interview, August 2, 2010.
35 Terranova, *Network Culture*, 118.
36 Ibid., 115-8.
37 Ibid., 118.

Not long ago, just in the very near past, it took at least days, or sometimes weeks, for a bad review to actually appear and wield influence after a preview screening. When it was finally out there, printed in a magazine or a newspaper, the review's circulation, however wide, was relatively limited – in theory more calculable and recipient specific. The damage was therefore also comparatively imaginable and definable. Nowadays, nevertheless, an online review could well be going round virtually at the same time as the test screening is happening. Intense discussions of the previewed film could then unfold across the web in no longer than five minutes. The promotional effect seems immediate. Yet what can you expect from those discussions? More often than not, the exchanges would unfortunately go no profounder than idle babble: 'The most idiotic film ever!', 'Real idiotic, you mean?', 'Super idiotic, like no other!', and so on and so forth. This is the demanding challenge in online marketing. Arbitrary hollow comments get disseminated in a fierce anarchy.
In the form of online discussion or otherwise, film marketing now entails persistently persuading people into participatory action [...] This alone makes a tough task, not to mention tackling the uncontrollable chaos our perpetual labour tends to end in.[38]

Within a productive network, all actions lead to more actions and nurture the requisite conditions for useful emergences. Under these circumstances, Helen Chen, who I quote in the opening section, is acutely concerned with the possibilities brought about by surprises. Each surprising emergence generated in a network indicates a possibility of beneficiality. However, for the emergence to make a genuine contribution, a capitalist control mechanism must effectively proceed with accommodation, which entails an incessant process of moulding the rules and selecting the aims. Without the process becoming a success, the control mechanism risks being overwhelmed by the dubious prospects of exploitable network interactions.

To capture the dynamics between control and emergences, Brian Massumi formulates a theory of that which he names 'determinable indeterminacies'. When social emergences appear, Massumi writes, they are perceived as 'indeterminacies' by the capitalist supersystem. To assimilate these emergences into the existing social order, the supersystem seeks the determination of indeterminacies. It would assign a 'socially recognized

38 Patrick Mao Huang, personal interview, August 2, 2010.

class' to an emergence, insomuch as the emergence turns into 'a potential market' and a 'particularized possibility for the exercise of power'.[39]

'On the formal level', Massumi concludes, 'contemporary capitalism's constituent elements are indeterminacies that are determinabilities'.[40] Since the merging of production and reproduction in late capitalism has ultimately amounted to the 'subsumption of life itself under capital', Massumi sees indeterminacies as 'the irruption of new forces of existence'.[41] This means that life is either defined as *'the power to exist'* or as 'forces of existence' and, in his formulation, is *transformed into an internal variable of the capitalist supersystem'.[42]* Life's vital forces stay 'unqualified, nonspecified' until the exercise of capitalist power 'qualifies, specifies, determines' them.[43] On the other hand, the positivity of capitalism is based on indeterminacies, whose determination makes possible the capitalist utilisation of life, or the essentially unqualified forces of existence.[44]

To function successfully as part of the late capitalist supersystem, this is to say, Helen Chen and her colleagues at Cimage, for example, must act in response to the surprising online survey results they had found on Yahoo! Taiwan. The actions these marketers were to take should determine *life*, by assigning socially comprehensible qualities to an emergence within which affective contribution from a large number of Internet users suggested the high marketability of a seemingly unsaleable movie. This way, the marketers might cultivate a predilection for peculiar films and turn into a subject of capitalist power the unusual forces of existence this predilection represents.

If the capitalist supersystem ever becomes overwhelmed by indeterminacies, however, an incomplete task of determination will conceivably hinder the creation of 'a potential market' and/or 'a particularized possibility for the exercise of power'. An overwhelmed mechanism is nevertheless not uncommon, as suggested by Huang's sense of frustration and the excitement-confusion I happened to observe in the Cimage office. Marketers do misread, misjudge, and (re)act inadequately. The inefficiency in their industrial labour crystalises the deficiency of a self-deforming system of governance. That is, to control through generation and/or determination of

39 Brian Massumi, 'Requiem for Our Prospective Dead (Toward a Participatory Critique of Capitalist Power)', in *Deleuze and Guattari*, eds. Eleanor Kaufman and Kevin Jon Heller (Minneapolis: University of Minnesota Press, 1998), 55.

40 Ibid., 58-9.

41 Ibid., 55.

42 Ibid., 55, emphases in original.

43 Ibid., 54.

44 Ibid., 54-9.

the unpredictable, it is necessary that the system first exerts 'self control' in a *determined* enactment of power relations. Since subject determination commences with self-determination, the system could falter in the face of its own indeterminacy even before (potentially) stumbling over subject unpredictability.

Marketing has become the centre of late capitalism, according to Deleuze.[45] In late capitalist marketing methods, one reasonably expects the key to the exercise of control. In a symptomatic fashion, nonetheless, twenty-first-century Taiwan Internet film marketing betrays the conundrum of control. It exposes the afflicting/encouraging fact that for all its threat and promise, control in late capitalism is, after all, contingent upon the governance system's at once compulsive and compulsory flirtation with 'out of control'.

This is the governance system that has rendered 'transcendental' politics an obsolete fiction. In late capitalism, where labour/life is genuinely subsumed under and mutually constitutive of capital, Hardt and Negri suggest, it is no longer very useful for political theories to pretend that 'the subject can be understood presocially' and then to impose on it 'a kind of transcendental socialization'.[46] The ultra-intimacy between labour/life and capital indicates the intense entanglement of the subject with control. While it has been clarified repeatedly that due to entanglement, the subject exists 'entirely within the realm of the social and the political',[47] not enough has been elaborated with regard to late capitalist governance and its reciprocal relation to the subject. Clearly, the governance system, described by Deleuze as a 'self-deforming cast', does not reside far from its subject in its subjection to modulation. That is, the system stays unqualified and non-specified until it exercises its power to qualify and specify the relational subject.

This mode of control is endeavour-economical, Terranova writes, because it 'does not require an absolute and total knowledge of all the states of each single component of the [network]'.[48] On the other hand, high stakes are inevitable since control now takes effect on the verge of randomness, the defence against which can only be conducted circumstantially and continually, in response to network dynamics in their very multiplicity. Seen in this light, the alleged late capitalist control is dictated by its own

45 Deleuze, 'Postscript', 6.
46 Hardt and Negri, *Empire*, 353.
47 Ibid., 353.
48 Terranova, *Network Culture*, 119.

operational logic. Just like the subject it seeks to control, the exercise of control also moves in an 'undulatory orbit', adjusted continuously in relation to the transmuting trajectories it may have in the first place initiated for its subject. In obtaining control and flirting with 'out of control', this means the mechanism of control is itself 'under control'. If ever effective, this destabilised control system represents, at best, a mixed blessing.

Statistical Control

In the face of uncertainty, many Taiwan film marketers in the new century have believed that the deficiencies of Internet marketing can be solved by mapping action and interaction patterns in computational-networked communications. As their producer counterparts turned to Hollywood productions for marketable generic formulae, marketers utilised statistics and the archive of cyberspace to figure out approaches that had proved efficacious in combatting unpredictability. Their attempts, reportedly, were not always worth the effort, mainly for the reason that wherever statistics and the cyberspace archive may help the marketers conquer the task of 'self-determination' and decide on executive tactics, the same methods might not assist in canalising online activities. In analysing the marketers' use of the methods in question, in the next two sections I will delineate the frustrations of their endeavours.

By and large equating valid market observation with accurate reading of statistics, Rachel Chen once claimed, 'Adequate promotional proposals have to be grounded in sensible market observation'. When disagreement hampers the progression of a shape-taking campaign, she added, 'It is all for the figures to speak. Where ticket sales matter, statistics determine the final decision'.[49] Unlike Helen Chen at Cimage, who looked at online audience surveys and was concerned with surprising emergences in her formulation of novel marketing strategies, Rachel Chen and her colleagues examined statistics, seeking patterns in past successful campaigns. In order to justify her method, Chen underlined the importance of risk management. 'This is like learning from predecessors', she explained, 'We do this to minimise the impact of probable risks'.[50]

Concurring with Chen, senior film marketer Liu Weijan was worried that problematic data collection and/or data analysis might create certain

49 Rachel Chen, personal interview, August 24, 2010.
50 Ibid.

pitfalls. In this regard, she admitted envying her Chinese counterparts, as 'the Chinese government is very meticulous in producing statistical indexes'.[51]

To exploit the strength and avoid the pitfalls of statistics, Patrick Mao Huang has looked to the application of Google's extensive knowledge about Internet users and Internet usage. As quoted above, Huang has expected powerful Internet service providers like Google to, through processing user profiles and web analytics, become ever more capable of motivating people and canalising their behaviours. His expectation has undoubtedly emanated from the assumption that having monitored 'what we do, what we read, what we type' when we engage ourselves with the Internet, the service provider is entitled to a statistically precise grip on the behavioural tendencies of general Internet users.

Unsurprisingly, Huang's anticipation matched Google's vision. Eric Schmidt, former CEO of the web search giant, first announced the company's interest in building the 'Google Serendipity' service in 2006. His early sketches of the service emphasised Serendipity's capability to 'tell me what I should be typing' when a regular Google user turns to the search engine for problem solving. Then in 2010, interviewed by *Wall Street Journal* journalist Holman W. Jenkins Jr., Schmidt further elaborated on the concept behind the new service in progress:

> Let's say you're walking down the street. Because of the info Google has collected about you, 'we know roughly who you are, roughly what you care about, roughly who your friends are'. Google also knows, to within a foot, where you are. Mr. Schmidt leaves it to a listener to imagine the possibilities: If you need milk and there's a place nearby to get milk, Google will remind you to get milk. It will tell you a store ahead has a collection of horse-racing posters, that a 19th-century murder you've been reading about took place on the next block [...] a generation of powerful handheld devices is just around the corner that will be adept at surprising you with information that you didn't know you wanted to know. 'The thing that makes newspapers so fundamentally fascinating – that serendipity – can be calculated now. We can actually produce it electronically', Mr. Schmidt says.[52]

51 Liu Weijan, personal interview, August 26, 2010.
52 Holman W. Jr Jenkins, 'Google and the Search for the Future', *Wall Street Journal*, August 14, 2010, accessed May 28, 2013, http://online.wsj.com/article/SB1000142405274870490110457542 3294099527212.html.

The utility of electronically produced serendipity lies in targeted brand/ product marketing. Due to the rapid development of smartphone and tablet PC technology, Google's exclusive access to a plethora of user information is expected to further the practice of targeted advertising. If the company did achieve its vision of electronic serendipity, a handheld device filled with 'information that you didn't know you wanted to know' from Google might make targeted advertising life-permeating, action-designating and desire/tendency-defining, provided that the involuntarily collected information induced immediate affective (re)actions that might pave the way for purchases made via handheld devices or otherwise.

Although targeted advertising as such appears individual-oriented, the ultimate trick of Google Serendipity lies ironically in statistics that efface individuality. Merely knowing 'roughly who you are, roughly what you care about, roughly who your friends are' via what you have already searched for online would not be adequate for the service to offer you 'information that you didn't know you wanted to know'. Like the widely renowned service of Amazon recommendations, Serendipity's grasp of what you may in the future buy or take an interest in stems more prominently from a statistical grip on what people have otherwise purchased since they have bought the same items as you. In other words, what the smart electronic device may know about you indicates what it knows about a large group of consumers, whom it presumes to be 'roughly' like you. Google Serendipity knows you (more than you do yourself) on the condition that your uniqueness is comprehensible through its electronic interface and translatable into a general quality of a seemingly predictable but faceless population. Ideally, via overall analytics, the anticipated service of Serendipity would manage to see through your consumption tendencies so that it could generate accurate online information to potentially instigate your action of consumption. To borrow Negri's incisive expression, a pattern-mapping project such as this is indeed 'fascinating and titanic'.[53]

If the statistical prophecy proved fulfillable, it would alleviate the distress caused by uncertainty. Yet to most online marketers' dismay, the sense of precariousness persists. In spite of all the effort put into research, Rachel Chen, for instance, declared regretfully that film marketing remains a gamble: 'I feel I must press the right button to make a complex machine work. But that particular button moves. I have no clue where to find it'.[54]

53 Negri, 'Value', 87.
54 Rachel Chen, personal interview, August 24, 2010.

Little may Chen know that her frustration is sustained by the very methodology she has considered promising. The problem with Eric Schmidt and numerous marketers' imagination, which revolves around statistics and/or Google Serendipity, pertains to the fact that, historically, statistics did not emerge to improve certainty but to enable knowledge of contingency.

Tracing the rise of modern statistics, Mary Ann Doane details the way in which statistical knowledge has displaced epistemological continuity, necessity, determinism, and reversibility with 'an emphasis upon contingency, irreversibility, discontinuities, and probability'.[55] This transition originated from the scientific efforts of the nineteenth century to reconcile the contradiction between Newtonian dynamics and the Second Law of Thermodynamics. Despite the Newtonian insistence on reversible time, the Second Law of Thermodynamics recognises the irreversible exhaustion/dissipation of usable energy and the irreversible increase/maximisation of entropy. Failing to subvert the domination of classical dynamics, the irreversibility foregrounded by the Second Law was, in the nineteenth century, accepted as a statistical law, one not so much defined by certainty or necessity as it was considered 'a measure of probability'. In experimental terms, a statistical acknowledgement necessitates a reconfiguration of the mechanism for knowledge production. That is, in thermodynamics, the possibilities of exceptions must be neglected for the statistical law of irreversibility to hold. Even if it was possible for entropy to decrease in certain observable phenomena, what counts in the establishment of statistical knowledge is a particular phenomenon's high probability. High probability, it has been assumed, indicates a general tendency in 'the behavior of large populations'.[56]

On similar premises, social statistics then pushed statistical epistemology to only acknowledge singularity where all qualities of specificity could be transcended to create 'the coherence of an imaginary or abstract population'. The trend began with the transference of the bell-shaped curve from its use in astronomical measurement to social measurement. Within the discipline of astronomy, the bell-shaped curve demonstrates the distribution of random errors as clustering around a central mean. In the same fashion, Belgian astronomer Adolphe Quetelet argued the utilisation of the curve in social measurement would represent 'a fundamental social law' by locating the condition of the 'average man' at the centre and all anomalies/extremes

55 Mary Ann Doane, *The Emergence of Cinematic Time* (Cambridge, MA and London: Harvard University Press, 2002), 124.
56 Doane, *Emergence*, 116-24.

at the edge. To Quetelet, Doane writes, such a representation of the 'average man' pointed to 'a real quality, the accurate measure of a homogeneous population', even if his presumption of accuracy and homogeneity violates the principle behind statistical epistemology.[57]

In elaborating Foucault's theory on neoliberal governmentality, Patricia Ticineto Clough makes a similar argument in relation to the biopolitical governance of 'man-as-species'.[58] Statistical epistemology shows 'the normal distribution of [individual] cases that serves as norm', she writes, 'meaning that [biopolitical] governance is less interested in the distinction between the normal and the abnormal but in a comparison of normalities'. The comparison leads to a process Foucault would call the 'normalization' of populations, which provides the foundation for life regularisation.[59]

However, suggesting neither necessity nor certainty, a statistical law presented in terms of probability is essentially a handling of chance. As Doane discusses by drawing on French biologist Francois Jacob's explanation, this means it is from the randomness evident in individual actions that the inductive grasp of an entire population's general tendency emerges. As a result, the individual has an irreducible status in the mechanism of statistical epistemology. Doane summarises Jacob's point, arguing that

> Although a statistical epistemology might seem to negate the individual in favor of the mass, there is a sense in which it makes the individual more profoundly *individual*, characterized by irreducible differences, random attributes. For this reason – and because analysis of such an individual yields no usable knowledge – the statistical method renounces knowledge of the concrete individual and concentrates on large populations.[60]

Hence, just as the Deleuzian control operates on the verge of the uncontrollable, statistics extract usable knowledge out of useless information. For that purpose, statistical laws underscore and repudiate individuality all at once. If statistical epistemology has thus 'completely transformed the way of looking at nature', it is because 'it brought together and gave the status of related and measurable quantities to order and chance – two concepts which until then had been incompatible'.[61]

57 Ibid., 126-7.
58 Patricia Ticineto Clough, 'The Case of Sociology: Governmentality and Methodology', *Critical Inquiry* 36.4 (2010): 632.
59 Ibid., 633.
60 Doane, *Emergence*, 125, emphasis in original.
61 Ibid., 124.

Due to the irreducible involvement of chance and singularity, statistical knowledge cannot possibly define every single individual in a population. Nor can it govern an individual's future action. As '[s]tatistics refuse certainties, precision, and necessity in favor of tendencies, directions, and probabilities', there can be no description of a definite 'pattern to which all individuals conform'.[62] The statistical law describes instead 'a composite picture', which is just an abstraction of a population. In contrast to its abstractness, '[o]nly individuals, with their particularities, differences and variations, have reality'.[63]

Haunted by typology and in support of biopolitical governing, social statistics from Quetelet onwards have, nonetheless, privileged the abstract summary of populations and endowed it with reality or certainty. On the basis of calculable probabilities that indicate everything but ineluctability, social statistics access inexhaustible, indeterminate, and chance-infused social reality 'as predictable, manageable risk'.[64] Its capture of indeterminacy, betrayed by the word 'risk', produces an excess, or in Clough's words, 'a fear of the possible gone out of control, a multiplication of dangerous [individual] cases, a crisis of the incalculable'.[65]

This being the case, it seems film marketers like Rachel Chen and Patrick Mao Huang have suffered ideologically from a splendid myth. To 'sensibly' handle their business, they have painstakingly sought for followable *patterns* that might assist in risk management. Unfortunately, their statistical methodology is only capable of yielding patterns that are entwined inescapably with incalculable exceptions.

The audience, on the other hand, may well be too accustomed to exceptions. Therefore, they could sometimes appear rather sophisticated about the validity of statistical knowledge. Many of my focus group participants admitted feeling tempted to visit the cinema when they had seen a film garner high ratings from a great number of Internet users. Following a few disappointing experiences with highly rated movies, nevertheless, Chun-yi mused, 'I suppose it is not entirely impossible that the marketers find ways to fiddle ratings, even if the ratings are published on seemingly trustworthy websites'.[66] Aware of the probable singularity of her sensibilities, Kuei-yin said she had learnt to ignore statistics altogether. 'If anything', she added,

62 Doane cites this phrase from Jacob's *The Logic of Life*, published in 1973.
63 In Doane, *Emergence*, 125.
64 Ibid., 126-7.
65 Clough, 'The Case of Sociology', 633.
66 Chun-yi, focus group discussion, August 15, 2010.

'I prefer being moved by behind-the-scenes anecdotes to being prompted by rating figures'.[67]

Whether marketers fiddle user ratings to prompt film consumption or not, within the setting of Internet marketing, the marketers' statistics-grounded and at best randomly rewarded efforts are unavoidably biopolitical. One need only consider how a miraculous service such as Google Serendipity has been anticipated for its 'probable' capacity to induce *actions* of consumption. Not unlike biopolitical governance, marketers use statistics because they aim to regularise life – reified in affect, or in the bodily capacities to act – by channelling behaviours of consumption. In the previous section, this objective was made clear in Patrick Mao Huang's optimistic/apocalyptic imagination. That is, through the effective tracking of the affect flow, which is manifested online in the seemingly haphazard occurrence of Internet activities, dominant Internet service providers might ultimately succeed in transforming lifestyles and *defining lives*.

In time, even if actual or futuristic biopolitical measures might lead to the normalisation of populations of film consumers, film marketing as action canalisation will always face challenges from unpredictable individual behaviours. Although the (random) nature of film audiences might appear readable with the assistance of carefully produced statistics, real actions by individual film consumers would remain singular, likely unregularise-able, despite fastidious pattern mapping or enthusiastic pattern creation. Much as this accounts for the frustration of popular statistical methodologies, it has, more importantly, underlined the uncontrollability of life/affect/labour under the subsumptive late capitalist regime. I will discuss uncontrollability in the concluding section.

Archival Control

When statistics are not available, marketers are readily drawn to the 'total mediality' of cyberspace for their own research. It is believed, as is by Jodi Dean, that every aspect of contemporary life can be found, said, and seen on the Internet.[68] Because everything has appeared 'searchable' and 'findable' online, search engines seem to have turned the Internet into 'a perfect archive'.[69] To Taiwan film marketers eager to get hold of 'major opinions',

67 Kuei-yin, focus group discussion, August 15, 2010.

68 See Dean, *Blog Theory*, 74.

69 Chun, *Control and Freedom*, 57.

the cyberspace collection of BBS conversations, blog comments, and any other form of computational-networked exchanges contains historically traceable information. Take for example their utilisation of the BBS platform PTT. Rachel Chen revealed in our personal interview that PTT-based research should ideally lead up to understanding the effectivity of past marketing schemes, the reception of released movies, the changing tastes of audiences, and so forth. The research outcomes, if translated into nameable 'trends', would then 'form the basis for future promotion plans'.[70] Thus, as an executive tool for market monitoring or market study, cyberspace has become an archival resource deployed for campaign design. Supposedly, it has provided post-2000 Taiwan film marketers with 'all that had happened online', so the marketers may 'learn from the history' to gain advertising leverage.

Nevertheless, speaking of Facebook as an information-rich platform for research, Patrick Mao Huang conceded a dissatisfying sense of insecurity. The dominance of social networking services, he said, has resulted in the disastrous and rapid disappearance of niche communities:

> Everybody 'likes' everything on Facebook nowadays. Years ago, you would not imagine anyone bookmarking hundreds of websites. But now, a lot of people 'like' more than a hundred Facebook pages. In niche marketing, this means a catastrophic loss of direction. We do not know anymore, for example, where to find the potential audiences of queer cinema, which used to have a very specific and loyal following.[71]

The value of information acquired via Facebook research, as a consequence, has dropped dramatically. 'We have completely lost effective indicators of popularity', Huang complained for instance, 'Most locally made films got more "likes" on Facebook than foreign films did. Then, the figures would not reflect actual box office receipts'. All in all, the immediacy of social networking seems to have created delightful mirages that turn out to be a disappointing confusion. 'Our labour-intensive investment in Facebook has appeared rewarding in terms of positive user responses', Huang elaborated, 'But what could these responses mean? What would we marketers end up with, constantly working overtime on a Facebook page? I don't know. I never feel confident to say'.[72]

70 Rachel Chen, personal interview, August 24, 2010.
71 Patrick Mao Huang, personal interview, August 2, 2010.
72 Ibid.

Since the success of Internet marketing relies on affect mobilisation, which in practice manifests itself in user participation, marketers have consciously or unconsciously deployed cyberspace as an archive of affective traces. They have assumed that variable patterns of online activities indicate changes in consumer inclination. A grasp of changing inclinations is necessary for marketers to generate and channel useful participation. If the grasp is to be accurate, an archive as far-reaching as possible may be preferred. A collection of affective traces that are too plentiful to be legible, however, becomes nightmarish.

The paradox is inherent in the formation of archives. Theorising cinema's intricate relations to time, machine, and storage, Doane provides a context-grounded example of the crisis caused by unlimited archiving. Cinema, Doane writes, shows a distinctive tendency towards archiving due to 'the camera's capacity to record indiscriminately'. Cinematic technology in early film history was hence more readily involved 'in the process of an unthought and mechanical recording', which 'seems to evade the issue of subjectivity, agency, and intentionality'. Quoting Friedrich Kittler, Doane argues a cinematic machine as such is as good as a 'random generator' of discourse. It feeds the discourse network with 'an opaque thisness' by fortuitously recording 'single and accidental messages'.[73] From such 'thisness' emerges what Doane names 'an archival moment', whose coming into being speaks of 'the enormity of the changes introduced by mechanical reproduction'.[74]

Counteracting the (Freudian) death drive, archiving to Derrida is driven by the aspiration to document all that *passes in time.*[75] Its practice, in this sense, logically reaches its full swing with its facilitation by mechanical reproduction. This eminent promise of cinema-mechanical reproduction nonetheless also forms its most pernicious menace, that is, the possibility of excessive representation/preservation of virtually everything. Doane explains:

> [...] the ability to represent everything – both the planned and the un-planned – also constituted, as Vaughan suggests, a threat. The anxiety generated would be that of sheer undivided extension, of a 'real time' without significant moments, of a confusion about where or why to look.

73 The quotes are from *Discourse Networks, 1800/1900*, published in 1990.
74 Doane, *Emergence*, 63-5, emphasis added.
75 Jacques Derrida, *Archive Fever*, trans. Eric Prenowitz (Chicago: University of Chicago Press, 1996), 10-2.

> If everything is recordable, nothing matters except the act of recording itself.[76]

While cinema at its early stage spontaneously set off a continual process of archiving, its democratic power of mechanical reproduction threatened to paralyse the system of signification. By indiscriminately filling the archive with documented history, cinema-mechanical archiving in full swing risked losing the relevance of documents to documentability.

On the platform of Facebook, where '[e]verybody "likes" everything', the indiscriminate expression of approval is recorded in the same fashion. The relevance of the archived affective traces has given way to haphazardness, which is enabled by the ease of responding positively to any information. Consequentially, approval figures lose their capacity to signal intelligible levels of popularity.

Ironically, like all other archives, cyberspace also suffers from limited storage in spite of preserving myriad random traces of online activities. In any possible situation, limitation is concretely concerned with spatial adequacy or, more specifically, 'global Internet capacity'. In a more abstract sense, the problem of storage pertains to the intrinsic impossibility of actual exhaustiveness. Given the practicalities, laws of exclusion, no matter how tacit, ineluctably govern the formation of archives. That which is given a place in an archive therefore always stands in tension with that which is left out. Therein lies the acute politics Foucault delineates in relation to discursive regularities and knowledge discontinuity:

> The archive is first *the law* of what can be said, the system that governs the appearance of statements as unique events. But the archive is also that which determines that all these things said do not accumulate endlessly in an amorphous mass, nor are they inscribed in an unbroken linearity, nor do they disappear at the mercy of chance external accidents; but they are grouped together in distinct figures, composed together in accordance with multiple relations, maintained or blurred in accordance with specific regularities [...] The archive is not that which, despite its immediate escape, safeguards the event of the statement, and preserves, for future memories, its status as an escapee; it is that which, at the very root of the statement-event, and in that which embodies it, defines at the outset the system of its enunciability. Nor is the archive that which collects the dust of statements that have become inert once more, and

76 Doane, *Emergence*, 65-6.

which may make possible the miracle of their resurrection; it is that which defines the mode of occurrence of the statement-thing; it is the system of its functioning.[77]

Not unlike statistical knowledge, an archive in formation fabricates intelligibility out of a random, indefinite, and technically unfathomable configuration of reality. In Althusserian terms, an archive as such embodies a seemingly history-less ideology whose analysis and description require a discrepancy in regularities. A valid archive diagnosis, Foucault writes, 'deploys its possibilities [...] on the basis of the very discourses that have just ceased to be ours'.[78]

The Foucauldian contention seems unarguable that an archive's selectivity only begins to reveal itself once the archive starts losing its currency. Perhaps this is why the limitations of the cyberspace archive stand more conspicuous to a non-marketer, who is less obsessed with the archive's (probable) utility. The most undeniable among these limitations pertains to technical configurations. Wendy Hui-Kyong Chun, for example, demystifies the operation of search engines, which seem to have made 'a perfect archive' of cyberspace. 'Search engines', she writes, 'do not search the Internet but rather their own databases'. These are produced by 'robots', 'spiders', or 'crawlers', who randomly travel through the Web to request and store web page files.[79]

In addition, the use of the cyberspace archive clearly underscores action over inaction. However much online communication involves un-actualised bodily potential for action, *virtual* affective traces of this sort remain unrecorded. All that has been searched for, found, reviewed, observed, and analysed within the cyberspace represents the Internet users' *actual* affective contribution. Because of their lesser trackability, even user actions like clicking, searching, and browsing are usually excluded from the archive. In its most 'usable' condition, it appears, the cyberspace archive records, presents, and promotes affective activities that have generated or continued the information flow to perceptibly further computational-networked communication. Elaborating the 'unrelenting process of inter-seduction' in cyberspace, Patrick Mao Huang made explicit that for optimal utilisation of the Internet in film marketing, he would expect the (potential)

77 Michel Foucault, *The Archaeology of Knowledge*, trans. A. M. Sheridan Smith (London: Routledge, 2002), 145-6, emphasis added.
78 Foucault, *Archaeology of Knowledge*, 147.
79 Chun, *Control and Freedom*, 107.

audiences to actively involve themselves in responsive interaction chains. 'Few Internet users base consumption decisions on thorough research. Seldom do they carefully compare film reviews and watch movie trailers *all by themselves*', Huang claimed, 'More often than not, they depend as much on messages from one another as on their own fervid response for film choices'.[80] As Internet marketers thus ascribe more productivity to chained *acts* of message circulation, the use/formation of the cyberspace archive no doubt reiterates the principal capitalist ideology.

The banished affective traces therefore compose a diffuse counter-archive that encompasses the productive cyberspace archive with its collection of the 'ambiguously productive'. One should not be surprised by the magnitude of this counter-archive.

All of my focus group participants, for instance, 'google' films they have seen. Accounting for her 'googling', Chun-yi provided a typical statement of motivation:

> It usually happened immediately after watching a film, when I was most excited about it. I would be eager to go through online discussions, search for well-written reviews, check out the official blog, read related media stories, etc. It could be for anything, really. Stunning visuals, impressive direction, moving narratives, or simply something I felt – I can't explain it well, but any effective element in a movie could prompt googling.[81]

Linking film viewing to online search, Chun-yi's experience exemplifies Henry Jenkins' observation about 'media convergence', and her delineation reveals the involvement of affect within such converging. 'Stunning visuals, impressive direction, moving narratives' or 'any effective element in a movie' fosters a scarcely explainable eagerness that leads to bodily performance of various online activities.

In most cases, the eagerness felt was reported to have faded within a few days of seeing a movie, which attests to many theorists' conviction that the late capitalist affective economy has burgeoned on the basis of 'short-termism'.[82] Several of my focus group participants, however, got into the habit of googling certain films regularly. Grace, an avid moviegoer, said she had been googling *Lan Yu* (Stanley Kwan) every now and then for

80 Patrick Mao Huang, personal interview, August 2, 2010, emphasis added.
81 Chun-yi, Skype interview, February 1, 2011.
82 See, for instance, Bernard Stiegler, *For a New Critique of Political Economy*, trans. Daniel Ross (Cambridge: Polity Press, 2010).

almost ten years since having seen the film in 2001.[83] 'I know the chance is small that I find newly updated information', she explained, 'but the search enables me to *re-experience the film* – all its atmosphere and the characters' emotions'.[84] Likewise, Chun-yi habitually checked the 'Quotes' columns on certain films' IMDb[85] pages. 'Reading the lines comforts me', she added, 'It brings back the feelings. Even if not quite as strong as it was, the excitement could definitely be evoked all over again'.[86]

Few would see as 'unruly' what Grace has done with *Lan Yu* or Chun-yi with IMDb. As the act-ors themselves have described it, that which they have done constitutes the most 'common' actions by the most 'ordinary' film spectators. 'Without much thought, it just happened' was the way Chun-yi stated it.[87] Indeed, automatically using cyberspace for an archive and willingly embracing stimulation from randomly associated information typifies much Internet usage. Grace's and Chun-yi's accounts only distinguish themselves by making it clear that even the most mundane communicative process is permeated with body affections and driven by physical impulses for actions. Ideally, from the perspective of capital or the film industry, the affections and impulses would be well-sustained and effectively channelled so that they either lead to purchase or at least result in broader dissemination and maximal production of information.

With Grace and Chun-yi, nevertheless, the ideal founders. Both affection-driven Internet users failed to disseminate or produce information in conducting their habitual web activities. Their affective contribution to computational-networked communication appears productivity shy – inconsequential not only to the progress of film promotion but also in terms of a lack of conspicuous traces saved in the archive of cyberspace. Given the specificity and outmodedness of the searched movies, if ever represented in web analytics, the contribution might still escape notice due to the relative rarity and haphazardness of its occurrence.

83 A Hong Kong-China co-production, *Lan Yu* is a queer romance film based on a Chinese novel published anonymously on the Internet in 1998. It tells the story of Lan Yu, a young gay boy who makes an unselfish sacrifice for his bisexual lover Chen Handong. After all the difficulties the pair has survived together, Lan Yu is killed in a tragic traffic accident, leaving behind him a devastated Chen Handong and a loving relationship yet to flourish.

84 Grace, email interview, March 7, 2011, emphasis added.

85 Internet Movie Database, http://www.imdb.com.

86 Chun-yi, Skype interview, February 1, 2011. Both Grace's and Chun-yi's statements here are also relevant to the discussion regarding intermediary vehicles and their intricate relations to bodily fantasy.

87 Chun-yi, Skype interview, February 1, 2011.

Thus, the cyberspace counter-archive – which is almost a blind spot – circumvents the late capitalist control by staying imperceptible. This explains why marketing fiascos are often deemed illegible, especially when well-researched promotional plans founder. In this view, the counter-archive renders inconclusive the productivity of industrial labour. The better researched a promotional plan tends to be, the more unproductive it may turn out in cases of ineffective marketing. For, a failed promotional plan as such implies more investment, both affective and monetary, lost to the cyberspace counter-archive and the (ambiguously productive) invisibility of certain affective online activities – presuming marketers who conduct archive research are all properly-paid active film industry employees. Little wonder that when commenting on the elusive market, *Formula 17* producer Aileen Yiu-Wa Li would lament, 'The situation we are in is horrific'.[88]

By extension, the counter-archive also throws into question the unruliness in cyberspace, thus far often attributed to the active participation of Internet users. Henry Jenkins' notion of 'collective intelligence' typifies arguments for such unruly activeness. In *Convergence Culture*, he contends that proactive information-sharing has enabled Internet users to penetrate and interfere with manipulation by the media industry.[89] Incontrovertibly archived in cyberspace and susceptible to industrial use, 'collective intelligence' nonetheless risks compliance with late capitalist archival control, which seeks power in pervasive exchange of 'thought'.[90]

Revolutionary Control

In classical Marxism, 'characteristic forms of thought' are the hopeful source of ideological conflict. Quoting Marx and Gramsci, Stuart Hall writes, 'There was […] some relationship, or tendency, between the objective position of [a] class fraction, and the limits and horizons of thought to which they would be "spontaneously" attracted'.[91] David Morley echoes this explication and states that social/economic backgrounds decide audience responses

88 Aileen Yiu-Wa Li, personal interview, September 10, 2009.
89 Henry Jenkins, *Convergence Culture* (New York: New York University Press, 2006). Regarding audience unruliness, see also John Thornton Caldwell, 'Screen Studies and Industrial "Theorizing"', *Screen* 50.1 (2009): 167-79.
90 See also Dean, *Blog Theory*.
91 Stuart Hall, 'The Problem of Ideology: Marxism Without Guarantees', in *Critical Dialogues in Cultural Studies*, eds. David Morley and Kuan-Hsing Chen (London: Routledge, 1996), 42.

to media messages.[92] Hall, who follows the materialist Marxist tradition, looks further into the intricate relation of economy to thought and locates the origin of ideological contestation within a field of material forces. 'The economic provides the repertoire of categories which will be used, in thought', he states. Material circumstances to him are at once 'the net of constraints' and the 'conditions of existence' for critical contemplation.[93]

On the basis of this classical Marxist premise, Jenkins deems 'collective intelligence' to be a valuable result of the online exchange of 'thought'. The economic status of Internet users, relative to the media industry, allows them the possibility of interrogating industrial practices. In this chapter I have, however, accentuated how interrogations and power struggles may circumvent 'thought' to emerge from the *act of exchange*. Concurring with Hall, I have demonstrated the ways in which certain material forces have disrupted capitalist control when facilitating computational-networked communication. The disruptions I have studied are, nevertheless, not essentially ideological. Neither do they result from 'thought'. Rather, they revolve around active potentialities of the human body, whose variability/unpredictability contributes to the material conditions of these disruptions.

Three types of body-mediated disruptions have been specified above in relation to twenty-first century Taiwan Internet film marketing, via the practice of which the Taiwan film industry painstakingly elicits affective participation from its potential audiences in computational-networked communication. With respect to a scheme of soft control, the industry at once tolerates, encourages, and sustains unpredictability in consumer activities to harvest profits from a multitude of (relatively) autonomous online interactions. Thereby surprises generated during the process threaten not only to hinder the objective of Internet marketing but also to thwart the marketers' decisions regarding working strategies. To circumscribe the threats, marketers seek help from statistics and the cyberspace archive. Nonetheless, their attempt at statistical control is challenged by the unforeseeable singularity of customer (re)actions. The archival control, on the other hand, suffers either from the overflow or the deficiency of trackable online activities.

Through these disruptions, the active body – instead of thought – comes between the audience and the film industry to hamper the effectivity of online film marketing. By extension, it also impedes the efficiency of capital

92 See David Morley, *Television, Audiences and Cultural Studies* (London and New York: Routledge, 1992).
93 Hall, 'The Problem of', 43.

reproduction. Crucial for economic value production, bodily capacities produce, in these cases of disruptions, 'anti-value' to late capitalism. Is it also from this materially generated anti-value that one should expect the rise of a Marxist revolution?

To Antonio Negri, who regards the labour capacities of affect as free from any reduction by economic calculation, the answer is absolutely in the affirmative. Uncontrollable bodily potentialities, he argues, breed the possibility of 'revolutionary reconstruction'.[94]

One of the keys to understanding the revolutionary potential of anti-value, bred in the long tradition of Marxist thought, may be found in the *excess*, that is the value that affect is able to produce but (late) capitalism remains unable to utilise. Brian Massumi, who argues the capitalist super-system 'gives rise to determinations', has portrayed revolution in relation to excess as such. On the premise of capitalist determination, he suggests, resistance under the late capitalist regime must first of all defy the system of determination. Instead of defining itself as specified oppositional practice, this is to say, resistance has to be the 'tactical embodiment' of the undetermined ground of capitalist power, thereby short-circuiting the capitalist canalisation of affective labour. Massumi envisages a possible example in mass communication, where he sees resistance in communicative patterns 'that fail to resonate with capitalist legitimation, either by excess or by deficiency or with humor'. Mimicking the exercise of capitalist power, these are patterns that might become 'at least momentarily unassimilable by the supersystem'. Therefore, from the supersystem's point of view, they seem to be 'simple negativities'.[95] Construed as such, resistance to Massumi is life/affect's excess production of *undeterminable* indeterminacies.

But life/affect as labour-power is already more or less undeterminable with respect to capital. This is evident in bodily disruptions to Internet film marketing. The potential failure to overcome life/affect's indeterminacies is immanent in capitalist power. In *Empire*, Negri and Hardt describe labour-power's 'liberatory capacities' as 'productive excess'. Their departure from Marx stands out, however, when they contend that (all) labour is in itself 'productive excess'.[96] Excess as such pins down both labour's intimacy to, and its autonomy from, capital. The fact that affect/labour spontaneously produces actions and movements the capitalist regime 'does not really know how to control' thence renders it necessary for the regime to take

94 Negri, 'Value', 88.
95 Massumi, 'Requiem', 61.
96 Hardt and Negri, *Empire*, 357.

'*repressive actions*'. That is, the regime must, for its own convenience, 'attack' the indeterminate, uncontainable affective movements/actions with 'a tireless determination'.[97]

Life, in this sense, marks the limit of capitalist governance. Overcoming life defines late capitalism's ultimate struggle. Framed this way, affect not merely represents the unruly object of capitalist control, but it also presents to the late capitalist economy a fierce resource-obstacle to be both effectively deployed and ruthlessly surmounted. The tension between capital and labour is, based on this premise, an infinite battle of efficiency. As the quality of capitalist domination is contingent upon the effectivity of capital reproduction, the more efficient the conversion of labour into capital is, the more dominant capitalism will be. In capital's highly intricate relation to labour, however, much of its pursued efficiency cannot avoid being potentially hindered by affect's uncontrollability or life's undeterminable indeterminacy. By itself, indeterminate life is the resistance that could lead to capital's unproductivity, which, to be precise, is capital's un-reproductivity.

Thus, to the capitalist (attempt at) control, the body may respond with displeasing, rather than 'useful and pleasing', randomness or unpredictability that in Negri's words represents labour/affect's intrinsic 'radicality'.[98] The question is how, or whether, an actual revolution would manage to materialise in the face of such radicality. In practical terms, can one imagine for example that Grace, Chun-yi, and their fellow Internet users, by searching/reading without forwarding or commenting, *spontaneously* bring about a reconstruction of the capitalist institution?

The imaginability holds, provided one is content with the volatility of all that is established ambiguously in the late capitalist regime. Within control societies, or societies in which control is at once intense and vulnerable due to reflexivity, it does not seem easy for the radical or the revolutionary to maintain its efficacy. The 'self-deforming cast' of late capitalism changes to keep revolution in the balance. Recent years, for instance, have witnessed a development in Internet marketing and communication: the possibilities brought about by randomness has now been further embraced so as to circumvent the probable deficiency in statistical control. I have in mind the new Facebook function, which allows registered users to view not merely what their Facebook friends have posted but also what their friends have 'liked' or commented upon via the social networking platform. This

97 Ibid., 399, emphasis added.
98 Negri, 'Value', 84.

gives Facebook users random access to posts they would not otherwise
see, and connects the users with numerous strangers whose lifestyles may
differ drastically from their own. If each Facebook user does have certain
behavioural tendencies, Facebook as a medium that (potentially) induces
actions of consumption is now looking to fortuitously canalise these tenden-
cies regardless of their (probable) specificities. I am certainly intrigued
by the effectiveness of this tactic, in comparison to the efficacy of a more
statistics-based service such as Amazon recommendations.

In perspectives like this, the 'anti-value' bodily capacities uncontrollably
produce – via, for example, disruptions to Internet marketing – has qualities
that are subject to change in relation to the ultra-dynamics between the
body and the capitalist regime. Because anti-value preserves in certain
bodies traces of (conscious or unconscious) capital defiance, nevertheless,
one may find its ultimate use in the relentless reconfiguration of bodily
potentialities. I will illustrate this last point by returning to the examples
of Grace and Chun-yi.

According to Massumi, who cites Daniel Stern, each body has an '*activa-
tion contour*'. Amorphous, the contour refers to 'a continuous rhythm of
seamlessly linked accelerations and decelerations, increases and decreases
in intensity, starts and stops'.[99] When a circumstantial event occurs, all
that is involved within the event, be it an object or a body, shares also 'an
encompassing activation contour'. The latter contour qualifies the relation
among the event participants, and it takes up the participants' separate
activated movements 'into its own complex unity of orchestration'.[100] The
two levels of activation contours are autonomous but proceed side by side.
With the occurrence of each event, a body involved would feel, embody,
record, and contribute to the relational order organised within the overall
contour.[101] Hence, in adjusting its own activation contour, the body at once
archives and changes the overall contour. The overall contour, meanwhile,
restructures bodily archives when it alters individual bodily contours.

In the light of this theory, by googling and reading film quotes online,
Grace and Chun-yi have built complex but fluctuating relationships with
their bodies, which archive their felt relations to their surroundings. When
they first saw their beloved films, the circumstantial events of their film
consumption generated overall activation contours that impacted upon
their bodily archives. Numerous other events then followed. In different

99 Brian Massumi, *Semblance and Event* (Cambridge: MIT Press, 2011), 107, emphasis in original.
100 Ibid., 112.
101 Ibid., 115-6.

manners, these reshaped their bodily archives of felt relations. Googling and reading, on each occasion of their occurrence, feed disparately into the transformation of the archived relations.[102]

The bodily archive defines the relation of the body to the world. Given the subsumption of life under capital, the formation and configuration of the bodily archive could hardly avoid mediation by the late capitalist economy. Easily trackable or not, both Grace's and Chun-yi's communicative actions (of googling and reading) remain preliminary labour, biopolitically endowed with dormant value under the late capitalist regime. How and when the dormancy may be overcome undoubtedly confronts the regime with the challenge of strategy reinvention. Yet when disruptive to marketers' archival control, the same online activities also interrupt the ultra-intimate connection between life and capital. However brief and local, the interruption manifests a subversive potential in mundane bodily movements. The potential marks an affective 'non-place' outside and beyond the reach of the film industry, to borrow Negri's terms.[103] Being a (consciously or unconsciously) felt relation to the world, this potential has as well been archived within the bodies of Grace and Chun-yi. The fact that this subversive potentiality has arisen from mundanity attests to Negri's anticipation that (if it ever happens) revolution would eventually re-construct reality 'from below', from the very basic activities carried out on the affective level.[104]

Whether and how an individual, or the human species as a whole, actualises bodily archived revolutionary potentials continues nonetheless to be an open question. The passage of the body's liberating capacities from the potential through the possible to the real, in Hardt and Negri's words, is an 'act of creation', which to Negri (and likewise to Massumi) depends on the body's active *reappropriation* of the late capitalist biopolitical context.[105] This means, whatever late capitalism may do for the purpose of capital reproduction and in order to mobilise the active power of the body, the body must for the sake of revolution also achieve via self-valorisation. In this sense, there is little reason to believe a project of reappropriation would come off any more conveniently. A valuable yet volatile force, affect retains the ultimate quality of unpredictability and therefore the quality of

102 Even though in experiential terms, Grace and Chun-yi have both declared that their online activities 'brought back' what they had felt about/with their beloved movies, their affective relations to the films have in actuality metamorphosed with their repetitive performance of the online activities.
103 Negri, 'Value', 82.
104 Ibid., 88.
105 Hardt and Negri, *Empire*, 357; Negri, 'Value', 88.

political ambiguity. It might obstruct the progress of capital reproduction and also the progression of anti-capitalist insurrection. On that account, precariousness cannot but define a body-mediated relationship between the consumer and a value/profit-seeking industry.

7 Mediation and Connections in a Precarious Age

Conclusion

In this book I seek to make three points about the relationship between the film industry and the audience with respect to the case study of post-2000 Taiwan queer romance films. Firstly, the film industry attempts biopolitical control over the audience for the sake of capital reproduction/financial sustenance. To achieve this control, the industry adopts communication-efficient cinematographic language, mainly from financially successful film works produced in Hollywood or the East Asian region. Besides this, the industry connects film products to a range of consumer products and markets the packages across multiple media platforms. Both efforts are aimed at seducing the audience's senses and, by extension, governing the audience's bodily capacities. Secondly, the biopolitical control in question is pursued with the assistance of film prosumption. With film product production, prosumption is inherent in filmmaking because for filmmakers to communicate cinematographically they must engage their spectatorial histories, which affectively prescribe how the spectator-turned-filmmakers express their subjective sensory perceptions. With film promotion, prosumption is instantiated by Internet marketing, whose optimal operation requires potential film audiences to affectively and actively participate in computational-networked communication. In either case, the film industry capitalises on film audiences' bodily capacities (to act, to communicate online or by means of the film medium) for value/profit generation. Lastly, the biopolitical control by the film industry yields unpredictable results. This is because media technologies do not by themselves dictate the (re)configuration of bodily capacities. The body links up with other bodies or everyday objects (consumer commodities) to modify and diversify the effect of communication, including the effect of cinematographic communication and Internet communication. On the basis of this modification/diversification, the body retains a quality of volatility while the film industry cannot avoid the impact of precariousness despite the endeavour to exercise control over the audience.

Precariousness in Prosperity

Since my field research, much has changed with regard to the operation of the Taiwan film industry. Between 2010 and 2013, there are nine locally made feature productions that have grossed more than NT$ 100 million ($ 3 million).[1] Compared to the legendary *Formula 17*, which was celebrated for grossing NT$ 6 million ($ 200,000) in 2004, local films have made impressive progress in terms of box office receipts. Thanks to increased production budgets, the improvement of technical skills has also been remarkable.

I remember being amazed by *Black & White Episode 1: The Dawn of Assault* (Tsai Yueh-Hsun 2012). *Black & White* was a locally made police drama, first broadcast by Taiwan's Public Television Service (PTS) in 2009 before being exported to Hong Kong, Singapore, Malaysia, Japan, and China. The popularity of the television series in the East Asian region attracted investment from China, which enabled the production of the film version. I saw the film in Taipei in early 2012. When I stepped into the cinema, I did not expect a proper action movie. Everything that I could recall about the original television series suggested a cheesy cop comedy. In the movie theatre, nevertheless, the incessant car chases, explosions, technological gadgets, physical stunts, and CGI effects kept bringing back memories of *Mission: Impossible – Ghost Protocol* (Brad Bird 2011), which I had seen in London a couple of months before. This is not to say the production team of *Black & White Episode 1* has shamefully copied a Hollywood product. Rather, I was fascinated to realise that in less than a decade, the Taiwan film industry had successfully made the leap from making low-budget romantic movies such as *Formula 17* to producing a special-effect-oriented action blockbuster.[2]

The great leap could indicate an issue, which is at once cultural and political-economic. That is, given the observable developments in post-2000 Taiwan filmmaking, one may argue that the Taiwan film industry has – for the sake of product marketability – aligned itself with the globally dominant cultural form of Hollywood genre films at the expense of aesthetic diversity and local identity. In Chapter 4, I addressed this issue and contended that the adoption of globally or regionally established generic conventions does not necessarily compromise cinematic creativity or local perspectives. This is firstly because intervention by bodies and objects in the process of

[1] See http://zh.wikipedia.org/wiki/台灣電影票房, accessed October 28, 2013.
[2] Equally special effect and action oriented, *Black & White: The Dawn of Justice* (Tsai Yueh-Hsun), a sequel to *Episode 1*, was released in 2014.

filmmaking could modify the effects of the adopted generic conventions and lead to innovation. Secondly, the body of the spectator-turned-filmmaker mediates the reproduction of generic formulae. Although the perceptive and communicative capacities of the mediating body are subject to the impact of cinematic affectivity, I have demonstrated in both Chapter 3 and Chapter 4 that the impact in question is negotiated within a broad network of bodies and things. This is to say, as post-2000 Taiwan filmmakers might have been fanatical about and affectively modulated by Hollywood productions, their subjective perceptions and bodily capacities for cinematographic communication were nonetheless shaped locally, among people and things they had accessed in local contexts. For these reasons, I have contradicted theories of lost creativity or local identity. Instead, I have argued that the politics of generic filmmaking must be studied with respect to film prosumption, including the ways in which the post-2000 Taiwan film industry has, for the sake of product marketability, capitalised on the bodily capacities of particular spectator-turned-filmmakers.

In the course of my field research, nevertheless, it was not uncommon to find spectator-turned-filmmakers sharing the same goals with film producers. Like their producers, filmmakers were concerned with box office receipts. *Miao Miao* director Cheng Hsiao-tse claimed, for example, that he wished to produce Hollywood-like movies because he believed those would be 'worthy, *enjoyable*' film works. Given this premise, he said, nothing but a box office success could suggest he had made a deserving movie and had achieved his objectives.[3] On the other hand, Aileen Yiu-Wa Li, the *Formula 17* producer, stressed that apart from market efficiency, she had a predilection for Hollywood aesthetics – she specifically named horror films, action movies, and sci-fi thrillers – since they *excited* her.[4] Many of my conversations with post-2000 Taiwan filmmakers and film producers had thus progressed in excitement, as my interviewees enthusiastically imagined an aesthetic revolution.

After seeing *Black & White Episode 1*, I had an urge to congratulate a number of the industry workers I had once interviewed, especially Aileen Yiu-Wa Li, who had co-produced the movie. I felt the industry workers' aspirations for a locally made, technically respectable commercial film production had been efficiently realised. I was eager to find out if the audience reception would meet their expectations.

3 Cheng Hsiao-tse, personal interview, July 30, 2010.
4 Aileen Yiu-Wa Li, personal interview, September 10, 2009.

Ultimately, *Black & White Episode 1* grossed slightly over NT$ 100 million in the domestic market. In comparison to many local feature films, it was a success. When its production budget of NT$ 350 million ($ 12 million)[5] is considered, the box office result, however, seems less satisfactory. In the previous year, ironically, a romantic novel adaptation *You Are the Apple of My Eye* (Giddens Ko 2011) grossed NT$ 450 million ($ 15 million) in the domestic market, having been produced special-effect-free at a budget of NT$ 50 million ($ 1.5 million).[6] Even though *Black & White Episode 1* later grossed NT$ 450 million in China,[7] its relative financial failure in Taiwan became a popular topic of conversation. Talking to industry workers and film journalists in Taipei, I was informed of several different theories. Firstly, cross-media adaptation was losing its currency. Although it was generally believed that with cross-media adaptation the film industry could capitalise on extra-cinematic audience formations that were already in place, the audience had learnt not to be exploited by the media industries. Secondly, I was told, the *Black & White Episode 1* production team had cast a number of Chinese actors for additional characters and laid off some of the original cast on the basis of operating a Taiwan-China co-production, which infuriated fans of the original television series. Lastly, the film's disappointing box office performance was said to have stemmed from ineffective marketing.

The Optimal Mediation

Memories of the above-mentioned theories came back to me when I later re-read a newspaper article about Hollywood blockbuster flops. The article from *The Guardian* reports that the summer of 2013 saw the financial failures of 'a plethora' of big-budget film productions, including *The Lone Ranger* (Gore Verbinski), *After Earth* (M. Night Shyamalan), *Pacific Rim* (Guillermo del Toro), *Elysium* (Neill Blomkamp), and *World War Z* (Marc Forster). The reporter Rory Carroll quotes film directors, producers, journalists, and financial analysts who lay out diverse explanations for these box office fiascos. It is argued that the novelty of 3D technology, which is frequently applied to high-profile, big-budget film productions, has worn off and caused the financial setbacks. It is also argued that 'Hollywood was not making

5 http://zh.wikipedia.org/wiki/痞子英雄首部曲:全面開戰, accessed October 28, 2013.
6 http://zh.wikipedia.org/wiki/那些年,我們一起追的女孩, accessed October 28, 2013.
7 http://blog.roodo.com/blue1989/archives/25710048.html, accessed October 28, 2013.

enough films people wanted to see'.[8] Commenting on Hollywood studios' grasp of audience preferences, Nikki Finke, founder of entertainment site Deadline.com, was reported in the article as saying, 'There is no predictability anymore because tracking has been completely useless. And there is a complete disconnect between critics and audiences'.[9] 'The secrets to the studios' healthy profits', Carroll then concludes, reside in inflated pricing, the issue of spinoffs, and the burgeoning overseas markets, identified in the article as Asia/China, Russia, and Brazil.[10]

To say that the Hollywood studios are in crisis would be an overstatement. As Carroll states in the article, the named blockbuster flops were paralleled by the 2013 summer success of *Iron Man 3* (Shane Black), *Man of Steel* (Zack Snyder), *Despicable Me 2* (Pierre Coffin and Chris Renaud), etc. With revenues from overseas markets, the blockbuster production system has worked to bring in 'healthy profits'. As a result, financial analysts claimed that 'Hollywood is barely chastened and is not about to change its business model'.[11] Likewise, the Taiwan film industry has prospered despite the local box office setback suffered by a movie like *Black & White Episode 1*. General box office revenues have increased since the turn of the century. Accordingly, the average production budget for a local feature film leaped from NT$ 10 million ($ 330,000) in the early 2000s to NT$ 50 million ($ 1.5 million) in the early 2010s, which indicates the relative ease of attracting investment.[12] Notwithstanding this prosperity, the Taiwan film industry – like Hollywood studios and most likely other film industries around the globe – is not exempt from the threat of precariousness. Most obviously, the threat manifests itself in box office flops of film works that the industry has heavily invested capital and technical skills in. Those, conceivably, were films expected to overwhelm the audience by massively impacting on their senses.

It has hardly been surprising that the financial failure of a high-profile movie would be (logically) attributed to a worn-out technological innovation (i.e. 3D technology) or a change in the main cast. It is also common sense that a film industry might profit from novel technologies, spinoffs, franchises, popular stars, and overseas markets. Film industries have

8 Rory Carroll, 'Hollywood Apocalypse Not Now Despite Summer Flops and Directors' Strops', *The Guardian*, August 31, 2013.
9 Ibid.
10 Ibid.
11 Ibid.
12 See the electronic version of *Taiwan Cinema Year Books* on http://www.taiwancinema.com/ CH, accessed October 28, 2013.

always operated on a collage of physical entities, including organic bodies, inorganic objects, and technologies. As the nexus of bodies and things has been mobilised to facilitate the industry's intended biopolitical control over the audience, I have demonstrated in this book that this nexus has also functioned to undermine industrial domination. Like control, the threat of precariousness emerges from a broad assemblage of organic and inorganic beings. Therefore, in this book I have ascribed the power negotiation between the film industry and the audience to a collective agency, on the basis of which setbacks in biopolitical control underline the volatility of the human body.

With a formulation facilitated by ethnographic research, these arguments track the constitution of social/political forces in intricate assemblages of organic and inorganic beings. They not only emphasise but in effect optimise the potentiality of *mediation* as a crucial element in control via communication – the potentiality to reinforce but also to challenge control, so to ultimately present governance as a project of relentless dynamics.

Bibliography

Adorno, Theodor W., and Max Horkheimer. *Dialectic of Enlightenment*, trans. John Cumming (London and New York: Verso, 1979).

Althusser, Louis. 'Ideology and Ideological State Apparatuses'. In *Lenin and Philosophy, and Other Essays*, trans. Ben Brewster (New York: Monthly Review Press, 2001), 85-126.

Altman, Rick. 'A Semantic/Syntactic Approach to Film Genre', *Cinema Journal* 23.3 (1984): 6-18.

Ang, Ien. *Living Room Wars* (London and New York: Routledge, 1996).

Baudrillard, Jean. 'The Evil Demon of Images'. In *Baudrillard Live: Selected Interviews*, ed. Mike Gane (New York: Routledge, 1993), 136-44.

—. 'Simulacra and Simulations'. In *Jean Baudrillard, Selected Writings*, ed. Mark Poster (Stanford: Stanford University Press, 1988), 166-84.

Baudry, Jean-Louis, and Alan Williams. 'Ideological Effects of the Basic Cinematographic Apparatus', *Film Quarterly* 28. 2 (1974-1975): 39-47.

Blackman, Lisa. *Immaterial Bodies* (London: Sage, 2012).

Bolter, J. David, and Richard Grusin. *Remediation* (Cambridge: MIT Press, 1999).

Brennan, Teresa. *The Transmission of Affect* (Ithaca and London: Cornell University Press, 2004).

Butler, Judith. *Frames of War: When Is Life Grievable* (London: Verso, 2009).

—. *Gender Trouble* (New York, London: Routledge, 2006).

—. *The Psychic Life of Power* (Stanford: Stanford University Press, 1997).

—. *Excitable Speech* (New York: Routledge, 1997).

—. *Bodies That Matter* (New York and London: Routledge, 1993).

Caldwell, John Thornton. 'Cultures of Production'. In *Media Industries*, eds. Jennifer Holt and Alisa Perren (Malden, MA: Wiley-Blackwell, 2009), 199-212.

—. 'Screen Studies and Industrial "Theorizing"', *Screen* 50.1 (2009): 167-79.

—. *Production Culture* (Durham and London: Duke University Press, 2008).

Callon, Michel. 'What Does It Mean to Say That Economics Is Performative?' In *Do Economists Make Markets?*, eds. Donald Mackenzie, Fabian Muniesa, and Lucia Siu (Princeton: Princeton University Press, 2007), 311-57.

Carroll, Rory. 'Hollywood Apocalypse Not Now Despite Summer Flops and Directors' Strops', *The Guardian*, August 31, 2013.

Cartwright, Lisa. *Moral Spectatorship* (Durham: Duke University Press, 2008).

Cashmore, Ellis. *Celebrity/Culture* (New York: Routledge, 2006).

Chang, Jinn-Pei. 'How Tsai Ming-liang Marketed and Funded His Films'. In *Taiwan Cinema Year Book 2004* (Taipei: Chinese Taipei Film Archive, 2004), 53-65.

Chang, Shihlun. 'New Cinema, Film Festivals, and the Post-New Cinema', *Contemporary* 196 (2003): 98-107.

Chiang, Hueihsien, and Ya-Feng Mon. 'Making Films for Pleasures', *Eslite Reader Magazine*, December 2006.

Chun, Wendy Hui-Kyong. *Control and Freedom* (Cambridge, MA and London: MIT Press, 2006).

Clark, Andy. *Being There* (Cambridge, MA and London: MIT Press, 1997).

Clough, Patricia Ticineto. 'The Case of Sociology: Governmentality and Methodology', *Critical Inquiry* 36.4 (2010): 627-41.

—. 'Introduction'. In *The Affective Turn*, eds. Patricia Ticineto Clough and Jean Halley (Durham and London: Duke University Press, 2007), 1-33.

Couldry, Nick. 'On the Set of *The Sopranos*'. In *Fandom*, eds. Jonathan Gray, Cornel Sandvoss, and C. Lee Harrington (New York: New York University Press, 2007), 139-48.

Crary, Jonathan. *Suspensions of Perception* (Cambridge: MIT Press, 1999).

Cvetkovich, Ann. *An Archive of Feelings* (Durham: Duke University Press, 2003).

Davis, Darrell William. 'Cinema Taiwan, A Civilizing Mission?'. In *Cinema Taiwan*, eds. Darrell William Davis and Ru-shou Robert Chen (London and New York: Routledge, 2007), 1-13.

—. 'Trendy in Taiwan'. In *Cinema Taiwan*, eds. Darrell William Davis and Ru-shou Robert Chen (London and New York: Routledge, 2007), 146-57.

Dean, Jodi. *Blog Theory* (Cambridge and Malden: Polity Press, 2010).

De Lauretis, Teresa. *Alice Doesn't* (London: Macmillan, 1984).

Deleuze, Gilles. 'The Brain is the Screen: An Interview with Gilles Deleuze', trans. Marie Therese Guirgis. In *The Brain is the Screen: Deleuze and the Philosophy of Cinema,* ed. Gregory Flaxman (Minneapolis and London: University of Minnesota Press, 2000), 365-73.

—. 'Postscript on the Societies of Control', *October* 59 (1992): 3-7.

—. *Cinema 2: The Time Image*, trans. Hugh Tomlinson and Robert Galeta (London: Athlone, 1989).

Derrida, Jacques. *Archive Fever*, trans. Eric Prenowitz (Chicago: University of Chicago Press, 1996).

Doane, Mary Ann. *The Emergence of Cinematic Time* (Cambridge, MA and London: Harvard University Press, 2002).

—. *Femmes Fatales* (New York and London: Routledge, 1991).

Ferreday, Debra. *Online Belongings* (Oxford: Peter Lang, 2009).

Foucault, Michel. *Security, Territory, Population*, eds. Michel Senellart, Franois Ewald, and Alessandro Fontana, trans. Graham Burchell (New York: Palgrave Macmillan, 2007).

—. *The Archaeology of Knowledge*, trans. A. M. Sheridan Smith (London: Routledge, 2002).

—. *Discipline and Punish*, trans. Alan Sheridan (London: Penguin Books, 1991).

Gillis, Stacy, ed. *The Matrix Trilogy* (London: Wallflower, 2005).

Gledhill, Christine. 'Rethinking Genre'. In *Reinventing Film Studies*, eds. Christine Gledhill and Linda Williams (London: Arnold, 2000), 221-43.

Grant, Barry Keith. *Film Genre: From Iconography to Ideology* (London: Wallflower, 2007).

Green, Joshua, and Henry Jenkins. 'The Moral Economy of Web 2.0'. In *Media Industries*, eds. Jennifer Holt and Alisa Perren (Malden, MA: Wiley Blackwell, 2009), 213-25.

Hall, Stuart. 'The Problem of Ideology: Marxism Without Guarantees'. In *Critical Dialogues in Cultural Studies*, eds. David Morley and Kuan-Hsing Chen (London: Routledge, 1996), 24-45.

Haraway, Donna. *Simians, Cyborgs, and Women* (London: Free Association Books, 1991).

Harbord, Janet. *The Evolution of Film* (Cambridge: Polity, 2007).

—. *Film Cultures* (London: Sage, 2002).

Hardt, Michael, and Antonio Negri. *Empire* (Cambridge, MA and London: Harvard University Press, 2000).

Ho, Regina. 'Review of Box Office of 2008 Taiwan Films'. In *Taiwan Cinema Year Book 2009* (Taipei: Chinese Taipei Film Archive, 2009), 100-8.

Hou, Chi-jan. 'A Mirage in Heavy Traffic'. In *The Database of Taiwan Cinema*. Accessed June 17, 2013. http://cinema.nccu.edu.tw/cinemaV2/squareinfo.htm?MID=15.

Hu, Brian. 'Formula 17: Mainstream in the Margins'. In *Chinese Films in Focus II*, ed. Chris Berry (London: Palgrave Macmillan, on behalf of British Film Institute 2008), 121-7.

Huang, Shih-Kai. 'A Political Economic Analysis of Taiwan Film Industry in the 1990s', Master's thesis, National Chung Cheng University, 2004.

Jenkins, Henry. *Convergence Culture* (New York: New York University Press, 2008).

Jenkins, Holman W. Jr. 'Google and the Search for the Future', *The Wall Street Journal*, August 14, 2010. Accessed May 28, 2013. http://online.wsj.com/article/SB10001424052748704901104 575423294099527212.html.

Kapell, Matthew, and William G. Doty, eds. *Jacking in to the Matrix Franchise* (New York: Continuum, 2004).

Kavka, Misha. *Reality Television, Affect and Intimacy* (London: Palgrave Macmillan, 2008).

Kember, Sarah, and Joanna Zylinska. *Life After New Media* (Cambridge, MA and London: MIT Press, 2012).

Kracauer, Siegfried. *Theory of Film* (Princeton: Princeton University Press, 1997).

Kuhn, Annette. 'Photography and Cultural Memory', *Visual Studies* 22.3 (2007): 283-92.

—. ed. *Little Madnesses* (London and New York: I. B. Tauris, 2013).

Latour, Bruno. *Reassembling the Social* (Oxford: Oxford University Press, 2005).

Li, Aileen Yiu-Wa. 'The Production Strategy for *Formula 17*'. In *Taiwan Cinema Year Book 2005* (Chinese Taipei Film Archive, 2005). Accessed March 21, 2013. http://www.taiwancinema. com/ct_52423_332.

Li, Ya-mei. 'Creativity and the Impasse'. In *Taiwan Cinema Year Book 2008* (Taipei: Chinese Taipei Film Archive, 2008), 112-7.

Marcuse, Herbert. *One-Dimensional Man* (Boston: Beacon Press, 1964).

Marks, Laura. *The Skin of the Film* (Durham: Duke University Press, 2000).

Marshall, P. David. 'Intimately Intertwined in the Most Public Way'. In *The Celebrity Culture Reader*, ed. P. David Marshall (New York and London: Routledge, 2006), 315-23.

—. 'New Media – New Self'. In *The Celebrity Culture Reader*, ed. P. David Marshall (New York and London: Routledge, 2006), 634-44.

Martin, Fran. 'Taiwan (Trans)national Cinema'. In *Cinema Taiwan*, eds. Darrell William Davis and Ru-shou Robert Chen (London and New York: Routledge, 2007), 131-45.

Martin-Jones, David. *Deleuze and World Cinemas* (London and New York: Continuum, 2011).

Massumi, Brian. *Semblance and Event* (Cambridge: MIT Press, 2011).

—. *Parables for the Virtual* (Durham: Duke University Press, 2002).

—. 'Like a Thought'. In *A Shock to Thought*, ed. Brian Massumi (London and New York: Routledge, 2002), xiii-xxxix.

—. 'Requiem for Our Prospective Dead (Toward a Participatory Critique of Capitalist Power)'. In *Deleuze and Guattari: New Mappings in Politics, Philosophy, and Culture,* eds. Eleanor Kaufman and Kevin Jon Heller (Minneapolis: University of Minnesota Press, 1998), 40-64.

McLuhan, Marshall, and Quentin Fiore. *The Medium Is the Massage* (Corte Madera: Gingko Press, 2001).

McRobbie, Angela. *The Aftermath of Feminism* (London: Sage, 2009).

Metz, Christian. *The Imaginary Signifier*, trans. Celia Britton et al. (Bloomington: Indiana University Press, 1982).

Mon, Ya-Feng. 'The Audience Looks for "Smart" Effects', *Eslite Reader Magazine*, January 2007.

—. 'Michelle Yeh: Pursue the Smart Money', *Eslite Reader Magazine*, January 2007.

—. 'Make Films for Audiences', *Eslite Reader Magazine*, December 2006.

—. 'Leste Chen: Listen to the Audience', *Eslite Reader Magazine*, December 2006.

Morley, David. *Television, Audiences and Cultural Studies* (London and New York: Routledge, 1992).

Mulvey, Laura. *Visual and Other Pleasures* (Basingstoke: Palgrave Macmillan, 2009).

—. *Death 24 x a Second* (London: Reaktion, 2006).

—. 'Visual Pleasure and Narrative Cinema', *Screen* 16.3 (1975): 6-18.

Neale, Steve. 'Questions of Genre', *Screen* 31.1 (1990): 45-66.

Negri, Antonio. 'Value and Affect', trans. Michael Hardt, *Boundary 2* 26.2 (1999): 77-88.

Parisi, Luciana, and Tiziana Terranova. 'Heat-Death'. Accessed May 10, 2013. http://www.ctheory. net/articles.aspx?id=127.

Pierson, Michelle. *Special Effects: Still in Search of Wonders* (New York: Columbia University Press, 2002).

Rai, Amit S. *Untimely Bollywood* (Durham: Duke University Press, 2009).

Ranciere, Jacques. *Aesthetics and Its Discontents*, trans. Steven Corcoran (Cambridge: Polity, 2009).

—. *The Politics of Aesthetics*, trans. Gabriel Rockhill (London: Continuum, 2004).

Riley, Denise. *Impersonal Passion* (Durham: Duke University Press, 2005).

Ritzer, George, and Nathan Jurgenson. 'Production, Consumption, Prosumption', *Journal of Consumer Culture* 10.1 (2010): 13-36.

Sobchack, Vivian. *Carnal Thoughts* (Berkeley: University of California Press, 2004).

Stacey, Jackie. *Star Gazing* (London and New York: Routledge, 1994).

Stiegler, Bernard. *For a New Critique of Political Economy*, trans. Daniel Ross (Cambridge: Polity Press, 2010).

Strauven Wanda. 'The Observer's Dilemma'. In *Media Archaeology*, eds. Erkki Huhtamo and Jussi Parikka (Berkeley: University of California Press, 2011), 148-63.

Su, Wei-ling. 'The Study of Taiwanese Movie Blog Marketing', Master's thesis, National Taiwan Normal University, 2009.

Tarde, Gabriel. *The Laws of Imitation*, trans. Elsie Clews Parsons (New York: Henry Holt and Company, 1903).

Terranova, Tiziana. *Network Culture* (London: Pluto Press, 2004).

Toffler, Alvin. *The Third Wave* (London: Pan Books in association with Collins, 1981).

Tu, Hsiang-wen. 'The Significance of Special Effects in Taiwan Film Production'. In *Taiwan Cinema Year Book 2007* (Chinese Taipei Film Archive, 2007). Accessed March 25, 2013. http://www.taiwancinema.com/ct_56135_343.

Väliaho, Pasi. *Mapping the Moving Image* (Amsterdam: Amsterdam University Press, 2010).

Walkerdine, Valerie. 'Video Replay'. In *Formations of Fantasy*, eds. Victor Burgin, James Donald, and Cora Kaplan (London: Methuen, 1986), 167-99.

Wang, Cheng-hua. 'Review of the Film Market in 2007'. In *Taiwan Cinema Year Book 2008* (Taipei: Chinese Taipei Film Archive, 2008), 130-53.

—. 'Review of the Film Market in 2005'. In *Taiwan Cinema Year Book 2006*. Accessed September 12, 2013. http://www.taiwancinema.com/ct_54271_219

—. '1998 Yearly Box Office Results for Chinese Language Films'. In *Taiwan Cinema Year Book 1999* (Taipei: Chinese Taipei Film Archive, 1999), 65-9.

Wei, Ti. 'From Local to Global: A Critique of the Globalization of Taiwan Cinema', *Taiwan: A Radical Quarterly in Social Studies* 56 (2004): 65-92.

Wen, Tien-hsiang. 'Crossing the Gate to a Moved Mass Audience', *The Liberty Times*, September 29, 2000.

Wright, Judith Hess. 'Genre Films and the Status Quo'. In *Film Genre Reader III*, ed. Barry Keith Grant (Austin: University of Texas Press, 2003), 42-50.

Wyatt, Justin. *High Concept* (Austin: University of Texas Press, 1994).

Wydra, Harald. 'Passions and Progress: Gabriel Tarde's Anthropology of Imitative Innovation', *International Political Anthropology* 4.2 (2011): 93-111.

Interviews

Black Black. Skype Interview, February 7, 2011.

Chang, Chi-wai. Personal Interview, January 21, 2010.

Chen, Helen. Personal Interview, August 3, 2010.

Chen, Leste. Personal Interview, August 10, 2010.

Chen, Rachel. Personal Interview, August 24, 2010.

Chen, Yin-jung. Personal Interview, January 17, 2008.

Cheng, Hsiao-tse. Skype Interview, March 5, 2011.

—. Personal Interview, July 30, 2010.

Chun-yi. Skype Interview, February 1, 2011.

—. Focus Group Discussion, August 9, 2009.

—. Focus Group Discussion, August 15, 2010.

Chun-yi, Village and San. Focus Group Discussion, August 15, 2010.

Emolas. Skype Interview, February 6, 2011.

Emolas and Grace. Focus Group Discussion, August 9, 2009.

Flyer, Emolas and Black Black. Focus Group Discussion, August 14, 2010.

Fu, Tian-yu. Personal Interview, August 14, 2009.

Grace. Email Interview, March 7, 2011.

—. Focus Group Discussion, August 9, 2009.

—. Focus Group Discussion, August 15, 2010.

Hsu, Hsiao-ming. Skype Interview, March 3, 2010.

Huang, Patrick Mao. Personal Interview, August 2, 2010.

Kuei-yin. Focus Group Discussion, August 15, 2010.

Lan. Focus Group Discussion, January 31, 2010.

—. Focus Group Discussion, August 15, 2010.

—. Focus Group Discussion, August 2, 2009.

Liao, Ching-Song. Personal Interview, August 18, 2010.

Linwx. Skype Interview, February 10, 2011.

—. Focus Group Discussion, January 24, 2010.

—. Personal Interview, July 27, 2009.

Liu, Weijan. Personal Interview, August 26, 2010.

Li, Aileen Yiu-Wa. Personal Interview, September 10, 2009.

Summer. Email Interview, March 1, 2011.
—. Focus Group Discussion, January 31, 2010.
—. Personal Interview, July 18, 2009.
Village. Focus Group Discussion, January 24, 2010.
Yee, Chih-yen. Personal Interview, February 5, 2010.

Films, Blogs, and Websites Cited

Cape No. 7. The Official Blog. http://cape7.pixnet.net/blog.
Island Etude. The Official Blog. http://www.wretch.cc/blog/EtudeBike.
KongisKing.net. http://www.kongisking.net/index.shtml.
Please Show Your Support for Miao Miao. The Official Blog. http://miao.pixnet.net/blog.
What Time Is It There?. The Official Website. http://whattime.kingnet.com.tw/index.html.

Index

Printed and bound by CPI Group (UK) Ltd, Croydon, CR0 4YY

23/04/2025

14661012-0002